SHAPING SPACE

PAUL ZELANSKI
University of Connecticut

MARY PAT FISHER

SHAPING SPACE

THE DYNAMICS OF THREE-DIMENSIONAL DESIGN

SECOND EDITION

HARCOURT BRACE
COLLEGE PUBLISHERS

Fort Worth Philadelphia San Diego New York Orlando Austin San Antonio

Toronto Montreal London Sydney Tokyo

Publisher **Ted Buchholz**
Acquisitions Editor **Barbara J. C. Rosenberg**
Developmental Editor **Terri House**
Senior Project Editor **Margaret Allyson**
Production Manager **Serena B. Manning**
Art Director **Garry Harman**

Address for Editorial Correspondence: Harcourt Brace College Publishers, 301 Commerce Street, Suite 3700, Fort Worth, Texas 76102.

Address for Orders: Harcourt Brace & Company, 6277 Sea Harbor Drive, Orlando, Florida 32887, 1-800-782-4479 or 1-800-433-0001 (in Florida).

COVER PHOTO:
Francisco Infante. Serial Work. 1978–89.
Photo courtesy International Images.

Other photographic credits appear on page 269, which constitutes a continuation of this page.

Printed in the United States of America

ISBN: 0-03-076546-3
Library of Congress Catalog Card Number: 93-80814

8 9 0 1 2 3 4 5 048 12 11 10 9 8 7 6 5

P R E F A C E

Shaping Space: The Dynamics of Three-Dimensional Design, Second Edition, is designed to fill a major gap among art textbooks. Unlike most other design books currently available, it serves as an introductory text for three-dimensional design courses. It approaches three-dimensional design with the thoroughness and sensitivity that have until now been granted only to two-dimensional design.

 Shaping Space can be used in a variety of three-dimensional courses. It can be used as a core textbook for the foundation-level course in three-dimensional design. As such, it will provide a rich background in three-dimensional aesthetics that broadens students' understanding and creativity beyond the characteristics of the media and methods emphasized in their studio work. It can also be used as a general appreciation textbook for lecture/survey courses in three-dimensional art, both fine and functional. It is also an appropriate supplementary textbook for beginning courses in specific three-dimensional arts, such as ceramics, sculpture, fiber arts, metal-smithing, interior decoration, stage design, applied design, landscape design, or architecture. All of these disciplines are incorporated into the book via discussion and illustration, for they share the same organizing principles and elements of design.

 We are excited about three-dimensional design—about the ideas that shape its creation and about how it affects the viewer. We explore these two aspects with care and enthusiasm for both conventional artistic wisdom and new approaches that stretch and transcend the old definitions of what can and should happen in a work of art. Our hope is that students will encounter ideas that have never occurred to them and become more aware of the limitless potential of shaping space.

SPECIAL FEATURES

The second edition of *Shaping Space* offers an engaging, in-depth exploration of the aesthetic and practical considerations of working three-dimensionally. Because the field of three-dimensional design is experiencing a dynamic and exciting period of change, we have included computer-aided and computer-made sculpture, craft techniques such as fibers and ceramics used to create nonfunctional art, multicultural and "outsider" art, art as social commentary, architecture and industrial design that is conceived sculpturally, public sculpture, sculpture parks, installation pieces, and performance art.

 In order to give the student a clearer picture of the artistic process, we have incorporated interviews with artists, both historical

and contemporary, where the artists explain what they are doing and why, in a way that is direct and insightful.

Studio projects are included in Part Four. There are many more projects than can be covered in most one- or two-semester courses, allowing instructors to choose the projects that they feel are most effective in introducing and broadening three-dimensional awareness and technical skill. For example, the instructor of a basic 3-D course who has a strong ceramics background might emphasize the use of clay, while pre-architecture students might focus on architectural solutions. For courses emphasizing refinement of technical skills, relatively few projects would be assigned, in order to allow the creation of well-finished work. For courses focusing on design potential, many projects could be assigned, using such media as nonhardening clay, wax, plaster, cardboard, wire and paper, all of which are inexpensive and allow quick developmental studies.

ORGANIZATION OF THE BOOK

Fundamentals of Three-Dimensional Art. The book begins with three chapters introducing basic considerations in three-dimensional design. Chapter 1 explores the ways in which we experience three-dimensional art, with discussions of the limitations of photographs in representing three-dimensional experiences, the degrees of three-dimensionality, and techniques commonly used to draw people into approaching and exploring a piece. Chapter 2, Working in the Round, discusses a variety of practical considerations encountered in three-dimensional work, such as the pull of gravity, the influence of the setting, and issues of size, materials, costs, planning methods, and balancing of form and function. Chapter 3 applies the classical organizing principles of design—repetition, variety, rhythm, balance, emphasis, economy, and proportion—to the development of unity in a rich assortment of works.

Elements of Three-Dimensional Design. The second part of *Shaping Space* devotes a full chapter to each of seven elements present in most three-dimensional works: form, space, line, texture, light, color, and time. Each element is explored in depth, with careful attention paid not only to standard descriptions of ways the element can be used but also to subtleties such as negative forms, implied lines, activation of the space surrounding a piece, use of shadows, and changes through time. The chapters on space and color are particularly strong in treating these elements seriously as major aspects of three-dimensional design.

Construction Methods. The third section of the book offers a chapter on each of four general construction methods—found objects, addition and manipulation, subtraction, and casting. Each is further broken down into subcategories described enough to pique the student's curiosity into exploring new media and methods but not to serve as detailed how-tos. For more specific how-to help, an anno-

tated list of practical reference books is provided at the end of each of these methods chapters.

Adaptations of the Organization. The sequence of the book follows a logical progression from fundamentals, to elements, to experimentation with different construction methods. But the parts and chapters can be assigned in any order, for each is self-contained, with few cross-references. For example, we have introduced the principles of design (Chapter 3) before the elements (Part Two), in order to give students a framework for unifying their solutions to studio problems dealing with the individual elements of design. But some instructors might prefer to introduce the elements before the principles.

In a class stressing design concepts, the third section—Construction Methods—might be given simply as a reading assignment, with students applying the information as needed in solving problems given in the earlier chapters. In a class that stresses construction methods, more emphasis might be placed on exploration of the third section, with the earlier chapters serving as background material to be drawn on in solving problems using found objects, addition and manipulation, subtraction, and casting.

The studio projects given in Part Four allow students to experiment constructively with media and methods with which they may not be familiar. These projects can be created with simple skills and inexpensive materials. Our assumption is that technical expertise with a particular medium can be developed by choice or by requirements of the individual teacher, though the main emphasis in an introductory course will be placed on mastering the fundamentals of design—what will work—and on stretching students' concepts of what is possible.

ACKNOWLEDGMENTS

We have enjoyed rewriting *Shaping Space,* partly because the subject is so fascinating, and partly because so many people have helped so enthusiastically.

We feel very grateful to the working artists whom we interviewed. All have been extremely gracious with their time, perceptive in their comments, and encouraging about this book.

Our reviewers also have been very generous with their time and thoughtful in their suggestions for improving this second edition. We greatly appreciate their help. We particularly wish to thank Gerald Rowen, Northhampton Community College; Greg Shelnutt, University of Mississippi; Josefa Filkosky, Seton Hill College; and Valerie Weihman, University of Wisconsin, Madison.

At Harcourt Brace we have been pleased to work with a staff so dedicated to high quality in art textbooks: Barbara Rosenberg, Terri House, and Margaret Allyson. The special attention that project editor Margaret Allyson gave to all aspects of this second edition was extremely helpful and is much appreciated.

Finally, we both want to express our love and appreciation to Annette Zelanski, whose moral support and constructive criticism have helped us to see this second edition to a satisfying and successful completion.

Many thanks to all of you,

Paul Zelanski

Mary Pat Fisher

TABLE OF CONTENTS

CHAPTER 14 Casting

230

PART FOUR STUDIO PROJECTS

243

PART ONE

FUNDAMENTALS OF
THREE-DIMENSIONAL DESIGN

CHAPTER 1

EXPERIENCING THREE-DIMENSIONALITY

Three-dimensional art has height and width, as a painting does, plus a third dimension—depth. This stark definition, though true, gives no hint of the excitement of actually experiencing three-dimensional art. To plunge into this experience, try this experiment: Loosely crumple a piece of paper, any piece of paper. Then look at it. Don't just glance at it briefly; really explore it all over with your eyes. Hold it in your hand and slowly turn it, watching how it changes as the parts you can see and the angle from which you are seeing them change. Play with its relationship to a source of light.

If you are giving yourself fully to this experience, you will find that your piece of crumpled paper becomes endlessly fascinating. Your eyes and mind will be intrigued by the ever-changing patterns created by the paper forms and the empty spaces they define—the myriad ridges, hollows, and tunnels and their relationships to each other, the gradations of light and shadow, the changing surface textures. If your piece of paper happens to have writing on it, follow what happens to the lines of words as they disappear over the edge of a fold. Spend a long time exploring as many ways of looking at your paper "sculpture" as possible. Let your fingers explore it as well.

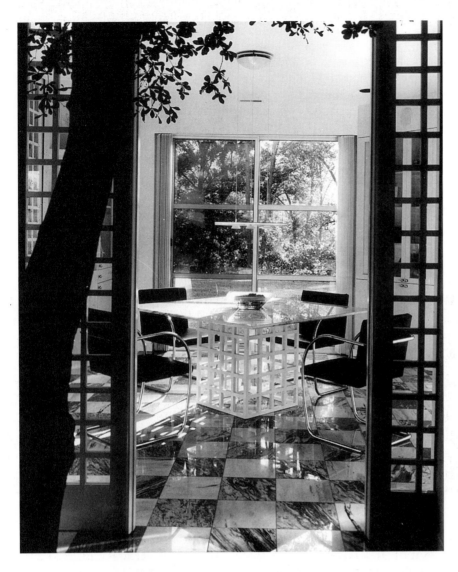

1.1 Vera S. Gospodnetic, Associate AIA. Gospodnetic Interplan, Richmond, Virginia, with Branko Siladin, architect, Zagreb, Croatia. Courtesy *Elle Decor* Magazine. Photo by Robert C. Lautman.

This seemingly simple exercise will help open you to fully appreciative experiencing of three-dimensional art. Actually, three-dimensional art experiences are all around us, but we are not fully aware of them. Imagine entering the room shown in Figure 1.1—the dining room of the house architect Vera S. Gospodnetic designed for her own family. If you were paying close attention, you would notice the way the French doors create a defined space and the converging parallel lines of the floor tiles draw your attention inward. The Mies van der Rohe chair seats seem almost to be floating forms, suspended in space without substantially visible support. The bowl on the reflective glass surface of the table also seems to be floating above the light latticework of the table's base. Squares appear repeatedly, broken by the flowing lines of the chair frames and the organic curve of the tree and leaves. The trees seen through the large window are echoed by the tree growing inside the house, creating an interplay of inside and outside forms and spaces.

You can imagine entering the room by just looking at the photograph, for we have a great ability to project three-dimensional experiences. Nevertheless, no photograph, no matter how well-planned or dramatic, can possibly replicate the highly personal act of experiencing a three-dimensional piece or place.

In this chapter we will examine some of the ways in which photographs distort the three-dimensional experience, demanding a great leap of imagination on your part to appreciate the works shown in this book. As an introduction to the vast range of possibilities for your own three-dimensional work, we will also look at the many different degrees of three-dimensionality and some of the techniques that can be used to draw viewers into the three-dimensional experience.

PHOTOGRAPHS OF THREE-DIMENSIONAL WORK

A black-and-white photograph obviously eliminates certain features of a three-dimensional work. The most obvious is color; another is the surface texture, weight, and balance of a piece—its "feel." Also lost is the sense of presence a three-dimensional work can create. A photograph in fact eliminates the use of all senses other than vision, and then it

1.2 (left) Umberto Boccioni. *Unique Forms of Continuity in Space.* 1913. Bronze (cast 1931), 43⁷/₈ × 34⁷/₈ × 15³/₄". The Museum of Modern Art, New York. Acquired through the Lillie P. Bliss Bequest.

1.3 (right) Umberto Boccioni. *Unique Forms of Continuity in Space.* Photographed from a different angle.

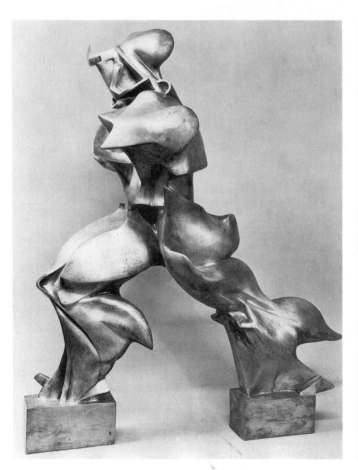

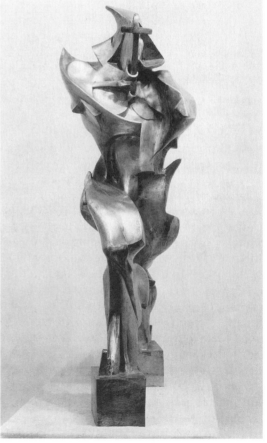

rigidly controls what we can see of a work and how we understand its totality.

Set Point of View

Presenting a single photograph of a three-dimensional piece confines the experience of the work to a single *point of view*—a set distance and angle from which the piece is viewed. Of the almost limitless possibilities, only one viewpoint is chosen to represent the experience of the whole. This approach obviously has its limitations.

The first photograph shown here of Umberto Boccioni's *Unique Forms of Continuity in Space* (Fig. 1.2) is the most commonly used view. It certainly captures the rapidity of the abstracted figure's motion, the sense of garments being blown back as it strides forward. This illusion of vigorous movement is what the artist was depicting, as if in a stop-action photograph. But from this side, what can we make of the shoulder area? Of the head? Figure 1.3 shows a head-on view which would never make sense by itself, but which gives us a bit more information about the piece. Here we discover that the front of the "face" is like a crucifix, and that where the upper garment opens down the center, it is caught by the wind and billows outward like an exterior rib cage. Here and there, areas of unfilled space are drawn into the embrace of the sculpture by flaring projections from the figure. We can also see the slick trajectory of the thigh from the hip.

Making a full circle around the piece would reveal even more views and surprises, more dark recesses and strange projections, distorted by the apparent motion of the figure. Boccioni makes us want to explore the sculpture from all sides to see what happens. Good three-dimensional art is like this: It compels us to walk all the way around it, examining it from many angles.

Flattening Out

Photographs inevitably distort our perceptions of a three-dimensional piece, for they present it on a flat two-dimensional surface. Looking at a two-dimensional photograph and mentally translating it into three-dimensionality is an ability most people in our culture have developed. When Australian aborigines are shown a photograph of an area they know, they cannot make the mental leap from the flat image to three-dimensional reality. But from experience with photographs, you have probably learned to read the clues to depths they provide. These clues include shadows, the overlapping of one area by another, the greater contrast in *values* (or gradations of lights and darks) and in sharpness of edges in areas closer to the viewer than in areas farther away, and linear perspective (the convergence of parallel lines toward a distant vanishing point, as in the floor tiles of Figure 1.1). By interpreting such clues, we may get some intellectual impression of how deep a piece might be. But the experience remains an intellectual one nevertheless; we cannot fully appreciate the three-dimensional impact of the piece and how the parts relate to one another in space. It is very difficult to judge from the photograph in Figure 1.4a the depth and feel of Frank Lloyd Wright's Guggenheim Museum with Jenny Holzer's installation on

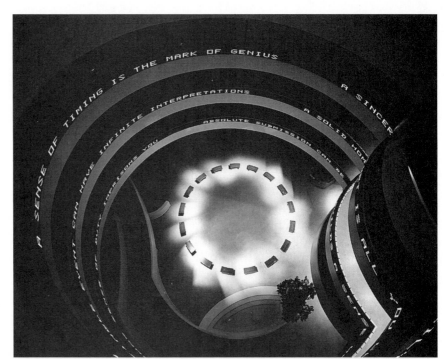

1.4a and **1.4b** Jenny Holzer. Selections from *Truisms, Inflammatory Essays, The Living Series, The Survival Series, Under a Rock, Laments* and new writing. 1989. Two views of extended helical tricolor L.E.D. electronic display signboard, 11 × 162 × 4" (27.9 × 411.5 × 10.2 cm). Solomon R. Guggenheim Museum, New York. Partial gift of the artist, 1989. Photos David Heald © The Solomon R. Guggenheim Foundation, New York.

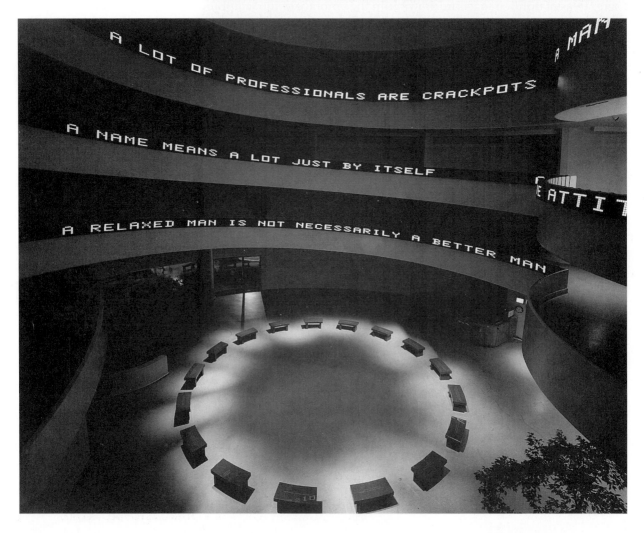

the ground floor and around the balconies of the spiraling ramp. Even though the nested curves are clues to depth, we cannot even be sure whether we are looking up at the dome or down at the base of the museum. The photograph in Figure 1.4b, taken from just above the ground floor, offers an entirely different experience of this work.

Though still too expensive a process to replace regular photography of three-dimensional objects, *holography* offers the opportunity to view a three-dimensional object from more than one point of view. The process uses a laser beam, which is split into two beams that spread to wrap around a portion of the object they are illuminating. When these beams are converged on a photographic plate, they form an interference pattern that makes the photograph appear highly three-dimensional. Even though the resulting image—a *hologram*—is presented on a flat surface, movements of the viewer bring new perspectives of the object into view.

Even more useful is computer simulation of the experience of viewing a work of art from many angles. Images designed on computers can be manipulated so they can be "seen" from any direction even if the piece has never existed in real three-dimensional space. Timothy Duffield, who is both a sculptor and a landscape architect, can "look at" his fantasy monuments ringing a mountain crater from many and dizzying perspectives, but he has never built them, and the site itself is imaginary. Duffield says:

> The computer is a wonderful design and visualization tool. The computer unlocks new avenues of realization. As a sculptor, there are ways that I view the world and interpret my life that are essentially sculptural but could never be expressed as actual sculpture. I've always used drawing as a means of exploring sculptural ideas that could never be realized because of time and financial constraints. The computer offers the ability to take these drawings several steps further, to give fantasy the aura of tangibility.*

The combination of videodiscs with computer technology also makes it possible for existing artworks to be videotaped in the round and then called up so that all sides can be seen as the viewer watches the screen. Some museum collections are being scanned onto videodiscs with interactive technology to simulate for viewers at computer stations the experience of walking through galleries. The screen itself is still a flat space, however, so the fullness of existing with and examining a piece in three-dimensional space is only approximated.

The potential of interacting electronically with a piece of sculpture is beginning to be manifested in a rudimentary way with the development of *virtual realities.* "Virtual" is a computer term referring to anything that exists only as digital memory in the computer rather than in physical fact. Virtual realities are computerized electronic experiences. The viewer dons special headgear containing miniature video monitors that block out visual impressions of the actual surroundings. The person also attaches movement-sensing wires to his or her body and can then

* Timothy Duffield, as quoted in the videotape, "The Computer: A Tool for Sculptors."

1.5 Charles Simonds.
*Dwelling, East Houston Street,
New York.* 1972. Unfired clay
bricks, each brick ¹/₂″ (1.3 cm)
long. Courtesy the artist.

1.6 Cliff Palace, Mesa Verde
National Park, Colorado. C. A.D.
1100. Photo Grant Heilman
Photography, Inc.

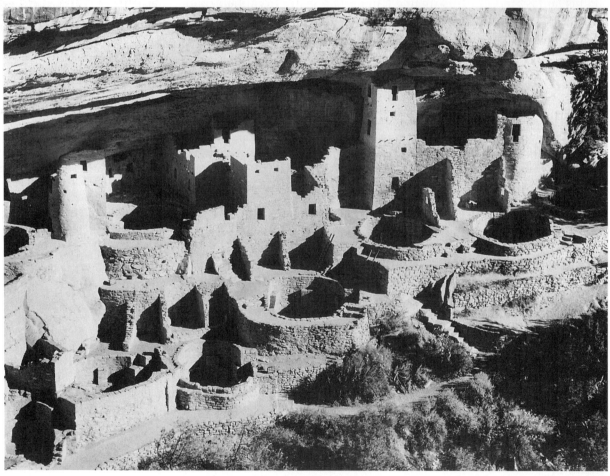

"walk into" and "manipulate" objects in a simulated three-dimensional environment. Whenever a viewer turns his head, for instance, computers change the image he sees as if he were actually looking at a different part of the space. When he "moves closer" to an object, perhaps by walking nowhere on a treadmill, the object he sees in the headgear becomes realistically larger. He can "reach out" his hand and see himself grasping and working with the object, as it were. Developed for scientific purposes, as were computers themselves, virtual-reality technology is a tool adaptable for use by artists. It is conceivable that a person could walk into an empty room, put on virtual-reality equipment, and then "move through" or "walk around" and examine from every angle a sculptural work that has never existed in physical form. He could even push its moving parts and watch what happens.

Scale

Another distortion introduced by two-dimensional photographs of three-dimensional works is the confusion of *scale*—the relative size of pieces. Many photographs give no clues to whether the object shown is very small or very large. Charles Simonds's *Dwelling,* shown in Figure 1.5, looks larger than the similar structures in the pueblo cliff dwellings shown in Figure 1.6, yet Simonds's work is a miniature of tiny clay bricks placed among the bricks of a building, photographed from close range, whereas the cliff dwellings are vast and photographed from a distance.

When photographers want to give some indication of scale, they will often include in the photograph something of known size—such as a bench or a human being—to serve as a standard of comparison. The photograph of the true cliff dwellings does include the overhanging rock ledge, but this serves as a clue to scale only for those who are familiar with the vast scale of these hollows in the cliffs of the Southwest.

An additional intellectual clue to the scale of a three-dimensional work is the size given in the caption. If you merely look at the photograph of the Doré vase (Fig. 1.7), you will likely interpret it as a fancy container for flowers one might use on a table. But read the caption: This piece is 11 feet tall; it weighs 6,000 pounds. Those cherubs are as large as real babies. Even with this information, to adjust your thinking to accommodate these figures and to imagine the true scale of this work takes a great imaginative leap on your part.

The Photographer's Interpretation

Yet another limitation introduced in photographs is the difference between the photographer's understanding of a piece and the artist's vision of it. Consider the vast difference between the standard museum photograph of Brancusi's *Bird in Space* (Fig. 1.8) and Brancusi's own photograph of the work (Fig. 1.9). The first gives us some idea of what the piece looks like; the second has a far more dramatic impact. Brancusi's photograph reveals what he was trying to capture: the mystical wildness of flight. At certain times, birds flying overhead express this quality; all you can see is a flash of light. By contrast, the standard photograph,

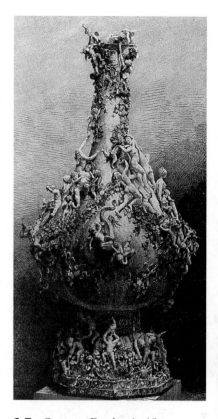

1.7 Gustave Doré. *La Vigne* from M. K. Halevy, *L'Eau Forte* (Paris: Barrie Frères, 1888), Plate XIV. Art and Architecture Collection, Miriam and Ira D. Wallach Division of Art Prints and Photographs. The New York Public Library; Astor, Lenox and Tilden Foundations. Based on Gustave Doré. *La Vigne (The Vintage Vase),* 1877–78. Bronze, 11' high × 6'8" diameter. Fine Arts Museums of San Francisco. Gift of M. H. DeYoung.

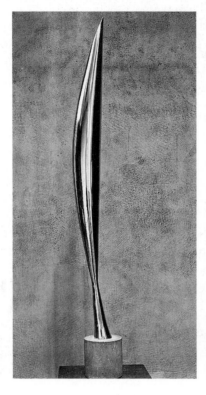

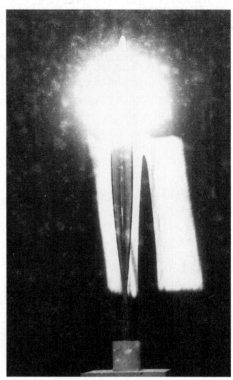

though graceful, has a static quality, as though it were a statement about a still object.

The Photograph as the Work of Art

Despite the limitations of substituting the second-hand experience of looking at a flat photograph for actual involvement with a three-dimensional piece, in some cases looking at a photograph is our only way of experiencing a piece. If the work is not nearby, a photograph will have to do. Photographs also preserve an impression of *installation pieces* erected temporarily in a particular setting. And in certain pieces of *conceptual art*—that is, work or events existing as ideas in the artist's mind, but not necessarily presented in tangible form—the phenomenon created may be so short-lived or difficult to experience that a photograph must serve as the documentation of the work.

Walter De Maria's conceptual piece *The Lightning Field* can best be appreciated during a lightning storm. Yet few of us would stand in the midst of these 400 lightning rods during a lightning storm to see what happens. We must thank John Cliett, who took the photograph in Figure 1.10, for sharing the experience with us.

Andrew Goldsworthy's outdoor conceptual art is ephemeral, often consisting of fragile materials such as twigs and ferns placed in natural settings with no attempt to protect them from decay and disruption by wind, rain, insects, and animal. In the case of *Icicle Wall* (Fig. 1.11), this ephemeral art is located where few people might chance upon it to witness its brief life. Goldsworthy constructed and photographed it

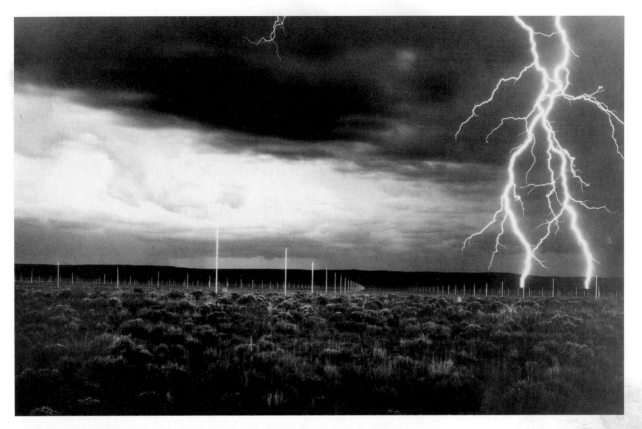

1.10 Walter De Maria. *The Lightning Field.* 1977, Quemado, New Mexico. Permanent earth sculpture 1 mile × 1 kilometer. 400 stainless-steel poles with solid stainless-steel pointed tips, arranged in a rectangular grid array spaced 220 feet (67.05 m) apart. Pole tips form an even plane. Average pole height is 20'7" (6.27 m). New Mexico, Dia Center for the Arts. Photo John Cliett © Dia Center for the Arts.

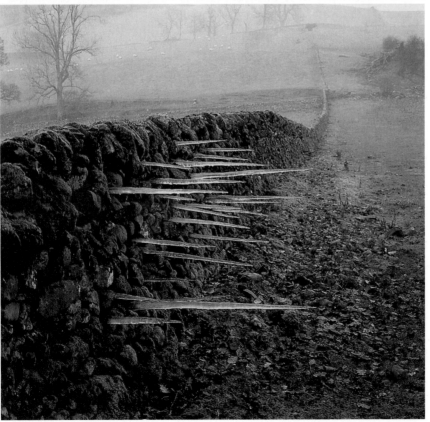

1.11 Andrew Goldsworthy. *Icicle Wall.* Dumfriesshire, Scotland, 1992.

so viewers could experience something of its dynamic anti-gravitational statement within this pastoral landscape. For the most part, however, the photographs you see of three-dimensional works were not intended to be the artistic statement in themselves. In most cases, you must pierce through the layers of abstraction and distortion introduced by the photograph and mentally project yourself into the feeling of actually experiencing the piece.

DEGREES OF THREE-DIMENSIONALITY

In experiencing three-dimensionality, we are controlled to a certain extent—depending on the success of the piece—by the intentions of the artist. We will be discussing artistic intentions and means of control throughout this book, but here we will be dealing with the initial fact of how three-dimensionally the piece is conceived. Possibilities range from nearly flat works to works designed to surround the viewer. The term *relief* refers to the raising of three-dimensional forms from a flat background. It appears that this artistic convention began very early, for relief works were carved on cave walls by prehistoric peoples. Perhaps the ancient sculptors noted bulges in the cave wall that already looked something like horses or bisons; a bit of carving brought out the desired form.

The shallowest form of relief is called *low relief,* or *bas-relief.* Although a formal definition of low relief is hard to pin down, the artistic attitude is one of relative flatness. In the gravestone carving in Figure 1.12, the angel is barely raised from the incised slate. Note that highlights and shadows are created by the ways the raised areas and strongly chiseled grooves reflect or block the light, helping to accentuate the image. The cooking screen sculpted by Surjit Kaur in traditional Punjabi folk style (Fig. 1.13) uses color differences to accentuate the

1.12 Detail from gravestone of Polly Coombes, 1795, Bellingham, Massachusetts. Carving attributed to Joseph Barber, Jr. Slate gravestone, size of full stone 29$\frac{1}{2}$ × 16$\frac{3}{4}$" (74.9 × 42.5 cm). Photo © Ann Parker, 1985.

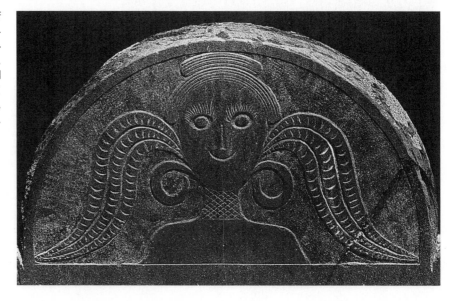

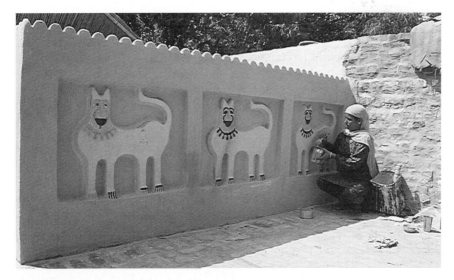

1.13 Vero Kaur applying yellow-tinted whitewash to Surjit Kaur's lion screen. Shiv Sadan, near Garhmukteshwar, Uttar Pradesh, India, 1992. Clay and wheat chaff, wall height 4'. Photo Mary Pat Fisher.

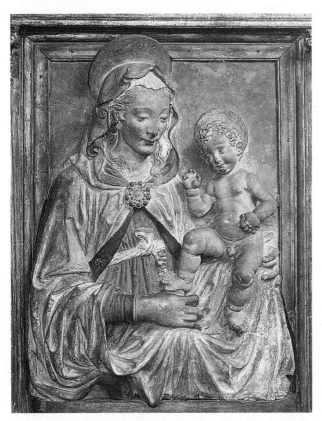

1.14 Andrea del Verrocchio. *Virgin and Child.* 15th century. Polychromed and gilded terra-cotta. The Metropolitan Museum of Art. Rogers Fund, 1909.

distinction between the background and the lions, which are hand-modeled in 2-inch relief from local clay and wheat chaff.

In *high relief,* forms are brought more fully off the flat surface, for a nearly sculptural effect. In Andrea del Verrocchio's *Virgin and Child* (Fig. 1.14), the figures even protrude in front of the "frame," as though they are starting to come off a flat canvas to appear as truly three-

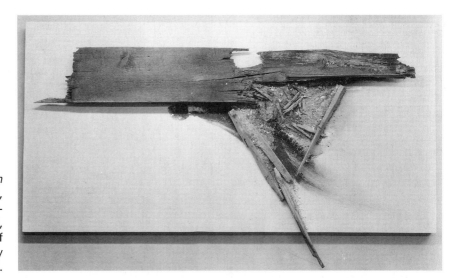

1.15 Robert Mallary. *In Flight.* 1957. Relief of wood, dust, sand, and synthetic polymer resin on painted plywood, 43½″ × 6′7⅝″. Museum of Modern Art, New York. Larry Aldrich Foundation Fund.

dimensional objects rather than as painted illusions of three-dimensionality. Here the artist has used strong *undercutting*—carving away of material between a projecting area, such as the Child's legs, and the substrate. In areas so worked, the forms are so three-dimensional that lighting inevitably brings out strong highlights and shadows. Look, for instance, at the dramatic difference between the right and left halves of the Virgin's face and at the play of light and shadow through the deep drapings of her robe.

Reliefs are not limited to figurative works in which the forms and their background are carved or cast from the same material. Witness Robert Mallary's *In Flight* (Fig. 1.15), a relief in which found materials have been affixed to a piece of painted wood. This piece controls the viewer's experience in the same way as the earlier examples: By presenting forms against a flat surface, it defines a limited space for the viewer's attention and a fixed point of view. Reliefs are designed to be looked at more or less straight on, perhaps with the head lifted somewhat, as in the cases of friezes placed above eye level on buildings.

One-Sided Works

The next step in three-dimensionality is work designed to be seen from only one side but not confined to a flat background. Like reliefs, these works are primarily *frontal*—that is, they are organized for viewing from the front. We can move around these pieces to a certain extent, but the artist does not strongly encourage us to do so.

Most jewelry is of this nature: All the visual interest lies on the front side, with the back only minimally elaborated. Instead of moving around or turning a piece of jewelry to see how its contours change, viewers would tend to scan it from edge to edge like a two-dimensional work, following the interplay of patterns on the surface.

Some one-sided pieces are large enough that viewers can walk along them, examining each section. If you encountered Louise Nevelson's *Sky Cathedral—Moon Garden + One* (Fig. 1.16), you'd probably

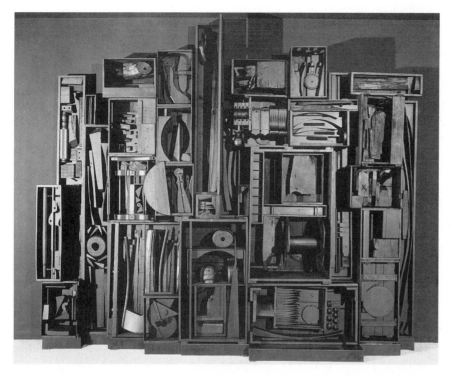

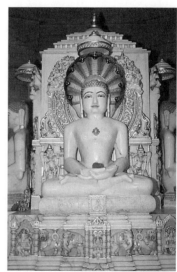

1.16 Louise Nevelson. *Sky Cathedral—Moon Garden + One.* 1957–60. Painted wood. 9′ × 10′8″ × 1′7″ (2.77 m × 3.30 m × 48.26 cm). Private collection. Courtesy of the Pace Gallery.

want to examine it in at least two ways: Stand back to see the whole thing from a distance, and walk from one side to the other, looking into the individual boxes to see what is happening in each one. However, Nevelson does not encourage you to stand to one side and look across the whole piece, for the contents of the boxes do not protrude much beyond the boxes themselves, limiting what you could see from this angle. Neither does she suggest that you explore the back of the piece, for it is backed against a wall, with all parts designed to be seen frontally.

The less flat a piece is, the more the viewer may be tempted to examine it from positions to either side of a straight frontal approach. But even when a piece is presented in the *half-round*—180 degrees of a fully three-dimensional circle—interest in exploring how it looks from many angles may be intentionally limited by the artist. The Twenty-third Tirthankara statue in Figure 1.17 is only half a figure, for it is placed against a solid backdrop and is to be seen only from the front. Four such frontal figures have been placed around the four sides of a cube, each facing in a different direction. This photograph reveals what visitors to the Jain temple will likely overlook in their spiritual concentration on each image: the flat, uncarved backs of the statues to either side.

Edward Kienholz and Nancy Reddin Kienholz's *People Holding Bound Ducks* (Fig. 1.18) suggests to viewers an environment that is not to be intruded upon but is to be examined visually from its edges at floor level. One is intrigued to wander back and forth along the exposed sides of the half-round installation, looking for visual clues and personal mental associations that might help make some sense of it: Why only fragments of bodies? Why the armbands? Why are things held under

1.17 Twenty-third Tirthankara statue, installed in Sri Atma Vallubh Jain Smarak Temple, Delhi, India. Marble with gold leaf, figure approx. 6′ tall. Photo Mary Pat Fisher.

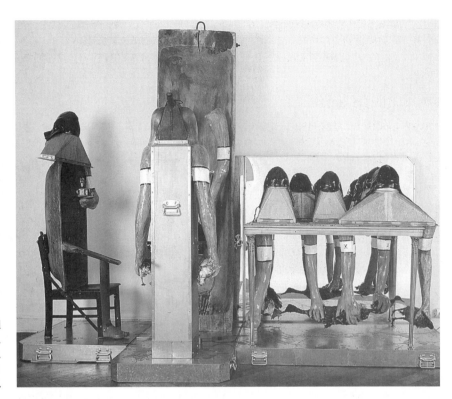

1.18 Edward Kienholz and Nancy Reddin Kienholz. *People Holding Bound Ducks.* 1989. Mixed media, 92¹/₂ × 116 × 44″. Photo L. A. Louver.

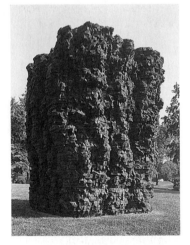

1.19 Ursula Von Rydings- vard. *For Paul.* 1990–92. Cedar, graphite, 14¹/₄ × 9 × 13³/₄′. Installed at the Storm King Art Center, Mountainville, New York. Photo Jerry L. Thompson.

the table rather than being placed atop it? Are the metal cases in some way functional? Why ducks? Is some grim statement being made? We cannot be sure of anything in this strange but evocative mini-world, set before us as a stage.

The Full Round

In contrast to reliefs and one-sided works, pieces done "in the round" are designed to be seen from all sides. Instead of being organized like a two-dimensional work, where all spatial relationships are fixed across a flat plane, areas in a fully round work have been organized with consideration of their constantly changing relationship to one another. Indeed, if they are successful, they should make us want to walk all around them, discovering how the forms and relationships change when seen from different angles. "In the round" is an expression applied to any fully three-dimensional piece, no matter how large or small or how shaped.

Ursula von Rydingsvard's *For Paul* (Fig. 1.19) is like a huge boulder looming above the viewer, larger at top than bottom. To see it only in a photograph is particularly frustrating, for its horizontal lines draw us to investigate it in the full round. We want to see what lies around the corner; the cutting and working of the wood also beckon us toward the piece almost as to a place of stable refuge. The artist herself was born of Polish parents, living in forced labor and refugee camps in Germany, and the stability of seemingly time-worn everyday materials often appears as a motif in her works. There is nothing sentimental

here, though. Von Rydingsvard says, "One of the things I would be most ashamed of is to have any pathos in my work. Or to have blatant pain. . . . I want this kind of packed pride, this containment of emotions."*

Walk-Through Work

The final degree of viewer involvement with three-dimensionality is the experience of actually being surrounded by a work of art—of walking not only up to and around a piece, but also into it. In so doing, you become the center of the work; rather than your circumnavigating its circumference, *it* encircles *you*. This feeling of being surrounded by a 360-degree experience is as impossible to represent in a photograph as the experience of exploring a work from all sides. Again, you must use your imagination to place yourself in the settings pictured.

To experience Wharton Esherick's stairway (Fig. 1.20), you would probably want to walk up to it and around it to see how the logs create two branching, spiraling pathways and to appreciate the weight, form, and texture of the steps and central support. In addition, you might want to climb the stairs to see where they go and how they get there. At each step toward, around, and up the stairs, your spatial relationship with the stairway and the rest of the interior would change, altering and enriching the experience of being surrounded by this architectural environment.

Or consider what you would do if you met Nancy Graves's *Camels* (Fig. 1.21). Unless you have no curiosity whatsoever, you would want to move around these realistic creatures in as many ways as the gallery allowed. You would want to look at them very closely to see how Graves managed to create such lifelike texture and form. You would want to walk all around and even between them, watching their changing relationships to one another—to look between the legs of one to see the head of another, to see the similarities and differences from head to head, neck to neck, hump to hump. If you have retained or

* Ursula von Rydingsvard, quoted in "Life under Siege," Avis Berman, in *Art News*, December 1988, p. 97.

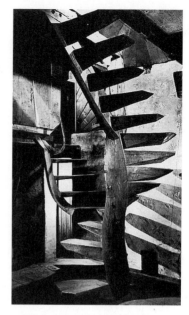

1.20 Wharton Esherick. Tree-like stairway hewn from solid logs. 1930. Red oak. Courtesy Wharton Esherick Museum, Paoli, Pennsylvania. Photo William Howland.

1.21 Nancy Graves. *Camels VII, VI, VIII* (left to right). 1968–69. Wood, steel, burlap, polyurethane, animal skin, wax, oil paint; 8 × 9 × 4' (24.4 × 27.4 × 12.2 m), 7½ × 12 × 4' (22.8 × 36.6 × 12.2 m), 7½ × 10 × 4' (22.8 × 30.5 × 12.2 m). National Gallery of Canada, Ottawa. Camels VII and VIII gift of Allan Bronfman, Montreal.

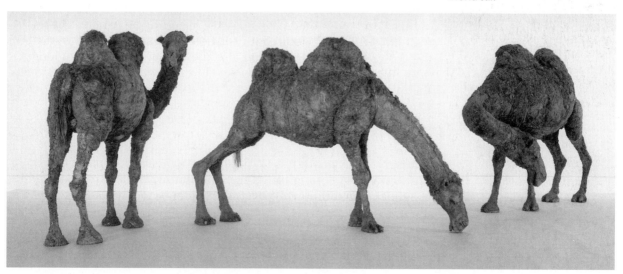

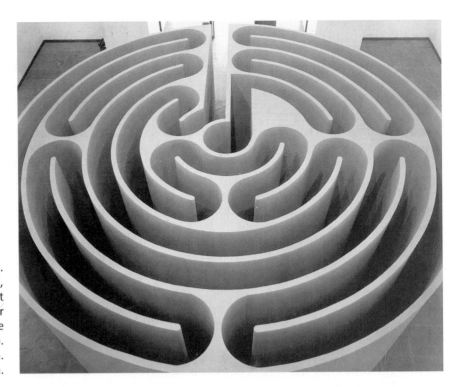

1.22 Robert Morris. *Labyrinth.* 1974. Plywood, masonite, oil paint. Height 8′ (2.44 m), diameter 18′ (9.14 m), 1′6″- wide passageway (45.72 cm). Private collection. Photo Will Brown.

remembered a child's ways of appreciating the world, you might even respond to the playfulness of the piece by walking under the belly of one and gazing upward to see what you can see, discovering in a very personal way how large a camel really is. If the piece called forth these kinds of reactions from you, you would be participating in it fully, rather than simply standing aside as a passive observer.

For a walk-through experience, a piece must obviously be large in scale, large enough for people to fit inside. And depending on the artist's intent, it may control the ways in which people can walk through it. Architecture often has defined passageways—like halls and doors and stairs—that limit the ways we can move through its interior spaces. We may or may not find the means of control pleasant. For many people, walking through Robert Morris's *Labyrinth* (Fig. 1.22) would be a disturbing or even frightening experience. Caught in the endless curves of this maze, one would have no sense of getting anywhere. The 8-foot-high (2.44 m) walls would both frustrate attempts to find the way into the center—or out—and would also press in uncomfortably along the sides. Whatever emotions are evoked in those who choose to try to find their way through the maze create the drama of the piece.

INVOLVING THE VIEWER

If it is effective, art in the round invites some kind of participation by the viewer. Depending on its size and nature, a piece may encourage us to pick it up and turn it over in our hands, feel its weight, stroke it, use it, sit on it, visually traverse the piece following its contours, walk

around it to see what it becomes on the other side, explore its passageways.

In its very three-dimensionality, art in the round has a direct impact on us. While a two-dimensional piece, such as a painting, is like a window that we must take the time to look through, a three-dimensional piece occupies space and time in our immediate environment. It competes with us for physical space, like a wall that we must either walk around or else bump into.

Yet even three-dimensional art can be ignored by the viewer. To a certain extent, people can walk past three-dimensional pieces without really seeing them, for the viewers' thoughts are elsewhere. One of the tasks facing you as an artist, therefore, is to draw attention to your creations, to invite people to notice and to respond to them.

We'll explore techniques for provoking a direct response from viewers throughout this book. In this section we examine some general categories of involvement-encouraging factors: tactile/visual appeal, engaging curiosity, realism, abstraction and stylization, scale, content, personal interaction, the unexpected, and verbal statements about the work.

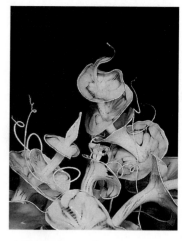

1.23 Dale Chihuly. Detail from Sheraton Hotel installation, Seattle, Washington. 1986. Blown glass. Photo Dick Busher.

Tactile/Visual Appeal

Involvement in three-dimensional art begins with the artist who creates it. As children, many of us begin exploring three-dimensional art by shaping claylike materials into forms that please our hands and perhaps our eyes. Witness the comments of eight-year-old Ruth Zelanski: "I like to work with clay because it feels mushy—and then when it's glazed and fired it feels nice and glossy." As she talks about her work, her fingers explore it constantly, following its contours, fitting themselves into its concavities, caressing its smoothness, noting the grooves made by fingernail marks. Her description of how she works is studded with highly physical verbs: "pound," "roll," "poke," "pinch," "rub," "mush." Although she explains that when faced with a block of clay she gets a form out of it by "sort of seeing it inside my head," she notes that the forms that evolve are "what my body wants to do."

The joy of touching expressed in children's clay modeling may often be part of what draws viewers into involvement with a piece. If you could touch Dale Chihuly's fantastic glass installation at the Sheraton Hotel in Seattle (Fig. 1.23), you would probably want to explore it with your fingers, caressing the delicate smoothness of the glass, testing the feel of the slim tendrils, following its fantastic organic curves. Even though one would not actually be allowed to touch this work, it is "visually tactile." We are invited to trace its flowerlike forms with our eyes, almost as if we were stroking them with our hand.

Art does not always appear to us as beautiful or provoke pleasant sensations, however. Artists may use subject matter, colors, and surface treatments that may trigger disturbing emotional responses. Lois Knobler's heads of fallen angels (one of which is shown in Fig. 1.24) are fashioned of materials that are otherwise innocently soft and familiar—stuffed stockings, gloves, t-shirts, string. But the artist has presented these materials in such a way that viewers may be afraid to touch or

1.24 Lois Jean Knobler. *Dubiel.* 1983. Mixed media. 14 × 9 × 10″ (35.56 × 22.86 × 25.4 cm), base 5½″ (12.7 cm). Photo Joseph Painter.

even to look for long, for they may bring to light an uncomfortable awareness of the dark side of ourselves. Art historian Joyce Brodsky responds to the heads thus:

> Never touch them for they are dangerous. Enough to see them—and some cannot be seen. The highest rank can be seen for only an instant. These heads are on the edge of deep and dark mysteries of psyche and flesh, of nerve pain beneath and sensuous—that unshared ache. . . . I cannot stand it for too long.

Yet even in turning away from such pieces, we are responding to them. They have touched us personally, and we must react.

Engaging Curiosity

Many works involve us by piquing our curiosity, by making us stop in our tracks to wonder "What is that?" "What does it mean?" "How should I read this?" or "How did the artist do that?" "What keeps that thing from falling?" "What happens on the other side?" A common device to lure people to explore a piece in the full round is the use of forms that disappear around the edge of what can be seen from a single point of view. We human beings are simply too curious to glance at a figure like Aristide Maillol's *The River* (Fig. 1.25) from a fixed position and let it go at that. Seen at the angle from which this photograph was taken, the piece provokes our native curiosity. We want to find out where the "missing" foot is and what it is doing.

1.25 Aristide Maillol. *The River.* Begun 1938–39, completed 1943. Lead (cast 1948), 53³/₄ × 7′6″ × 66," on lead base designed by the artist, 9³/₄ × 67 × 27³/₄". The Museum of Modern Art, New York. Mrs. Simon Guggenheim Fund.

Our knowledge of the human body creates a vague dissatisfaction that is not quieted until we've "found" all the expected parts. If we see one hand or foot, we look for a second one; we want to follow the arm line out from the shoulder to complete the suggestion that an elbow lies just out of view. Sculptures frequently twist torsos into extreme positions, not only for the sake of the visual excitement thus created, but also to hide parts of the anatomy from view, piquing viewers' curiosity. An effective piece of three-dimensional art may change continually as we move around it, beckoning the curious onward.

Pieces may also engage our curiosity by presenting us with visual puzzles we don't immediately understand. In *The River,* the woman clearly seems to be off balance, moving so playfully that she is likely to fall off her perch. What keeps her from falling? From the angle that the photograph is taken, there is no way of telling. Many people would therefore be drawn into walking around the sculpture to try to see how and where the woman is anchored.

Representation

Certain works engage our attention by accurately replicating forms with which we are familiar. This approach is called *representational art*—visual accuracy in artistic representation of objects from our three-dimensional world. Such works are recognizable, bringing a satisfying sort of involvement if the piece reminds us of something we know.

There are many degrees of representation. Artists may not try to copy all details of an object precisely, concentrating rather on certain features that convey the intended content of the piece. John Rogers's *"Wounded to the Rear," One More Shot* (Fig. 1.26) emphasizes the wounds—arm in sling, leg being bandaged—of the Union soldiers but not the sweat, dirt, blood, and terror actually experienced in war. The artist's intent seems to be to evoke pride in heroism, rather than horror.

In extremely representational work, the artist may attempt to describe the visual characteristics of an object precisely, without any editing or sentimentalizing. In such cases, viewers' interest in recognizing the real may take the form of amazement that such artful duplication is possible. Marilyn Levine's *Spot's Suitcase* (Fig. 1.27) so perfectly replicates a worn leather suitcase—down to the limpness of the strap, the

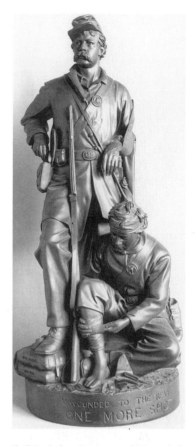

1.26 John Rogers. *"Wounded to the Rear," One More Shot.* American Civil War period. Bronze, height 23½" (60 cm). Metropolitan Museum of Art, New York. Rogers Fund, 1917.

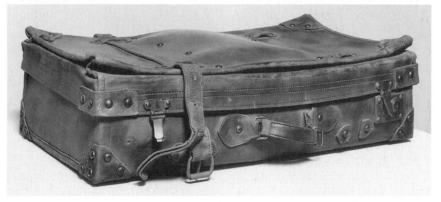

1.27 Marilyn Levine. *Spot's Suitcase.* 1981. Ceramic, 7½ × 28 × 15" (17.78 × 71.12 × 38.1 cm). O.K. Harris Works of Art, New York.

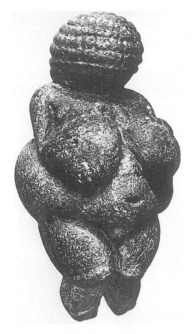

1.28 *Venus of Willendorf.*
c. 30,000–25,000 B.C. Stone
(cast of original), height 4³/₈″
(10.16 cm). Naturhistorisches
Museum, Vienna. Photo Art
Resource, New York.

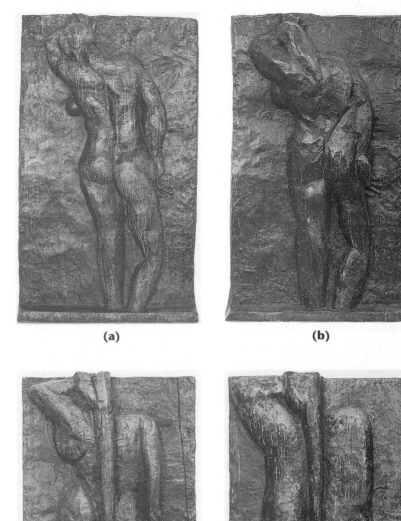

(a) (b)

(c) (d)

1.29a Henri Matisse. *The Back, I.* Paris and Issy-les-Moulineaux, 1908–09.
Bronze, 6′2³/₈″ × 44¹/₂″ × 6¹/₂″ (188.9 × 113 × 16.5 cm).
1.29b Henri Matisse. *The Back, II.* Issy-les-Moulineaux, 1913. Bronze,
6′2¹/₄″ × 47⁵/₈″ × 6″ (188.5 × 121 × 15.2 cm).
1.29c Henri Matisse. *The Back, III.* Issy-les-Moulineaux, 1916. Bronze,
6′2¹/₂″ × 44″ × 6″ (189.2 × 111.8 × 15.2 cm).
1.29d Henri Matisse. *The Back, IV.* Nice, c. 1931. Bronze, 6′2″ × 44¹/₄″ ×
6″ (188 × 112.4 × 15.2 cm). (All) The Museum of Modern Art, New York. Mrs.
Simon Guggenheim Fund.

patina of the old hardware, the slightly scuffed texture of the leather surface, and the lighter area where half of one clasp used to be—that it is difficult to grasp the fact that the piece is actually ceramic. If you saw it in a gallery, you would want to touch it to verify its nature. We are intrigued by that which successfully fools us.

Abstraction and Stylization

A third way of involving viewers is to eliminate all but a few characteristics of a figure, forcing people to use their imagination to link this highly simplified form with the more detailed object they know. This technique is called *abstraction*—reduction of details in order to focus on a thing's essence. In the ancient *Venus of Willendorf* (Fig. 1.28), the female form is reduced to its procreative features—the great breasts and rounded belly of pregnancy, the essence of fertility. Everything extraneous—arms, feet, even the face—is deleted to center focus on the fecundity of woman.

Figures 1.29a through 1.29d allow us to watch this process of abstraction, as it evolved over a period of years in a single artist's approach to the same subject. Henri Matisse created a series of low-relief bronzes of a woman's back. From a fairly naturalistic approach in *The Back I,* he straightened, simplified, and rounded forms, until in *The Back IV* the figure is like a pillar of strength, an almost architectural representation of the solidity of Woman.

In addition to eliminating nonessential features, artists may *stylize* a form, subordinating accurate representation to a desired way of design. In Figure 1.30, the horse has been transformed into a few arched cylinders, yet it is still recognizable as a horse. In general, the more an artist abstracts or stylizes a representational figure, the more viewers must bring to the work, drawing on memories, imagination, and intellect to make sense of what they see.

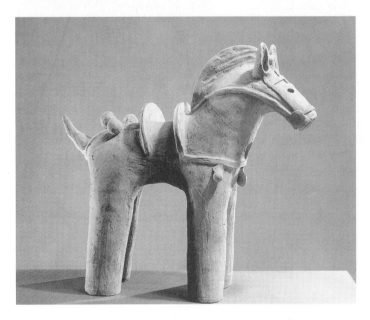

1.30 *Horse.* Haniwa figure, Japanese, 5th-6th century A.D. Terra-cotta, 23½ × 26″ (38.42 × 66.04 cm). The Cleveland Museum of Art. Norweb Collection.

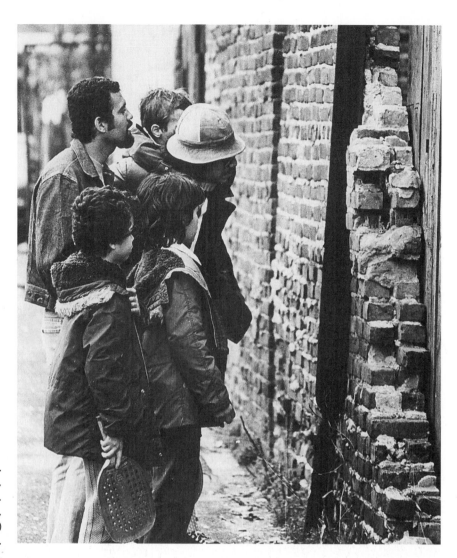

1.31 Charles Simonds. Passersby with *Dwelling, East Houston Street, New York.* 1972. Unfired clay bricks, each brick ½" (1.3 cm) long. Courtesy the artist.

Scale

Viewers may be enticed into responding to a work because of its *scale*—its size in relationship to its surroundings. The very small draws us in, for we must get close in order to see it. The people shown in Figure 1.31 have stopped on the street, lured by the tiny scale of the minature cliff dwellings Charles Simonds has constructed among the bricks (detail shown in Figure 1.5). Like most of us, these passersby are fascinated by miniaturization, especially when craftsmanship produces a precise image of something that is much larger in real life.

The very large provokes an emotional response as well. Claes Oldenburg elicits strong reactions from viewers by vastly enlarging objects as mundane as a clothespin (Fig. 1.32). A vast cathedral, like Chartres (Fig. 1.33), dwarfs viewers, filling them with awe at the soaring vastness and grandeur of the universe. And some works are so huge that viewers cannot comprehend the whole from their limited point of view.

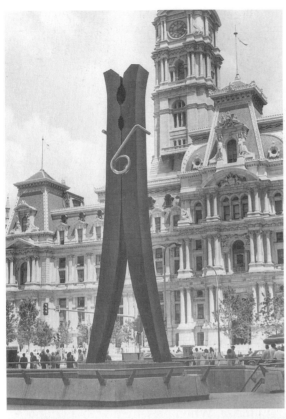

1.32 Claes Oldenburg. *Clothespin*. 1976. Cor-Ten steel, height 45' (13.72 m). Center Square, Philadelphia. Commissioned by the developer, Jack Wolgin, in compliance with the Philadelphia Redevelopment Authority's One-Percent Fine Arts Program.

1.33 Chartres Cathedral. c. 1194–1221. View through nave, looking toward the apse. Chartres, France. Photo Marburg/Art Resource, New York.

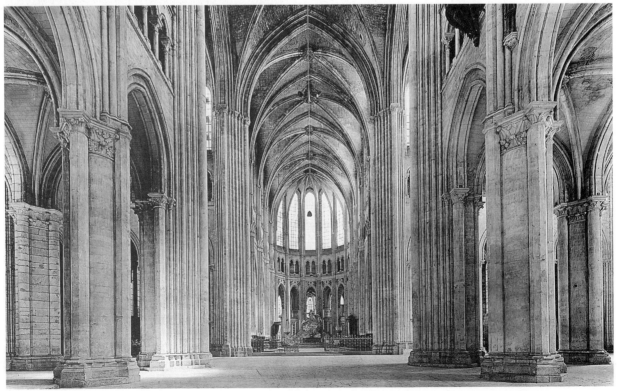

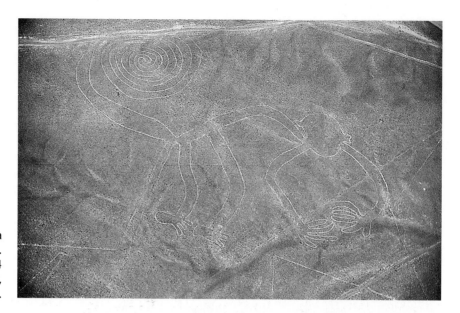

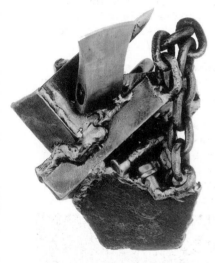

1.34 Monkey drawn in Nazca lines, Peru. c. 100 B.C.–A.D.700. Photo Bates Littlehales © 1964 National Geographic Society, Washington, D.C.

1.35 Melvin Edwards. *Freedom Weapon Variant.* 1986–92. Welded steel, 9½ × 10 × 9¾″. CDS Gallery, New York.

The mysterious Nazca lines in Peru cannot be comprehended from the ground at all; only an aerial photo reveals the ancient patterns created by removing rocks to expose the lighter soil. In Figure 1.34, a Nazca line forms a gigantic monkey whose left hand alone is 40 feet (12.2 m) across.

Scale can thus be manipulated to involve viewers by making them feel *they* are changing in size. When presented with a Lilliputian village, we become towering Gullivers; when we see works that seem to have been created by giants, we become like Lilliputians.

Content

We are also drawn into experiencing what a work is "about." In contrast to its form, the *content* of a piece is its subject matter (e.g., "a woman") plus all its emotional, intellectual, symbolic, spiritual, and/or narrative implications.

Much of today's art has political content, often referring to the experiences of ethnic, racial, or gender oppression. Melvin Edwards's welded steel works, such as *Freedom Weapon Variant* (Fig. 1.35), clearly say something about the historical experiences of the American descendents of African slaves. But it is a statement more like poetry than prose—this small but powerful piece is allusive rather than specific. The axe could refer to the breaking of chains, to slave labor, or to murder. The heavy steel rod gives the impression of having been bent by very strong hands. One has the impression of an implosion of strength—of energy turned in on itself rather than manifested by outward action. Unless a work is openly illustrative, its content may exist in subtle connotations, in layers of meaning that require viewers to devote considerable time, attention, and perhaps historical and political knowledge of their interpretations.

Unless the artist chooses to provide explicit statements about the intended content of a piece, its nature can only be described subjectively.

Two people may interpret the content of a given work quite differently. Consider responses to spiritual connotations, for instance. Certain works suggest themes that are universally understood. Chartres Cathedral (Fig. 1.33) was designed to uplift the consciousness of worshippers, helping them to transcend their narrow personal viewpoint to experience a more cosmic awareness. The spaciousness and height of the interior and the upward thrust of its columns and arches will tend to convey the same connotations to people of all cultures.

Although the grand scale of Chartres would have an impact on anyone's consciousness, many religious pieces have spiritual connotations only for those who are personally imbued with a particular spiritual tradition. For those familiar with the mystical Christian tradition, *The Ecstasy of St. Theresa* (Fig. 1.36) narrates a known story and evokes personal memories of the feeling of spiritual ecstasy. The statue of *Coatlicue* (Fig. 1.37), goddess of earth and death, must have inspired awe or even terror in her Aztec worshippers.

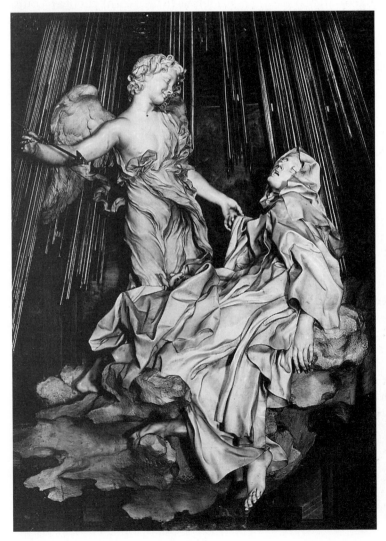

1.36 Gianlorenzo Bernini. *The Ecstasy of St. Theresa.* c. 1645–52. Marble, life-size. Cornaro Chapel, Santa Maria della Vittoria, Rome. Photo Alinari/Art Resource, New York.

1.37 *Coatlicue,* Goddess of Earth and Death (the Earth Mother). Aztec. 15th century. Andesite, height approx. 8¹/₂." Head formed from facing heads of two rattlesnakes; necklace of hearts, hands, and skull. One of a pair of colossal statues which stood in the courtyard of the Great Temple at Tenochtitlan. Museo Nacional de Antropologia, Mexico City. Photo Werner Forman/Art Resource, New York.

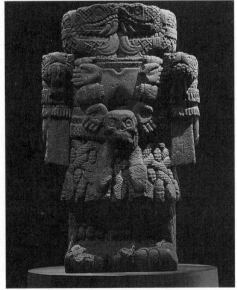

It is possible to become involved with such pieces on levels other than what was originally intended, however. There is the intellectual challenge of interpreting ideograms and symbolic messages on pieces such as *Coatlicue*. We can also admire the artfulness with which religious works were created—like Bernini's skill in sculpting the hardness of marble to look like the softness of fabric in *The Ecstasy of St. Theresa*. But if we not only appreciate the artfulness of a work but also respond to it as an evocation of a tradition that has deep personal meaning for us, the content we perceive in the work includes emotional and spiritual implications.

The spiritual content of a work is not limited to specifically religious connotations. Pieces growing out of the artist's personal exploration of life may speak volumes to the viewer who is similarly searching.

Personal Interaction

There are numerous ways of drawing people into a living encounter with a work of art. Some art is designed to be worn, such as Louise Nevelson's necklace (Fig. 1.38). Wearing a work of art takes what is usually a private experience between the viewer and the piece into the public domain. Now one responds not only to his or her feelings about the piece but also to other people's reactions. Others may come unusually close to examine the worn art; the wearer may not even be able to see it.

1.38 Louise Nevelson. *Neck Piece.* Photo © Peter Namuth, New York.

1.39 Louis Kahn. Detail of the Suhrawardi Hospital at Sher-e-Bangla Nagar, the capital's official complex, in Dhaka, Bangladesh. 1962–83. Photo Shamin Javed.

Architecture involves "viewers" by forcing them to walk through fixed passageways and to experience environments varying between open and confined. The great arched openings of Louis Kahn's Suhrawardi Hospital in Dhaka (Fig. 1.39) create a feeling of welcome airiness in this hot climate and at the same time delineate inner and outer passageways to regulate the flow of foot traffic.

Large *installation pieces*—designed environments installed in museums, sometimes temporarily—may have a similar way of involving viewers. Hiroshi Teshigahara's bamboo installation (Fig. 1.40) tells us precisely where to walk: inside the bamboo tunnel, noticing the play of light and shadow as filtered by the bamboo strips. The intrigue of walking into a piece of art has often been used as a come-on in roadside

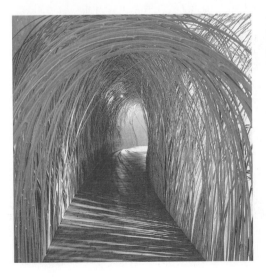

1.40 Hiroshi Teshigahara. Bamboo installation at 65 Thompson Street Gallery, New York. 1990. Photo © Dorothy Zeidman, 1990, New York.

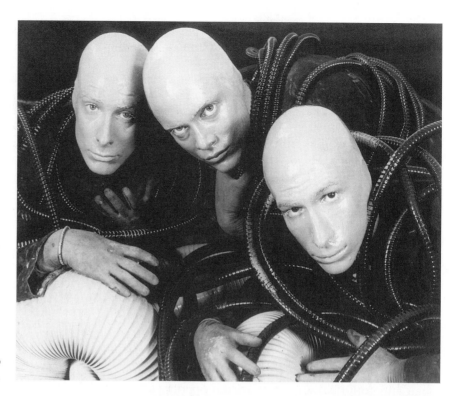

1.41 Blue Man Group. Photo Martha Swope.

1.42 Nam June Paik. *Tadaikson (The More, the Better).* 1988. 1,003 video monitors. Photo Isik Myung, courtesy National Museum of Contemporary Art, Seoul.

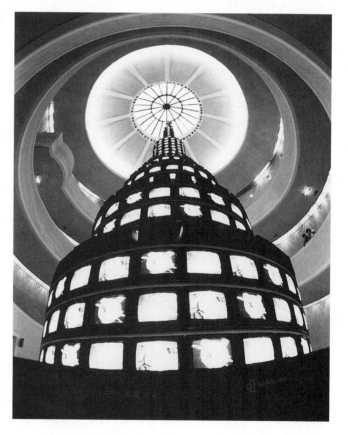

folk art, luring customers into shops by disguising the stores as oversized lobster traps, tipis, chickens, wheels of cheese, hot dogs, derby hats, or even open-jawed fish.

Performance pieces involve viewers in a live experience conducted or set up by the artist. Often these are staged as theater, with captive audiences. Performances by the Blue Man Group (Fig. 1.41) are sold out several years in advance. This troupe is composed of three men who paint themselves blue and enact bizarre routines, many of which are parodies of other modern artists. To be fully involved in appreciation of these performances one must have enough awareness of the contemporary art scene to follow the insider's jokes on which the routines are built.

Contemporary art often refers to contemporary culture itself, and this content tends to draw people into personal interaction with the works. *Video art* uses the apex of popular culture—the familiar but still compelling presence of television—to draw people into an artistic event. In Seoul, South Korea, where busy shops are full of bright merchandise and electronic gadgetry, video artist Nam June Paik created an installation piece called *Tadaikson (The More, the Better)* (Fig. 1.42). Its 1,003 video monitors are reminiscent of shops displaying many televisions all going at once. But in this case, the programs playing are arranged in colorful, diagonally repeating patterns that transcend the content of each program. In Paik's hands, rapidly evolving video technologies are used both vigorously and ironically to create three-dimensional works that simultaneously capitalize on and subvert the mesmerizing, frantic effects of the medium.

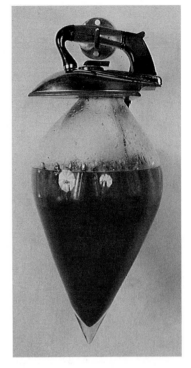

1.43 Donald Lipski. *Blood #8.* 1991. Mixed media, 21 × 10¹⁄₂ × 10″. Courtesy Galerie LeLong, New York.

THE UNEXPECTED

Some artists evoke viewer involvement by surprise. Something may suddenly be perceived in an unexpected place, like the Nazca lines in the Peruvian desert (Fig. 1.34). Coming upon such an anomaly provokes people to wonder, "Why?"

Some art startles us with seemingly incongruous elements that defy our stereotyped notions of how things "should be." In Donald Lipski's *Blood #8,* one is visually stimulated or confused by the contrast of an iron that produces not steam but a glass vial of blood (Fig. 1.43). Similarly, faced with Meret Oppenheim's fur cup (Fig. 1.44), viewers find themselves incapable of reconciling their mental associations with "fur" and with "cup." Such works become visual puzzles, luring viewers into the mental exercise of trying to figure out what is going on.

Verbal Statements

Though not strictly part of a work of art itself, written statements about a piece or about a particular artist's work may also help draw people into the experience the artist intended. Sometimes these statements are written by art critics or museum curators; sometimes they are written by the artists themselves. Those working in *applied design* disciplines—the creation of functional projects, such as interior design, landscape

1.44 Meret Oppenheim. *Object* [Le dejeuner en fourrure]. 1936. Fur-covered cup, saucer, and spoon. Cup, 4³⁄₈″ (10.16 cm) diameter; saucer, 9³⁄₈″ (22.86 cm) diameter; spoon 8″ (20.32 cm) long; overall height 2⁷⁄₈″ (7.6 cm). The Museum of Modern Art, New York. Purchase.

design, and industrial or product design—are often required to give verbal explanations of their ideas to prospective clients.

Many artists find it difficult to articulate what they are trying to do, for they have chosen a nonverbal medium to express their nonverbal ideas. Often the impulses that lead them to work in a certain way are as mysterious to them as to others. But Linda Howard, whose monumental works will be shown later in this book, observes that making the effort to define what one is doing may be as beneficial to the artist as to the viewing public. Howard explains:

> I work intuitively, preconsciously, nonverbally. Creating the work brings it to a more conscious level, because then there is a visual, tangible form. Then the next step of responsibility—which most artists don't take, but which is very important for me and actually for all artists—is to try to figure out from this statement, that is the piece, a verbal statement: "What is it that I'm trying to do?" It's really important for me to sit down and try to figure out my words for what it is I think I'm doing. I may not be right, but at least it brings that much more clarity to my work. You have to figure out what it is that you're doing—no one is going to tell you. You can't just say the work should speak for itself. You should either have the answers or try to seriously search for the answers. Putting your ideas into this even more conscious verbal form then frees your creativity as you return to the preverbal process of creation again.

CHAPTER 2

WORKING IN THE ROUND

All art begins as an idea in the mind of the artist and is developed through a dialogue with the medium. To bring this evolving idea into reality, to create the form imagined, requires dealing successfully with a number of technical details. Each idea demands certain specific practical considerations and specific skills. Yet it is possible to look at general considerations that arise in every attempt to create art in the round. The care and ingenuity with which artists approach these technical details will make the difference between pieces that fall apart or simply don't do what the artist intended and those that give high-quality expression to the artist's vision.

GRAVITY

We are so accustomed to accommodating the force of gravity in our everyday existence that we give it little thought. Yet this downward pull must be dealt with very consciously and carefully by the three-dimensional artist. Over a period of time, the sheer heaviness of things begins to tell. Even apparently lightweight objects are surprisingly

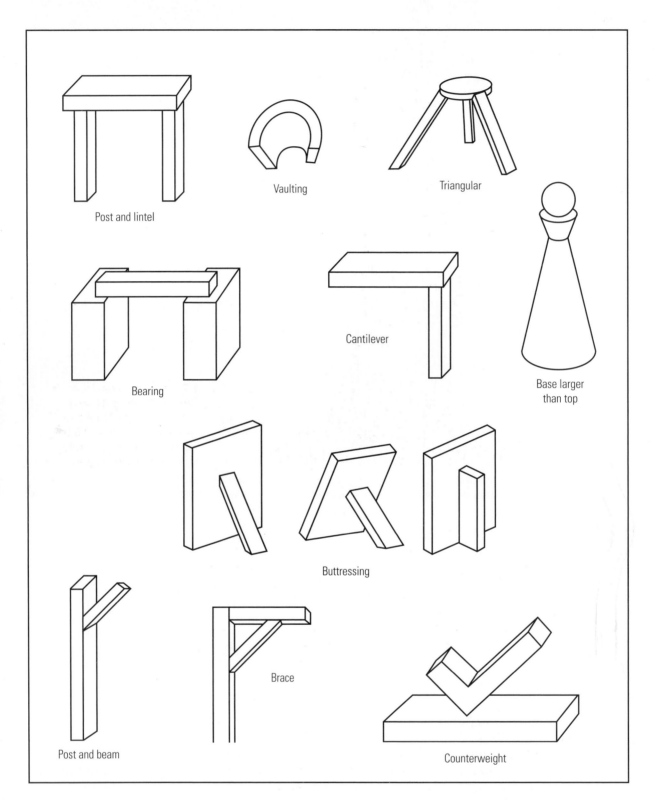

Post and lintel

Vaulting

Triangular

Bearing

Cantilever

Base larger
than top

Buttressing

Post and beam

Brace

Counterweight

2.1 Architectural Systems

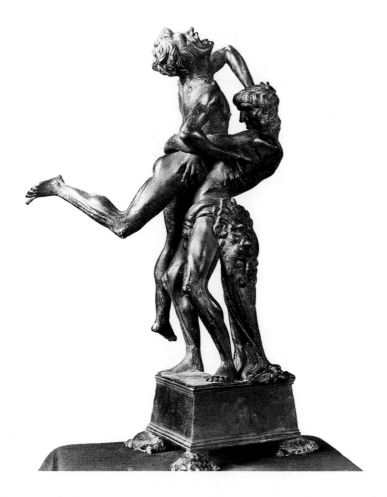

2.2 Antonio Pollaiuolo. *Hercules Crushing Antaeus.* c. 1475. Bronze, height with base 18″ (45.72 cm). Museo Nazionale, Florence. Photo Alinari/Art Resource, New York.

gravity-bound. Have you ever tacked a poster to a wall, nice and flat, only to discover later that it has bowed out as it slid downward, enlarging and perhaps eventually tearing the upper tack-holes? Or try holding your arm out parallel to the floor; as time passes, its heaviness becomes increasingly apparent and difficult to resist. The pull of gravity may present the artist with difficult challenges, but in some cases the successful defiance of gravity's tendency to pull things down may be a major ingredient of the excitement of a work.

Some artists learn to accommodate the force of gravity by trial and error; others conceive ideas that require extensive intellectual knowledge of physics or architectural systems, as in Figure 2.1. At the simplest level, any three-dimensional artist learns that whatever projects from the vertical axis is subject to downward pressure and must be firmly anchored to prevent its breaking off and counterbalanced to prevent its pulling the whole piece over. Antonio Pollaiuolo's *Hercules Crushing Antaeus* (Fig. 2.2) is only 18 inches high, including its base, and yet the weight of Antaeus's out-stretched leg would be enough to topple Hercules off the pedestal. In addition to building up a strong vertical mass from other parts of the two figures to help anchor the leg on the left and thrusting Hercules's back far to the right as a counterbalance, the artist's ultimate solution to offset the pull of Antaeus's raised

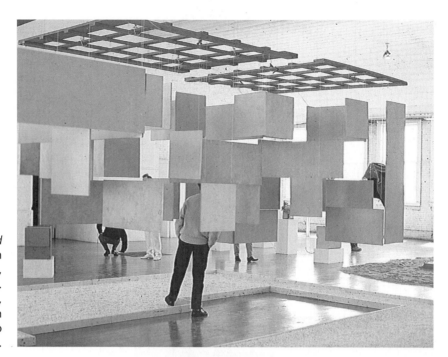

2.3 Helio Oiticica. *Grand Nucleus.* 1960–68. Acrylic on wood, nylon thread, gravel, approx. 8 × 28 × 12′. Installation at P.S. 1 Museum, Long Island City, New York, in "Brazil Project," 1988. Photo Mustapha Barat.

2.4 Christo. *Valley Curtain.* 1970–72. Span 1,313′ (417 m). Height curving from 365′ to 182′ (111.25 m to 56.39 m). 200,000 sq. ft. (18,587 sq. meters) of nylon polyamide fabric, 110,000 pounds of steel cables. Grand Hogback, Rifle, Colorado. Project Director Jan van der Marck. Photo Harry Shunk © 1972 Christo, New York.

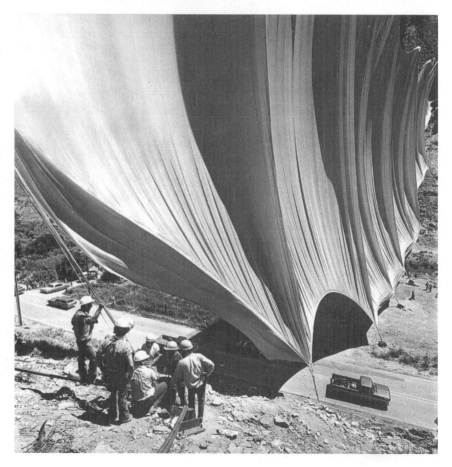

leg was to add a secondary form behind Hercules. The sculpture would probably be more exciting and aesthetically pleasing without the prop, for then Hercules would seem to be the strong force holding Antaeus in the air, but given the state of the art of bronze casting at the time, Hercules himself had to be propped up.

In some works, there is no indication of the tug of gravity, for the artist has skillfully hidden the means of defying it. Helio Oititicica's *Grand Nucleus* (Fig. 2.3) seems to be floating because the nylon threads used to hang the wooden grids from the ceiling and the rectangles from the grid are thin enough to be almost invisible. Instead, the artist has treated the floor area of this installation piece in such a way that one gets the impression the thing is being held up by some invisible force field generated in the empty but defined space below it.

Certain works require great engineering skill if they are to counter the force of gravity successfully. To hang a 200,000 square foot (61,000 sq m) orange nylon curtain across Rifle Gap in Colorado (Fig. 2.4), Christo had to hire consulting engineers and contractors to help devise ways to support the weight of the curtain from above. The initial solution involved cables running from 7-ton concrete anchors on either side of the gap, but geologists' tests showed that these would have been pulled right out of the mountain. Instead, construction crews had to construct 200-ton concrete top-anchors to offset the anticipated pressures of gravity and wind on the curtain.

Adding the weight of a person to a piece adds additional considerations. We believe *Three Sofa de Luxe* shown in Figure 2.5 will keep its shape. But will it hold three? Will its form change? If we put weight against the sides will they hold or bend? The designer had to take these possibilities into account, or the chair would have unnerved—as well as unseated—potential buyers.

2.5 Jasper Morrison. *Three Sofa de Luxe.* 1992. Collection of upholstery with frame in wood, metal, and multi-density polyurethane foam. Aluminum feet. Cover in Panno or leather is suggested. Photo courtesy Cappellini S.P.A.

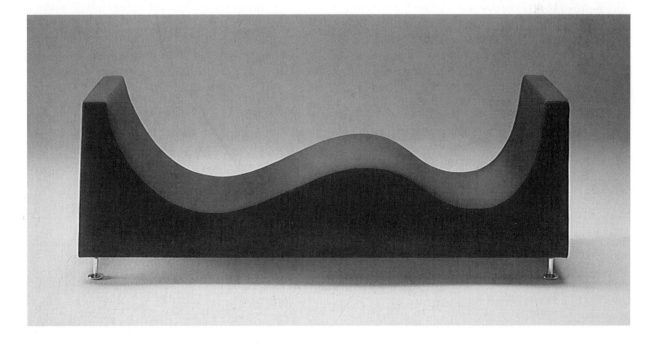

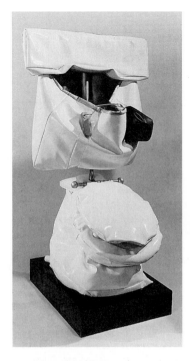

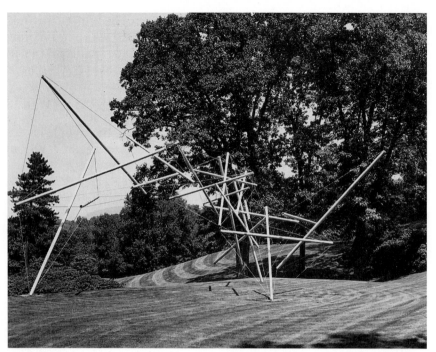

2.6 Claes Oldenburg. *Soft Toilet.* 1966. Vinyl, plexiglass, and kapok on painted wood base. Overall: 57^1/$_{16}$ × 27^5/$_8$ × 18^1/$_{16}$" (144.9 × 70.2 × 71.3 cm). Collection of Whitney Museum of American Art, New York. 50th Anniversary Gift of Mr. and Mrs. Victor W. Ganz. Photo Jerry L. Thompson.

2.7 Kenneth Snelson. *Free Ride Home.* 1974. Aluminum and stainless steel. 30 × 30 × 60'. Storm King Art Center, Mountainville, New York. Gift of the Ralph E. Ogden Foundation, 1975. Photo Jerry L. Thompson.

Gravity is not necessarily a disagreeable force with which to work, however. For the artist who understands it, calling viewers' attention to this everyday phenomenon can be central to the idea of a piece. Claes Oldenburg presents a humorous glimpse of what would happen to a familiar object—the toilet—if it were too soft to resist the pull of gravity (Fig. 2.6). And in Kenneth Snelson's *Free Ride Home* (Fig. 2.7), the metal tubes seem to defy gravity like an acrobat flipping high through the air. Even though the cables holding the tubes aloft are slightly visible, the mastery with which they have been rigged from only three points touching the earth creates the drama of the sculpture.

THE SETTING

In many cases, a second major consideration is where a piece will be presented. In recent years, there has been a noticeable shift from regarding art as a private or museum experience to presenting large pieces in public settings. Town planners, architects, politicians, and corporations are recognizing that art presented in public spaces may enhance the appeal of those spaces. Despite negative public responses to some pieces, state and municipal governments and private businesses are increasingly setting aside a percentage of the cost of new buildings to be used for the purchase of works of art. The setting of such pieces—foyers of large buildings, public plazas, and the like—dictates a very different approach

than the assumption that a piece will be displayed on a mantel or desktop, or behind glass in a museum.

Awareness of whether a work is to be shown inside or outside makes a big difference in the design process. In general, considerations of safety and vandal-proofing dictate simpler designs for outdoor sculptures, for people are more likely to try to climb on them. Indoor works can be more delicate. For large outdoor works, engineering consultants may be needed to help calculate specifications for factors such as wind loads, snow loads, seismic stability, and the necessary size and depth of footings.

Anything to be used outdoors will also be exposed to weathering processes. If the material used will age, the change should be one that the artist considers desirable. For example, some artists value the shiny brown or green patina that develops on bronze as the surface corrodes. The *Great Mosque* at Djenné, Mali, West Africa (Fig. 2.8), has been built of mud brick in a climate where rain is infrequent. When it does rain there, however, it pours, but the mosque has stood for over 85 years with only sporadic replastering.

If a piece is to be used in a specific place, the lighting of the area should also be determined and perhaps controlled by the artist. Daniel French, sculptor of the *Abraham Lincoln* for the Lincoln Memorial, complained that the lighting in the building did not bring out the strength and drama of the face as he had conceived it. To prove his

2.8 Great Mosque, Djenné, Mali, West Africa. 1907. Mud brick. Photo © Carollee Pelos, 1981.

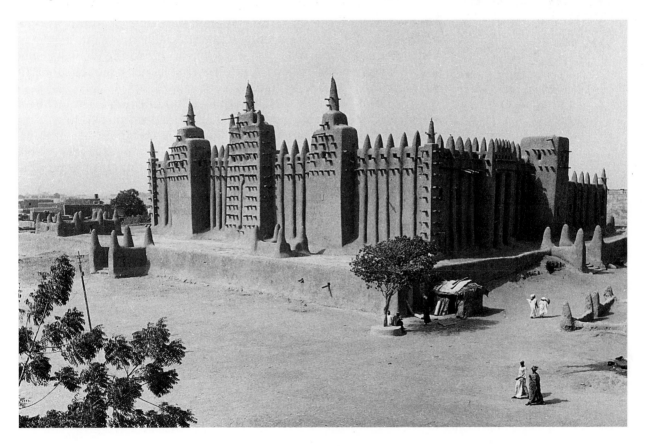

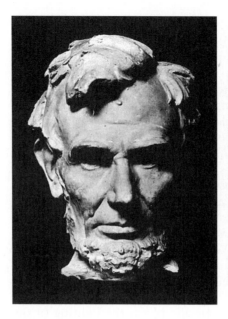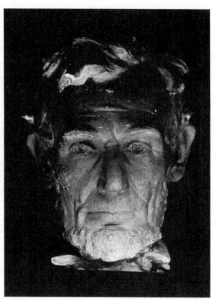

2.9a (left) Daniel Chester French. Head of Abraham Lincoln. 1911–1922. Plaster model, executed in 1917, 50½″ high (including shirt collar), same size as head of white marble statue, total figure 19′ high. Lincoln Memorial, Washington, D.C., architect Henry Bacon. Photographed by order of the sculptor in 1922 under replication of original lighting conditions.

2.9b (right) Daniel Chester French. Head of Abraham Lincoln. 1911–1922. Photographed by order of the sculptor in 1922 under desired lighting conditions. (Both photos) Chesterwood Museum Archives, Chesterwood, a property of the National Trust for Historic Preservation, Stockbridge, Massachusetts. Photo De Witt Ward.

point, he made two photographs of a full-size model of the head, one with natural light cast upward, as through the east door entrance of the building (Fig. 2.9a), and the other with artificial lighting shining down on the sculpture from a 45-degree angle (Fig. 2.9b). The characteristics thus revealed were so strikingly different that French's requests for artificial lighting were finally granted.

For his fanciful Team Disney office building (Fig. 2.10), architect Arata Isozaki had a large pool created just to reflect the building. With its central tower, the corporate headquarters looks almost like a steamship with smokestack. But when the water is mirror-calm, the whole thing—reflection and all—seems almost to be floating in an impossible sky, the stuff of dreams.

Pieces designed for a particular setting must of course take its size and characteristics into account as well. The challenge to the commissioned artist is to exercise creativity in conceiving pieces that work well not only in themselves but also in relationship to the scale and nature of their surroundings.

To relate a work to its environment does not necessarily mean copying the style of the surroundings. Boston's Post Office Square once was dominated by an ugly parking garage that blocked the sunlight. The area was so depressing that, instead of using the square, people avoided it. Now the square features a series of garden rooms, trellised colonnades, sculptural fountains, specimen plantings, and inviting openings from the surrounding sidewalks. Throngs of office workers and tourists enjoy this urban oasis in good weather, and the buildings on the square have been redesigned to focus upon the park rather than to turn their backs on it.

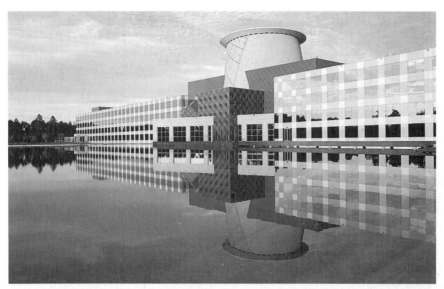

2.10 Arata Isozaki, architect. Team Disney Building. Photo © Peter Aaron/Esto.

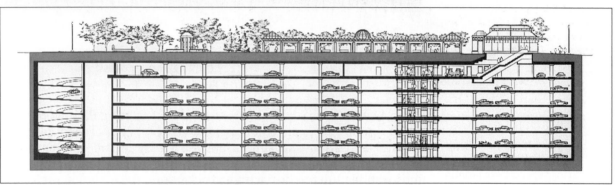

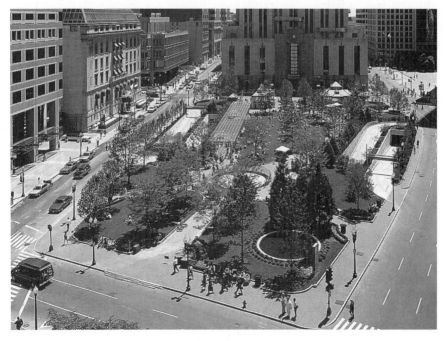

2.11 (above) Underground garage and park at Boston's Post Office Square, Parsons Brinkerhoff Quade & Douglas, Inc. (Boston), prime consultant and civil engineer; garage; Ellenzweig Associates (Cambridge), architect, garage and park structures; LeMessurier Consultants (Cambridge), structural engineer, garage; The Halvorson Company, Inc. (Boston), landscape architect, park. Drawing by Ellenzweig Associates.

2.12 (left) Underground park and garage at Boston's Post Office Square. Photo © Peter Vanderwarker.

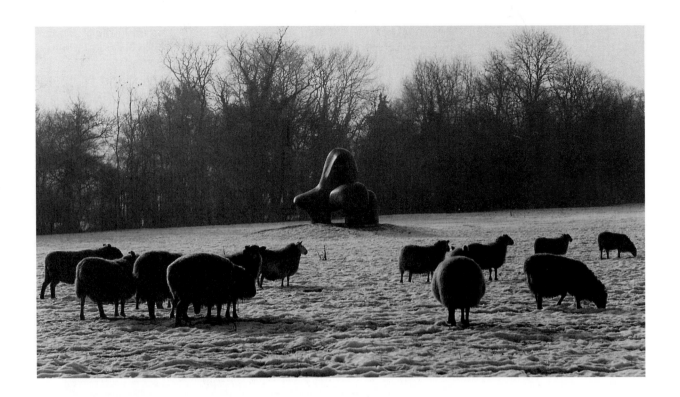

2.13 Henry Moore. *Sheep Piece.* 1971–72. Bronze, edition of 3, height 570 cm. Hoglands, Hertfordshire, England. Photo Errol Jackson, © The Henry Moore Foundation, London.

Artists have highly individual ways of relating their work to its environment—yet none ignore it. One version of a successful relationship between art and its surroundings is Henry Moore's placement of his large sculptures in the pastures around his home in England. Moore finds architecture too distracting a background for his work, preferring the sky as a backdrop. He explains:

> There is no background to sculpture better than the sky, because you are contrasting solid form with its opposite space. The sculpture then has no competition, no distraction from other solid objects. If I wanted the most foolproof background for a sculpture, I would always choose the sky.

In Moore's *Sheep Piece* (Fig. 2.13), the coexistence of art and nature is enhanced by the presence of the sheep who share a pasture with the piece. The distinctively rounded, huddled bulks of the live sheep visually reinforce the essence of Moore's sculptural forms.

SIZE

Size is of importance not only in scaling a work to its surroundings but also in the practical details of creating, transporting, and displaying the work. Look back at Kenneth Snelson's *Free Ride Home* (Fig. 2.7). Its scale is aesthetically successful in its open outdoor setting, leaping into the sky above the low walls. But imagine the process of assembling the piece. Obviously, it could not be built in a studio or workshop and then

transported intact, for it is far too large to fit through a door or onto a truck. Since he chose to work on this large scale, the artist had to make the parts separately and figure out how to assemble them on-site. If artists envision circumstances in which they will not be on-site to supervise the assembly and setup of their works, they must also prepare detailed instructions for others to follow.

The size chosen will also determine whether a piece can be constructed by the artist working alone or whether help will be needed. Even relatively small pieces of very dense materials like marble or glass may be too heavy for one person to maneuver; works made of lighter materials such as aluminum can become much larger before assistance is needed. Some three-dimensional pieces, such as marble sculptures, need not be carried around while they are being worked, and the artist can mount them on a revolving stand for easy access to all sides. But the problem remains: How then to transport such works of art out of the studio to be displayed?

For functional designs, the size of the piece relative to the size of the intended user is a major practical consideration. For instance, if the handle of a mug is too small, large-handed users drinking hot liquids may burn their knuckles. Older people find low sports cars or high vans difficult to climb into and out of. And the relatively new science of *ergonomics*—the study of how people relate physically to their environment—has led to design of office furniture that minimizes fatigue and improves work efficiency by properly fitting and supporting the human body. The Ergon chair (Fig. 2.14), designed by William Stumpf for Herman Miller, has a shortened seat to prevent restriction of the blood vessels in the thighs, an anatomically contoured back and seat to support the user's upper and lower back, open sides that encourage people to move somewhat instead of getting cramped and numb from sitting still, and armrests that double as backrests when the person is sitting sidewise in the chair. The model shown is designed specifically for people who work long hours seated at computer terminals or other office machines, offering the support of a high seat-back with adjustable height, and height and angle adjustments for the chair as a whole to help fit it to the individual user. Despite the many functional aspects of the chair, it also works well aesthetically, with a nice marriage of the flowing upper forms to the convincingly untippable and mobile five-footed base.

2.14 Ergon 2® chair/seating by Herman Miller, Inc., Zeeland, Michigan. 1976. Photo courtesy Herman Miller, Inc.

MATERIALS

In choosing and working with materials, artists range between two extremes: crafting the material to look like something else, or presenting the material in such a way that its own nature is emphasized. Either way, the unique qualities of each material must be taken into account.

In Chapter 1, we noted that the viewer-involving device in Marilyn Levine's *Spot's Suitcase* (Fig. 1.27) is the use of clay to look exactly like worn leather. At this extreme, the denial of the characteristics of the medium is sometimes called *trompe l'oeil,* or "fool the eye." Similarly, some artists have developed great skillfulness in sculpting the hardness

2.15 Eduardo Chillida. *Locmariaguer VII.* Courtesy Sidney Janis Gallery, New York.

of marble to look like the softnesses of skin, hair, and draped clothing, as in Bernini's *Ecstasy of St. Theresa* (Fig. 1.36).

Eduardo Chillida's *Locmariaguer VII* (Fig. 2.15) is made of nearly 2-inch-thick steel plate that has been cut and folded back on itself, as if by the hands of a giant. To force this material out of its customary rigid flatness, Chillida drew on his Basque background in steel-forging skills, a heritage that dates back to the Roman occupation. The power apparent in this uncustomary manipulation of the material is a major part of the drama of the work.

At the other extreme, artists may choose to work a material as little as possible, presenting it in a form closely resembling its natural state. Elyn Zimmerman's *Marabar* (Fig. 2.16) presents the natural textures and forms of carnelian granite boulders as an interesting contrast to the straight lines of the National Geographic Society building and as a reference to the interests of the society. Zimmerman further accentuates the weather-worn and grainy outer surface of the boulders by splitting them and polishing their cleft faces to an utterly smooth and reflective sheen that is the exact opposite of their exteriors.

Another approach to a material is to work it in such a way as to bring out its inner beauty. To the unknowing, a burl growing on a tree trunk would appear to be just an ugly, irregular knob. But woodworkers have discovered burls to be filled with swirling grain patterns

2.16 Elyn Zimmerman. *Marabar.* 1984. Plaza and garden sculpture, National Geographic Society, Washington, D.C. Shown: 5 natural cleft and polished carnelian granite boulders ranging in height from 3¹/₂′ to 10¹/₂′ (91.44 cm to 3.05 m), surrounding a pool, 60′ × 6′ × 18′, constructed of polished carnelian granite. Courtesy Elyn Zimmerman, New York.

2.17 Bruce Mitchell. *Star Chamber.* Walnut burl, 12 × 24 × 23″. National Museum of American Art, Washington, D.C./Art Resource, New York.

that, when planed and polished, have a unique beauty. In shaping *Star Chamber* (Fig. 2.17) from a walnut burl, Bruce Mitchell chose to retain a portion of the gnarled outside to emphasize by contrast the natural beauty of the interior lines and colors. One longs to caress this bowl with one's fingers, to explore its smooth curves and test the feeling of its strange knobs.

Each material has its own unique qualities that artists must understand and respect, whether they choose to emphasize or deny these qualities. Claes Oldenberg's statement about materials illustrates a healthy respect for their cussedness:

> I like to work in material that is organic-seeming and full of surprises, inventive all by itself. For example, wire, which has a decided life of its own, paper, which one must obey and will not be ruled too much, or cardboard, which is downright hostile, or wood with its sullen stubbornness. I am a little afraid of metal or glass because they have the capacity like a lion to gash and kill, and if I gave them the freedom I give my other materials they probably would.

Use of different materials in combination requires particular skills and knowledge of their unique properties. John Matt's *Wind Chant* (Fig. 2.18) combines the reflective surfaces of polished aluminum with the warm feel and colors of woods—Philippine mahogany, walnut, and rosewood. Matt notes that wood can always be expected to move—to shrink, expand, and perhaps crack—no matter how thick, old, or dense it is. Metals have very different properties that allow them to bend and to span distances without being very thick. In this piece, all wood parts are allowed to move independently of each other and of the metal. It is also possible to join wood to metal without the wood's cracking, but careful craftsmanship is essential.

The wealth of new materials available to the artist today and the flexibility of today's aesthetics allow artists to use anything they choose—from plastics to camel fur—so long as it works, carrying out the role for which it was chosen. Robert Walker encourages exploration

of the potentials of new high-tech materials like the absolutely clear acrylics he uses in his color sculptures. When we look at Walker's *Vertical Wedge Form* from two different angles (as in Plates 15 and 16), it almost convinces us that we are seeing two distinct pieces, the color change is so dramatic.

Walker notes that many sculptors today have become "techno-freaks," in that they are thoroughly absorbed in the unique qualities of their chosen medium. Admitting, "I can't deny that I'm in love with this material," he points out that his work with dyed and cast acrylics requires not only appreciation for the material but also highly specialized training. He feels that it is important for artists to develop their mastery of whatever medium they choose, "so they can produce what their minds conceive of."

Respect for the material cannot be overemphasized, for carelessness in this area can undermine even the most elegant of designs. Witness the initial fate of Christo's *Valley Curtain*. After months of elaborate preparations and hundreds of thousands of dollars of expenses, the huge curtain unfurled itself prematurely during its test run, snagging and tearing on the rocks. Why? Workmen tying the knots that were to hold the curtain bundled around the cable until everything was ready ran out of the tape they were supposed to be using. Rather than climb down to get a new roll of tape, they simply used old tape they found stuck to the curtain. Under stress, first the tape gave way, and then the knots, and then the curtain itself. No detail—including the suitability of each material for its intended purpose—is too small to be overlooked.

PLANNING THREE-DIMENSIONAL WORK

Sometimes artists work directly with their chosen material, manipulating it until it approximates their vision. But when a piece will be large, use costly materials, or require time-consuming techniques of construction, the artist will usually begin by experimenting with its form, using some medium that is cheaper and more easily manipulated.

Often drawings are used in the planning stage. If so, the artist must learn to translate a three-dimensional idea into two-dimensional sketches and, in turn, envision them three-dimensionally. Usually several sketches are required, studying the form from many different points of view. Before beginning construction of *Wind Chant* (Fig. 2.18), John Matt filled pages of his sketchbook with drawings like those shown in Figure 2.19, "thinking nonverbally" about forms, their relationships to each other, and ways of putting them together.

In fields such as architecture and landscape or interior design, plans may include *layouts* viewed from overhead, requiring an additional leap of the imagination to envision the three-dimensional reality of the projected work. Pieces that must be *fabricated*—constructed using industrial techniques—by someone other than the artist may require mechanical drawings to scale for precise duplication. Views from the top, end, side, and sometimes cross-section specify exact sizes and fittings for the craftsperson to use. Often cross-sections are included with dotted lines to indicate the inner construction of joints that will not be apparent

2.18 John Matt. *Wind Chant.* 1979. Aluminum and hardwood, 6'2½" (1.88 m) tall, 6'9" (2.06 m) long, 2'7" (78.74 cm) wide. Collection of the artist.

2.19 John Matt. Excerpt from preliminary sketches for *Wind Chant.* Black fine-point ball-point pen on white drawing paper. Photo by Frank Noelker.

2.20 Linda Howard. Section of blueprint detail drawings for *Rectangles.* 1982. Finished piece of redwood, 25 × 14 × 7' (7.62 × 4.27 × 2.13 m). Collection Pacific Lumber Company, San Francisco.

2.21 Claes Oldenburg. *Proposed Colossal Monument to Replace the Washington Obelisk, Washington, D.C.: Scissors in Motion.* 1967. Crayon and watercolor, 30 × 19¾" (76.2 × 50.2 cm). Collection David Whitney.

on the surface, as in Figure 2.20. This is an excerpt from the mechanical drawings for Linda Howard's *Rectangles,* a 25-foot-long (7.62 m) hanging redwood sculpture put together with nuts, bolts, washers, and steel rods.

For *site-specific* works—those to be installed in a particular location—drawings of the piece in place as the viewer will see it are usually necessary. They are helpful in judging how well the piece fits into its surroundings, not only in form but also in scale. In Claes Oldenburg's drawing for a *Proposed Colossal Monument to Replace the Washington Obelisk, Washington, D.C.: Scissors in Motion* (Fig. 2.21), we get the sense of what it would be to see these scissor blades thrusting far above the trees into the sky. Such drawings, when done by famous artists like Oldenburg and Christo, become collector's items in themselves.

Computer technology now offers the potential for planning by program—for creating computer programs that will generate two-dimensional drawings of projected three-dimensional projects in perfect perspective. Computer-aided designs can be rotated, shrunk, or enlarged for viewing from any angle or distance. In effect, the varying graphics displays that can be called up allow the artist to walk around a work before it is even constructed. The programs also allow the designs to be changed in specific dimensions, as variations on a basic theme. The rapidity of changes once the initial program is created makes it possible for artists with a knowledge of computer programming to experiment with a greater variety of solutions to any visual problem they can conceive, changing specifications until they find the design that works best.

Bruce Beasley makes complex intersections of geometric forms, cast in bronze (as in Fig. 2.22). He has found computer-aided design a great help in planning and in working with the bronze foundry:

I found these forms very cumbersome to make in a traditional cut-and-assemble method. I was determined to find a way to make this imagery spontaneous and simple to work with. The computer system I use employs constructed solid modeling. The computer is thinking in

2.22 Bruce Beasley. *Precursor.* Ed. 9, 1992. Cast bronze, 10¹/₄″ h × 20″ w × 18¹/₂″ d.

2.23 Bruce Beasley. Early computer image of *Precursor.*

solids, not just in surfaces. I compose all my sculptures beginning directly on the computer. I am able to make any shape or combination of shapes that appeal to me, and see them from any angle or eyepoint. It is truly like having a three-dimensional drawing pad where you can set the horizon line. Both emotionally and functionally, the computer model is a fully three-dimensional object. However, a change that might take several days or weeks of cutting and fitting in cardboard or metal can be done in a few minutes on a computer. It allows me to be very spontaneous about making changes. The pieces are then more resolved because it is so easy to make little changes in things that don't work.

Once the form is fully resolved, or at the point at which I wish to see it in real space, I plot the patterns directly on matboard to make an evaluation model. This model may precipitate further changes, or I may decide to go ahead and make the piece in bronze. If the piece is to be cast, I plot the patterns on foamcore and assemble the foamcore model for the foundry to burn out, as though it were a wax original.*

Figure 2.23 is an earlier computer image of the work that was eventually cast as *Precursor* (Fig. 2.22). By comparing the two, you can see the adjustments that Beasley made on the computer before the final piece was cast.

After or instead of drawings, planning can also be carried out in a variety of three-dimensional modes, allowing direct apprehension of the intended forms. Sculptors often mold a small *maquette* of soft clay as they do their initial nonverbal thinking about a piece. The work itself may be a further evolution of the idea rather than a literal translation of the maquette into a larger scale and more durable material. Sometimes, however, construction of the final work may be done by assistants copying the model. In this case, the model may be small-scale, with enlargements carried out by exacting caliper measurements,

* Bruce Beasley, as quoted in video "The Computer: A Tool for Sculptors," and in personal communication, June 25, 1993.

2.24 Frederick Hart working on a detail of a plasticine model for *Ex nihilo,* tympanum to be carved over entrance to the National Cathedral, Washington, D.C. Photo Darrell Acree, Washington, D.C.

2.25 John Matt. Maquette for a proposed sculpture. Paper and thread, height 2′ (60.96 cm). Photo courtesy the artist.

or it may be full-scale. Frederick Hart's 2-ton full-scale plasticene model for *Ex nihilo* (Fig. 2.24) is being carved in stone above the entrance to the National Cathedral in Washington by master stonecarvers. The model itself was preceded by a traditional planning process: Hart first sketched the design and made a small plasticene model of it. The model was then cast in plaster and enlarged to a rough full-scale plasticene copy. After Hart finished the detail work on the model, as shown, it was cast in plaster by sections. The stonecarvers work from this cast, taking its measurements to carve the final piece.

Maquettes may be made of anything the artist finds suitable. John Matt's maquette shown in Figure 2.25 is made of paper and thread, hanging from a 2-foot-high (.61 m) stand. Matt explains that if he were seeking a commission for the piece, his next step would be to construct a larger model—perhaps 10 feet (3.05 m) high—of aluminum and stainless

steel for a more realistic preview of what the actual piece would look like. In his vision, the piece would be 50 to 100 feet (15.25 to 30.5 m) high, perhaps soaring and floating through the foyer of a large building. Even in the 2-foot-high (.61 m) maquette Matt includes the small paper figure of a human dwarfed by the sculpture, to create a sense of the vast scale he envisions.

Some artists prefer to do their experimenting directly, learning from a piece itself what is possible as it evolves. Arthur Hoener, whose sculpture shown in Figure 2.26 was one of a series based on repetition of same-size wooden modules, explains this way of working:

> So many decisions are made as I go along that each piece becomes a sketch for the next piece. I'm already turning the next piece over in my mind as I see what develops on an individual piece. I find that trying to do any drawings ends up restricting what form I can make. So rather than restrict the form to drawings, I allow my mind and the work in progress to develop new ideas.

Hoener's way of working does not imply a lack of planning, however. In his mind, he determined the general plan: "This time I'll use alternating pieces of dark and light wood that are an inch and a quarter thick, and this time I'll use a 45-degree angle and then cut them and sand them for a tight sensuous surface that exposes the interior form." With this coherent pattern in mind, Hoener could then work freely with the individual modules, "weaving" them together in the ways that seemed to work best as the sculpture took shape.

FORM VS. FUNCTION

Traditionally, a distinction has been made between the fine arts and the applied arts. *Fine art,* such as sculpture, is meant to be looked at; the *applied* or *functional arts,* such as architecture, interior design, landscape design, and product design, are meant to be used. Although these definitions seem distinct in theory, in actuality the line between the two is imprecise.

Crafts—functional pieces made by hand—help to blur the distinction between form and function, for while they serve some useful purpose they are typically also designed with an appreciation of aesthetic considerations. That is, they are created with attention to the *elements of design*—form, space, line, texture, light, and color—and the *principles of design*—repetition, variety, rhythm, balance, emphasis, economy, and proportion—that are explored in the next chapters of this book. For example, Oskar Sørensen's *Silver Liqueur Decanter,* shown in Figure 2.27, has been handcrafted with loving awareness of the effects of form, line, surface texture, and light.

Techniques developed for use in creating functional works are now often adopted in construction of nonfunctional works designed solely as artistic experiences. Ceramics have been used for creating vessels since ancient times, but those same technologies are now being appropriated for an unlimited variety of non-functional works of art.

2.26 Arthur Hoener. *Standing Figure No. 2.* 1969. Honduras mahogany and poplar, 7'5" × 2'6" × 1'9" (2.26 m × 76.2 cm × 53.34 cm). Collection the artist's family, photo courtesy Margaret Hoener.

2.27 Oskar Sørensen for Tostrup. *Silver Liqueur Decanter,* bird-shaped. 1937. 10.6" (27 cm) high. Marks: "830 S. J. Tostrup, Oslo." Collection Oslo Museum of Applied Art. Acquired through the Grosch Fund, 1938.

2.28 (above, left) Evelyn Klam. Two Boxes. Porcelain, engobes, slips, 8 × 8" each. From Susan Peterson *The Art and Craft of Clay* (Englewood Cliffs: Prentice-Hall, 1992). Photo © Udo Hesse.

2.29 (above, right) Ross Lovegrove. *Advanced Wet Shave Ceramic Razor.* Photo courtesy Studio X, London.

New works conceived in clay are unlike anything ever seen before in other media. Evelyn Klam's boxes with organic forms pushing their way outward (Fig. 2.28) are created of porcelain, a very demanding medium, but skill in its use allows her to approach it freely. She says, "When I am at work, I can completely forget myself, and the possibility of playfulness brings me over and over again to new results."*

To create monumental aesthetic experiences like the *Valley Curtain* (Fig. 2.4), Christo draws on methods and materials not traditionally linked with art—from excavation, drilling, concrete pouring, curtain fabrication, and cable-hanging to the great complexities of "non-art" activities such as obtaining permits from landowners, highway departments, environmental protection agencies, and local officials, and raising the funds necessary to support his visions.

Another variation on the form/function relationship appears in *industrial design*—styling of the functional, often mass-produced, products that fill our environment, from appliances to office interiors, with consideration of their aesthetic appeal. After years of unimaginative look-alike designs in razors, a razor has been designed with sculptural contours and a high-tech ceramic blade that will never become dull or rusty. Hence the Advanced Wet Shave Ceramic Razor (Fig. 2.29) can be promoted as ecologically preferable to the mountains of disposable razors thrown away around the globe.

Even personal computers are developed and judged partly on the basis of exterior design characteristics. Manufacturers consider design an important marketing tool, a way of increasing sales. Industrial designers have been commissioned to enhance the visual appeal of everything from automobiles and refrigerators to soda bottles.

In some cases, and in some historical periods, form has been the primary consideration in creating functional pieces. The saltcellar that Benvenuto Cellini created for Francis I (Fig. 2.30) elaborates form far beyond what is strictly necessary in a vessel for salt. By contrast, rather than elaborating form for its own sake, some artists have felt that in a functional piece, form should evolve alongside functional

* Evelyn Klam, as quoted in Susan Peterson, *The Craft and Art of Clay,* Englewood Cliffs, New Jersey: Prentice Hall, 1992, p. 267.

2.30 Benvenuto Cellini.
Saltcellar of Francis I. 1539–43.
Gold, 10¼ × 13″ (26 × 33 cm).
Kunsthistorisches Museum,
Vienna.

considerations. At the *Bauhaus,* a famous German design school that opened in 1919 with the statement "There is no essential difference between the artist and the craftsman," form and function were seen not as isolated considerations but as a single unity, an organic whole. In this approach to integrity in design, industrial designers may enhance the way a product functions. The streamlined locomotive that Raymond Loewy designed for the Pennsylvania Railroad reduced wind drag by 33 percent. And the *Bauhaus/Blocks* designed by Alma Sledhoff-Buscher (Fig. 2.31) are classically appealing in form, texture, and color and at the same time well suited to the function of entertaining and educating children. Scaled for manipulation by small hands, they fit perfectly into the rectangular package and can be combined to create a great variety of representational and nonrepresentational forms.

2.31 Alma Sledhoff-Buscher.
Bauhaus/Blocks. Designed
1923. 21 wood pieces, 10 ×
2½ × 1¾″ (25.4 cm × 6.35
cm × 4.57 cm).

2.32 (above) Jean Muller. Brotonne Bridge over the Seine near Rouen, France, completed 1977. Campernon Bernhard Engineering Firm, Paris. Photo Reinhart Wolf/Bilderberg.

2.33 (right) Shaker dwelling room. Early 19th century community, Enfield, New Hampshire. Henry Francis du Pont Winterthur Museum, Winterthur, Delaware.

On a grander scale, the marriage of computer-aided mathematics, modern technology, and artistic sensitivity allows creation of technically and artistically elegant structures like the Brotonne Bridge (Fig. 2.32). Designed by Jean Muller, the cable-stayed plan is free from the clutter of overhead trusses. Instead, the precise calculation of stresses allows the bridge to be hung from only two central towers, a design that is at once structurally sound, inexpensive, and lyrically graceful.

Certain pieces we now appreciate as fine art were initially created not as art but as useful objects. The Shaker furnishings (Fig. 2.33) many now admire for their beauty of form were created under strictly functional considerations. Lines were sparse and storage recessed to avoid cluttering or pampering the senses so that all thoughts could be directed toward God. Pegs on the walls allowed chairs to be hung out of the way when the floor was being cleaned. Paint was usually not applied to the native wood, for to do so was considered an elaboration. From our vantage point in time, we judge these Shaker rooms as aesthetically pleasing, but at the time, the preferences of the larger society were for the ornate.

Despite all these exceptions and variations, the fact remains that an artist designing a functional piece does so with a slightly different attitude than one designing a piece that is not meant to be used. A functional piece must work. If it doesn't, it is not successful on a practical basis, no matter how successful it is aesthetically. In some cases, aesthetics must be sacrificed somewhat in the interests of functionality. A case in point: The *Max II Cups and Saucers* (Fig. 2.34) were designed by Vignelli Associates to be both highly functional—the pieces stack neatly in a small space, can be used indoors or out, and are mass-producible of high-quality plastic—and aesthetically elegant. However, one of the strong points of the cup design, from an aesthetic point of view, proved to be nonfunctional and had to be abandoned. This was the open-channeled handle, presenting a negative (or unfilled) space that flowed intriguingly up the handle and disappeared down into the interior of the cup. Unfortunately, when users filled the cup to the brim (as American coffee-drinkers are likely to do and as the designers had not predicted), the hot liquid would use this convenient channel to flow out onto their hands. Consequently, the design had to be changed to place a dam at the top of the handle, arresting the flow not only of coffee but also of the eye. The version shown is the original one, still the designers' favorite.

2.34 Massimo and Lella Vignelli, Vignelli Associates for Heller Design. *Max II Cups and Saucers.* 1970. Melamine. Cup: height 2^{11}/$_{16}$" (68 mm), diameter 3^3/$_{16}$" (80 mm), width at handle 4^1/$_2$" (110 mm). Saucer: diameter 5^3/$_4$" (145 mm). Permanent Collection of Design, The Museum of Modern Art, New York. Photo Mario Carrieri Fotographo, Milan.

COST AND AUDIENCE

Finally, many artists are forced to be aware of who might buy their pieces and how much they can afford to pay. There are some who create works of art chiefly to satisfy their own curiosity or inner compulsion; they may or may not connect with buyers who like their work. Others must pay some or a great deal of attention to the marketplace or to specific clients or employers.

The costs of producing a piece depend on three factors: the time, materials, and tools involved. If a potter designs a cup with a handle

2.35 Gianlorenzo Bernini. *Triton Fountain,* Piazza Barberini, Rome. 1642–43. Travertine. Photo Albert Squillace, Bronx, New York.

that takes an hour to pull, the piece cannot be sold for $5. A fine piece of marble is a beautiful medium with which to work, but it is not inexpensive. An industrial designer might have wonderful ideas for products that must be set aside because the company has already invested heavily in some different technology and cannot afford to retool for the processes required. As a student, you will be working chiefly with inexpensive materials and readily available tools; if you become

successful as an artist, the prices you can get for your work may allow you to move into more expensive materials and processes.

Who is the audience? Must a piece be mass-producible for instant appeal to a mass market? Or, at the other extreme, is the audience a profitable corporation willing to spend a large sum to bring art to its employees and customers? What are the artistic tastes of this audience? Aesthetic preferences change, sometimes rapidly. Today there is an appreciation of simple, clean lines, perhaps as an antidote to the busy clutter of our lives. There is also an attraction to honesty in design. For example, public fountains were once expected to be graceful, highly ornamental works like the *Triton Fountain* in Rome (Fig. 2.35). The water coming out of a figure was secondary to the figure itself. By contrast, in Isamu Noguchi's *Horace E. Dodge and Son Memorial Fountain* (Fig. 2.36), the water and the fountain cannot be separated. The water pipe is one with the water; together they create a dramatic statement that

2.36 Isamu Noguchi. *Horace E. Dodge and Son Memorial Fountain,* Civic Center Plaza, Detroit. 24′ (7.32 m) high, stainless-steel loop, granite well, 35 sprays and light sources. Photo Balthazar Korab.

2.37 Makoto Sei Watanabe, architect. Aoyama College, Tokyo.

reflects the technologically advanced character of the Civic Center, itself designed to present Detroit as a forward-looking city. The new aesthetic that allows appreciation of Noguchi's fountain accepts a thing for what it is: A fountain *moves water,* and in this case, it even responds to changes in the weather by moderating the flow.

Consider the audience for architecture in Tokyo, where there is no central city, no order, no unifying continuity over time or from one building to another. New buildings are soon torn down to be replaced by even more modern and outrageous edifices. Old and new, large and small, are thrown together with no intentional aesthetic relationships. Arata Isozaki, architect of the Team Disney Building (Fig. 2.10), says, "Tokyo is a distressingly ugly and chaotic city, but it also possesses such mysterious vitality that building in it is a great challenge to an architect."*

Makoto Sei Watanabe's solution in his design for Aoyama College—itself a design school—was to exceed all other buildings in shock value. Like a mad grasshopper from a science-fiction movie, it rears its "legs" above the surrounding jumble of buildings (Fig. 2.37). To enter

* Arata Isozaki, as quoted in Michael Webb, "An Architect at Home in both the East and West," *Smithsonian,* July 1992, pp. 66–67.

it and discover floors that are actually horizontal, with recognizable classroom chairs in which a human can comfortably sit, becomes the greatest surprise. Yet if it did not function well as a space for classes, it would not have been commissioned.

Despite changes in tastes and values, certain pieces transcend the mood of their times to invoke a more timeless appeal. They become classics because their excellence in design—both aesthetic and functional—is unquestionable. The *Bauhaus/Blocks,* for instance (Fig. 2.31), were designed in 1923 but are still being sold today, for they work on every level. In this chapter, we have examined some of the practical considerations that determine whether a piece works well; in the next chapter we will look at the general aesthetic considerations that determine the success of a work of art.

CHAPTER 3

ORGANIZING PRINCIPLES OF DESIGN

The characteristics that make a piece work well are difficult to define. Toshiko Takaezu, who creates huge pot-forms in clay, as well as weavings and bronze bells (see Fig. 3.1), says:

> An artist is a poet in his or her own medium. When an artist produces a good piece, the work has mystery, an unsaid quality. It contains a spirit and is alive. There's also a nebulous feeling in the piece that cannot be pinpointed in words. That to me is a good work!*

Each piece is different and created with different intent. The *intent* of a work is the central idea or problem with which the artist is working. This idea forms the intangible focus of the work, that which underlies its form. One artist's intent may be to create an extremely lifelike representation of some object; another may be trying to reveal

* Toshiko Takaezu, as quoted by Douglas Dreishpoon, "Toshiko Takaezu: Recent Work," catalog for Pennsylvania Academy of Fine Arts, Morris Gallery, March 6–April 26, 1992 show.

the beauty of a material or of pure form. The intent might be to evoke a particular emotional atmosphere or intellectual realization.

Currently, many works' intent is political: confronting complacency and bigotry, defying mainstream standards of taste, or asserting the validity of oppressed cultures. Pepon Osorio's *La Cama* (Fig. 3.2) exaggerates the decorative quality associated with Puerto Rican popular culture, with multiples of mass-produced trinkets and religious icons. This is not a parody, but a proclamation that what has been dismissed as bad taste by a secular, intellectual art establishment has cultural and social value. The bed is rich in memories of Osorio's wife and collaborator, Merian Soto, and of his "second mother" who took care of him when he was a child. The bedcover is ornamented with a great number of *capias,* or commemorative ribbons used in Puerto Rico to celebrate special occasions. They have been donated by dozens of the couple's friends in the Puerto Rican community in the United States, where they serve as a testimony to the value of the family and of the Puerto Rican culture.

The intent of a work might be the solving of a visual problem the artist has created, such as the studio projects suggested in this book, or the addressing of a particular concern. It is what the piece is "about." Without some initial sense of intention, the artist has nothing around which to unify a piece.

3.1 Toshiko Takaezu. *Bronze Bell.* 1980s. 21 × 36." Collection of Bristol Myers Squibb Pharmaceutical Group. Photo Charles Cowles Gallery, New York.

3.2 Pepon Osorio. *La Cama* (*The Bed*). 1987. Mixed media/ medio mixto, 75 × 67 × 78". Collection El Museo del Barrio, New York. Photo by Tony Velez.

Working from a central intention, artists have traditionally striven for *unity*—the coordination of all parts of a work to express their intent. To unify a work is to make its many parts appear as one coherent whole. Despite vast differences in intent and style, artworks whose aesthetic value holds up over the centuries tend to have certain unifying characteristics in common. Traditionally, they have been labeled the *principles of design.* These aesthetic considerations—repetition, variety, rhythm, balance, emphasis, economy, and proportion—are general ways of organizing a work. They satisfy the mind's desire to create order out of chaos. Although unity is sometimes treated as a separate principle of design, the term is used here to connote the combined result of all organizing principles of design.

The principles to be discussed in this chapter are not absolute rules. A successful piece need not conform to all of them, and many artists use them more intuitively than intellectually. The principles can also be interpreted in many different ways. Art is a living field; it changes with its times. And three-dimensional design today does not represent a single, unified approach to art. Rather, contemporary three-dimensional expression ranges from the strictly representational to totally nonrepresentational, from efforts to create beauty to attempts at social commentary, from sculpture to functional pieces. Although the same principles are relevant to all these works and to all historical periods, to define and use the principles in a narrow sense is to ignore their limitless potential.

Before we examine the principles one at a time, note that they are artists' ways of unifying their manipulation of the *elements of design*—form, space, line, texture, light, color, and time. These elements will be explored in detail in subsequent chapters.

REPETITION

Repetition is the use of similar design features again and again. This device gives the mind of the viewer an obvious way to understand what the eye is perceiving: "They're all alike," or "Oh, look, this one is like that one, and here's another one." Looking down the stairwell at the Guggenheim Museum (Fig. 3.3), one is immediately struck by the repetition of similar lines, creating what appears to be a series of nested triangles. We don't perceive one line in isolation; instead, we "read" from one to the next to the next, grouping them logically into a pattern.

In three-dimensional work, forms that are identical may not appear so, for each has a different relationship to the light source and thus a different pattern of values (light and dark areas). By repeating the same quiet, minimal rectangle at precise intervals in his untitled piece (Fig. 3.4), Donald Judd gives us the opportunity to become aware of the changes in value that occur from one to the next and the shadow patterns between them. The blocks are quite different visually if we pay attention to what we actually are seeing rather than immediately assigning them a mental category—"Oh, ten blocks"—and not looking to see what is really happening. However, if repetition is not handled beautifully by the artist, with attention to surfaces and proportions and

3.3 Frank Lloyd Wright. Stairwell, Guggenheim Museum, New York. Photo Robert E. Mates © The Solomon R. Guggenheim Foundation, New York.

intervals, the effect can be irritating, like someone repeatedly poking you in the arm.

Repetition is often handled subtly, satisfying our desire for order without calling attention to itself. Moshe Safdie's *Habitat* (Fig. 3.5) is built from a series of identical 70-ton rectangular modules. But since they can be put together in different ways—with different ends facing the viewer, and with varying degrees of overhang—the fact of their repetition may be intellectually discovered but does not announce itself at first glance.

As is true of other organizing principles of design, repetition is a framework within which the artist may feel a paradoxical sense of freedom. As Arthur Hoener, whose work was shown in Figure 2.26, explains:

> I've found that I have the greatest freedom if I use certain restrictions—
> if, for instance, I make up my mind to use repetition of light and dark
> modules of the same size to develop a form. Most such decisions are
> based on one's knowledge of the principles of design: I know that if
> I use repetition, for example, the piece will hold together. Then I have
> tremendous freedom in developing the form—in pushing it as far
> as I can.

3.4 Donald Judd. *Untitled.* 1990. Orange anodized aluminum with clear plexiglass. Ten units, each $6\frac{1}{8} \times 27 \times 24''$. Overall $10' \times 27'' \times 24''$. The Pace Gallery, New York. Photo Bill Jacobson Studio.

3.5 Moshe Safdie. *Habitat,* Montreal. Built for the 1967 Expo. 354 modular construction units comprising 158 houses. Each modular box is 17′6″ × 38′6″ × 10′ (5.33 × 11.12 × 3.05 m), pre-cast in concrete with metal reinforcements. Photo Jerry Spearman, Montreal.

VARIETY

While our minds can apprehend repetition with some facility, they can also create order from the chaos of incoming sensations when they can discern some unifying theme among disparate inputs. The organizational principle of variety does not refer to chaos, for few people can tolerate total meaninglessness—unless perhaps randomness is itself the organizing theme of a work. Rather, *variety* is a form of order in which the organizing principle must be discovered by the viewer. In works organized on the principle of variety, parts that are seemingly different from each other nonetheless have something in common.

Variety is often expressed as variations on a theme. At first glance, the separate parts of *Eva Hesse's Studio* (Fig. 3.6) seem to have something to do with one another, but their variety is initially much more apparent than their similarity. Nevertheless, just below consciousness you may feel that they are related somehow. You feel their similarity more quickly than you consciously perceive it. Then gradually you

3.6 Eva Hesse. *Eva Hesse's Studio.* 1966. Robert Miller Gallery. Photo Gretchen Lambert © The Estate of Eva Hesse.

may become aware of the common themes on which these parts are variations: All are hanging; all have drooping, ropish qualities; and all make references to circles or elongated circular forms. Then you may begin to pick out pairs of similar things, such as the single round ball in a string bag vs. a cluster of sagging ovoid forms in separate string bags, or two small spheres on a table with rope drooping to the floor vs. one large sphere sitting on the floor with its tube attached above. It becomes like a child's puzzle to solve: Which things go together? Which thing is different? Is it somehow similar, too?

The unifying theme in some works is almost beyond the viewer's grasp. Confronted with Robert Rauschenberg's *No Wake Glut* (Fig. 3.7), we may have an intuitive sense that these juxtaposed objects fit together

3.7 Robert Rauschenberg. *No Wake Glut.* 1986. Construction of found metal objects (aluminum and steel), 61$\frac{1}{2}$ × 89$\frac{1}{4}$ × 18$\frac{1}{4}$″. Photo © Dorothy Zeidman 1987.

3.8 Antoni Tàpies. *Pipe and Brown Bag (Tub i tela marro).* 1970. Object-assemblage, 10¼ × 43¾ × 17¾" (26 × 111 × 45 cm). David Anderson Gallery, Buffalo, New York. © 1993, Fundació Antoni Tàpies, Barcelona.

somehow, but our minds cannot easily seize the unifying principle of the piece. The only obvious conclusion is that they are all found objects. We are likely to try to read the faint letters and assign them a meaning having something to do with boating. But then what are those ribbed cylinders on the left? The arc on the right? Muffler parts? Steering wheel parts? Do they also have something to do with boats? Perhaps it doesn't really matter what they are. All refer to circular motion, which is picked up again in the ribs of the cylinders. With this bare unifying thread, the work holds our attention as we look from one object to the next, trying to decipher what they are and how each one relates to the whole. Perhaps it has more than one solution; perhaps it has no solution. The sense of the whole is elusive, hovering right on the edge of our consciousness barely beyond our reach. Our inability to grasp just what is going on does not mean that the piece has failed, however. In presenting exactly enough information to suggest some hidden unity, the piece encourages us as viewers to try to pull the parts together into a coherent whole.

Variations may also be seen as variations in the elements of design. Artists may present us with *contrasts*—juxtaposition of dissimilar areas. These contrasts engage our participation in comparing, for instance, light and dark areas, wide lines and thin lines, heavy forms and lightweight forms, filled spaces and unfilled spaces. Antoni Tàpies presents quiet contrasts in *Pipe and Brown Bag* (Fig. 3.8) between hard and soft, geometric and organic, container and contained, inside and outside, smooth and rough, light and dark. Since Tàpies has presented these opposite qualities in approximately equal proportions, they seem like two halves of a single whole, completing each other like yin and yang.

Variety may be handled boldly, as in the juxtaposition of dramatically contrasting areas. Or it may be handled less obviously, with a dark area gently blending into a light area, wide dwindling to narrow. This gradual introduction of variety is known as *transition*. Transitions obviously help to tie a work together, for they easily lead the mind from one quality to another, revealing the logic of their relationship.

RHYTHM

Repetition and variety in art tend to create a certain visual *rhythm*—a more or less regular pattern created by the elements of design as they seem to move and change through time and space. It is actually the eye that moves across the changing surfaces of the piece. Movements

3.9 Six of the seven statues of Ahu-Akivi, Easter Island. 17th century or earlier. Height 30′ (9.14 m). Photo Eugene Gordon/Photo Researchers.

in and out, up and down, flowing and pausing, and sudden changes in size, value, or complexity create visual effects that can be compared to music. As the eye explores a three-dimensional piece, the viewer may get a sense of accented and unaccented beats or of crescendos and decrescendos. Rhythm exists as a substratum that usually does not call attention to itself, but nonetheless helps to unify the viewer's perception of a piece.

Beats may be quite distinct. The forms of the Easter Island statues (Fig. 3.9) can be seen as accented beats, separated by the unfilled spaces between them. The statues suggest a series of dramatic single pulses, like heavy individual beats played on a deep-throated drum or gong. In Frederic Remington's narrative sculpture *Coming through the Rye* (Fig. 3.10), individual visual beats are less distinct, but a rapid staccato rhythm is set up nevertheless as the outlines of the forms abruptly shift direction up and down, in and out, through space. The many hooves striking the

3.10 Frederic Remington. *Coming through the Rye.* 1902. Bronze (cast no. 12). Amon Carter Museum, Fort Worth (1961.23).

3.11 Max Bill. *Monoangulated Surface in Space.* 1959. Gilded brass, 15 × 18 × 26" (38.1 × 45.72 × 66.04 cm). © The Detroit Institute of Arts. Gift of W. Hawkins Ferry.

ground in succession, punctuated by the upraised arms, make this a very "noisy" piece of sculpture.

In some pieces, there may be a sense of movement that has no beginning and no end. The curving lines of Max Bill's *Monoangulated Surface in Space* (Fig. 3.11) set up a continuing song, endlessly flowing back into itself. As it rises, the "sound" swells in a gentle crescendo; as the two sides meet and flow downward again, the rhythm resolves temporarily into a decrescendo and then rises again with barely a pause. The piece almost becomes a visual mantra, like a continually chanted "Om."

Some works echo—or contrast with—the rhythm of their surroundings. Pieces that suggest a single beat are sometimes very effective in contrast with the cacophony of an urban environment. Michael Singer's *First Gate Ritual Series* (Fig. 3.12) fits in with the soft rhythm set up by its natural environment—the whispering ripples and highlights of slow-moving water. The work gently adds its own lightly sustained, overlapping notes to the passing flow of shimmering reflections.

BALANCE

3.12 Michael Singer. *First Gate Ritual Series.* 1976. Oak and rock. Installed at the Nassau County Museum of Fine Art, Roslyn, New York. Photo Michael Singer.

The sense that a three-dimensional work is visually balanced is another way in which a work may satisfy the mind's search for order. If pieces were not in fact balanced or anchored, they would fall over. But beyond the physical fact of their remaining as placed, works convey a sense of *visual balance.* Each area suggests a certain *visual weight,* a certain degree of lightness or heaviness. Factors such as value, texture, form, size, and color affect our perception of visual weight. For example, light colors

3.13 Beverly Pepper. *Cleopatra's Wedge.* 1991. Steel, 18'6" high by 6'6" wide (5.60 × 1.90 m). Courtesy Andre Emmerich Gallery, New York.

3.14 Pirro Ligorio. *Fountain of the Organ,* Villa d'Este, Tivoli. c. 1550. Photo Alinari/Art Resource, New York.

appear lighter in weight than dark colors; transparent areas seem to weigh less than opaque areas. Yellow areas seem to expand in size, whereas blue areas tend to contract. To balance a work is to distribute the visual weight of its parts in such a way that the viewer is satisfied the piece is not about to pull itself over.

One form of visual balance is *symmetrical balance*—the formal placement of identical parts on each side of an imaginary *vertical axis,* a central line that could be drawn vertically through the piece.

In *Cleopatra's Wedge* (Fig. 3.13), Beverly Pepper features this vertical axis, with sides of the slender wedge flaring only slightly outward from this imaginary line. The cube on which it rests, and the inverted cone upon which *that* rests, follow the same principle of absolute symmetry. The impression given is that this perfect symmetry is absolutely necessary as the only force that allows the tall wedge to remain balanced on the base. In *The Fountain of the Organ* (Fig. 3.14) the organpipe-like jets of water are exactly the same on both sides, like mirror images of each other. Such a configuration tends to create a secure, safe feeling, a sense of solidity that transcends the fluidity of the medium.

Asymmetrical balance is a trickier balancing act. Here, areas on either side of a central vertical axis are not identical but appear to have

3.15 Jacques Lipchitz. *Prometheus Strangling the Vulture.* 1944–53. Bronze, 91³/₄ × 90 × 57". Collection Walker Art Center, Minneapolis. Gift of the T. B. Walker Foundation, 1956.

3.16 Mark di Suvero. *Mozart's Birthday.* 1988–89. Private Collection. Courtesy of the Oil and Steel Gallery, Long Island City, New York.

3.17 Vico Magistretti. "Atollo" Table Lamp. 1977. Aluminum with Nextel finish, 27" high, diameter of shade 19¹/₂". The Museum of Modern Art, New York. Gift of O-Luce Italia.

the same visual weight nonetheless. To balance forms asymmetrically, a *thrust* away from the vertical axis in one area may be balanced by a *counterthrust* in the opposite direction on the other side of the vertical axis. In Jacques Lipchitz's *Prometheus Strangling the Vulture* (Fig. 3.15), the projection of the vulture and Prometheus's head to the right are offset by the thrust of the form billowing out to the left, making it appear logical that Prometheus could indeed be balancing his considerable weight atop the small ball at the base. Here, the central axis is suggested by presentation of an actual *balancing point*—a fulcrum at the base upon which the entire upper portion of the composition seems to be balanced.

In asymmetrically balanced pieces, the balancing point may not fall in the exact center of the work. Mark di Suvero's *Mozart's Birthday* (Fig. 3.16) has two apparent balancing points: the tops of the triangular bases from which everything else seems to be hung, suspended, or propped. By contrast, the symmetrically balanced "Atollo" Lamp shown in Figure 3.17 has a single balancing point in dead center.

Designs must be balanced vertically as well as horizontally; that is, if an imaginary line is drawn horizontally through the center of a piece, representing its *horizontal axis,* the area above the line must be balanced by the area below the line. In judging this *vertical balance,* we may feel that absolute symmetry—the same weight above as below—is actually unbalanced. Based on our experiences in the three-dimensional world, we expect that greater weight is needed on the bottom to support the area rising above the horizontal axis. In John Storrs's skyscraper-like *Forms in Space* (Fig. 3.18), we sense that the great height of the figure relative to its width is possible only because of the "support" of the shorter outer columns for the tallest central columns.

The complexities of visual balancing are compounded by the fact that the components of the balance change as one walks around a three-dimensional piece. Although our view of Lipchitz's *Prometheus* (Fig. 3.15) is frozen by the photograph, the projection of forms on either side of the balancing point is quite different from other points of view, but equally well balanced. Because balance is often too complex to be determined intellectually, artists are more likely to work with it intuitively, manipulating the elements of design until areas feel balanced in relationship to one another.

Can a piece of three-dimensional work be visually unbalanced? It depends on the intent of the artist. In some cases, a suggestion of imbalance is central to the excitement of a piece. In *Prometheus* the lack of a broad base for Prometheus's great bulk makes his struggle with the vulture all the more exciting, for he seems to have precise balance as well as considerable strength. In Arthur Hoener's *Standing Figure No. 2* (Fig. 2.26), the fact that the sculpture seems slightly off balance adds to its sinuous quality, as though it were in motion.

EMPHASIS AND ECONOMY

Many works are successful because they adhere to the principle of *emphasis*—stressing of a particular area or characteristic rather than presenting a maze of details of equal importance. One method of achieving emphasis is to make one area or quality *dominant,* or most important visually, with other areas contributing but subordinate. That area to which the eye is drawn most compellingly may be the largest, brightest, darkest, or most complex part of the whole, or it may be given special attention because it stands out for some other reason. In Naum Gabo's *Linear Construction* (Fig. 3.19), we could see the oval void in the center as the *focal point*—the place where our gaze tends to center. Though consisting of unfilled space, it stands out because it runs through the physical

3.18 John Storrs. *Forms in Space.* Metals in combination. Without base: height 20¼" (51.30 cm), greatest width 4" (10.16 cm). With base: height 25" (63.5 cm), base height 4¾" (11.68 cm), width 5½" (13.71 cm), depth 3⅛" (8.12 cm). The Metropolitan Museum of Art, New York. Francis Lathrop Fund, 1967.

3.19 Naum Gabo. *Linear Construction.* 1943–48. Lucite with nylon thread, 24⅛ × 24¼ × 9⅞" (61.2 × 61.5 × 25.0 cm). © The Phillips Collection, Washington, D.C.

center of the work and because its simplicity contrasts with the fine lines of the filled areas that surround it.

Although focal points are commonly used as unifying characteristics in two-dimensional art, a three-dimensional work may not have a single focal point, since there may be no one point that can be seen from all sides. Gabo's piece is transparent, thus allowing the central void to be seen from all angles. But in works that must be walked around, the eye may be led from one area to another, so the notion of focal

3.20 Antoni Gaudi. *Church of the Sagrada Familia.* 1903–26. Barcelona. Photo MAS, Barcelona.

3.21 Hans Coper. Ceramic pot. Height 8″ (20.32 cm). From Tony Birks *Hans Coper* (Sherborne, Dorset: Marston House). Photo Jane Gate.

point is not easily applied. One-sided works may be organized around a single dominant area, however. And in works that physically surround the viewer, such as gardens, a contrasting element such as a fountain or piece of sculpture may be used to draw people into or through the work.

Another form of emphasis is the directing of all elements of design toward the intended goal. In Antoni Gaudi's *Church of the Sagrada Familia* (Fig. 3.20), the aesthetic intent is to uplift the awareness of the viewer. To this end, the major forms rise in slender spires, making the cathedral's height much greater than its width. The visual accent is on the vertical, creating a pronounced upward thrust. The lattice-like cutouts make the materials appear much lighter than they actually are, creating an airy effect, as though the building were actually stretching upward in a spiritual reaching that defies the pull of the earth's gravity.

Yet another way of creating emphasis is to limit the viewer's focus to only a few elements of design. This device is called *visual economy*—stripping away all nonessentials to reveal the essence of a visual idea. In pieces such as the pot shown in Figure 3.21, the late British potter Hans Coper limited his use of colors and textures to leave the viewer room to experience the bare essence of abstract form. This austere aesthetic eliminates clutter, allowing the mind to focus on the beauty of the seemingly simple.

To use the principle of visual economy is not simple, however. To reduce an aesthetic statement or a form to its simplest components requires an elegant mental feat. It also asks much of the viewer. For *minimal art*—art based on the idea that less is more—to work, precisely enough information must be given, in the right scale and proportion, and the viewer has to be willing to fill out the picture from his or her own experiences in the three-dimensional world. Richard Serra has used

3.22 Richard Serra. *Right Angle Prop.* 1969. Lead antimony. Plate: 72 × 72" (183 × 183 cm). Angle: 36" (66 cm) length. Solomon R. Guggenheim Museum, New York. Purchased with funds contributed by the Theodoron Foundation, 1969.

two simple lead forms in *Right Angle Prop* (Fig. 3.22) in an attempt to express physically the verbal infinitive "to prop." If the viewer's mind is willing to make this imaginary leap with the artist, it is possible to reach a similar visual equivalency. It is much more difficult to emphasize by understating than by overstating, for in understatement directing of the viewer's understanding is reduced to an absolute minimum. Many may not understand, or care to try.

PROPORTION

A final, subtle organizing principle of design is *proportion*—the size relationships among parts of a work. When proportions are correct, when they "feel right," the work as a whole will tend to fall into place with a satisfying sense of order in the mind of the viewer.

The issue of proportion can be approached mathematically. The ancient Greeks felt that the most aesthetically perfect size relationship between two unequal parts of a whole was 1 to 1.618. In a rectangle whose short side was one foot (.3 m) long, for instance, the length of the long side would be 1.618 feet (.49 m). Enshrined as the *golden section,* these proportions were thought to be the epitome of beauty and were used in the designing of buildings such as the Parthenon (Fig. 3.23). The same size ratio can be found in many natural growth patterns, such as the size relationship of successive florets in the center of a daisy, or stages of growth in a nautilus shell.

Parts of the human body also exist in specific size relationships to each other. The representational artist must bring the ratios between parts of the body into conscious awareness to satisfy viewers' sense of proper proportion. Students usually learn, for example, that the body as a whole is seven and a half heads high. Finger joints, hands, and arms exist in predictable mathematical relationships to each other.

Aside from known associations with the proportions of the human body or other familiar figures from our three-dimensional world, we have a subtle intuitive sense of what looks correct. The proportion of base to shade in the Atollo Lamp (Fig. 3.17) seems exactly right. This sense of perfect correctness was captured by the Zen monks who designed the Ryoan-Ji Garden in Kyoto (Fig. 3.24). The outer dimensions of the garden, the height and distance between rocks, the distances between the rocks and the viewer, the mountainlike height of the rocks from this distance, the width of the furrows in the raked sand, and the proportion of the sand raked in concentric circles around the islands of stone—all aspects of the composition exist in such perfect relationship to one another that the viewer feels a great sense of peace, of everything being as it must be. One feels that if a single proportion were changed, the unity of the piece would be destroyed.

Although the principles of design have been examined separately, they work together to create an impression of unity. Satisfying proportions are not the only unifying feature of the Ryoan-Ji Garden. Consider the other principles discussed in this chapter—repetition, variety, rhythm, balance, emphasis, economy. How is each reflected in the organization of this classic work, making it a coherent, aesthetically pleasing whole rather than several unrelated rocks stuck in some sand?

3.23 Parthenon façade within Golden Section.

3.24 Rock garden of Ryoan-Ji Temple, Kyoto, Japan. Courtesy Consulate General of Japan, New York.

PART TWO

ELEMENTS OF
THREE-DIMENSIONAL DESIGN

CHAPTER 4

FORM

Form is perhaps the most obvious element of three-dimensional design, for *form* defines what three-dimensional art is: It is that which occupies three-dimensional space (in contrast to a *shape,* which is flat, two dimensional). Yet defining form itself is not so simple. A limited definition of form is the actual physical contour of a work, the volume or mass that it carves out of space. In Tony Smith's *Die* (Fig. 4.1), the form is clearly a 6-foot (1.83 m) cube. But in certain works the questions of what constitutes the form of the piece is less obvious.

In Clayton James's handbuilt pots (Fig. 4.2), the forms are shells enclosing empty space. Yet the volume they enclose seems to be a positive force in itself, as if it were pushing the walls of the pots outward.

In Sylvia Stone's *Another Place* (Fig. 4.3), the form of the piece could be described as a sprawling assembly of flat Plexiglas panels. By such a definition, its form is almost nonexistent, since the thin Plexiglas occupies very little space and is also transparent. Stone's work almost transcends form in the literal sense. But to limit understanding of form to its physical existence is to overlook the fullness of the experience of such a piece. To broaden our understanding, we could say that the form

4.1 (above) Tony Smith. *Die.* 1962. Steel, 6′ (1.83 m) cube. Courtesy Paula Cooper Gallery, New York.

4.2 (left) Clayton James. Handbuilt forms. Photo © Mary Randlett.

4.3
Sylvia Stone. *Another Place.* 1972. Plexiglass, 6′8″ × 17′ × 28′2″ (2.03 × 5.18 × 8.59 m). Photo Linda Schwartz.

of the work includes the interior spaces it encloses and the varying but barely visible Plexiglas configurations that can be grasped at the very edge of perception as the viewer shifts position.

The elements of design can be understood as dynamic aspects of three-dimensionality that the artist manipulates in order to create desired effects. The words we use for these elements—form, space, line, texture, light, color, and time—are simple and familiar terms in everyday language. Yet their use to describe what happens in a work of art vastly expands the potential of their meaning to encompass a world of nonverbal experience that can only be poorly hinted at through the use of words.

In these chapters on the elements of design, we hope to indicate something of the great range of effects that can be created through use of each element. Although artists work with many elements of design at once, directing them toward a unified goal, we must study them by isolating each element and exploring what it can do. For form, we consider interior as well as exterior forms, secondary as well as primary contours, negative as well as positive forms, static forms and dynamic forms, and representational, stylized, abstract, and nonobjective forms.

EXTERIOR VS. INTERIOR FORMS

We normally think of form as referring to the outside of a piece—its *exterior form*—but works may also reveal an *interior form*. Comparing the relationships between the two may be a major part of the aesthetic experience.

At the most literal level, the inner form is simply the reverse of the outer form of a hollow piece. A bowl has both a convex exterior form and a concave interior form. Elena Karina draws us into the intriguing interior forms of her ceramic sculpture (Fig. 4.4), whose open fringes appear as a colony of plants or animals kept in motion by the sea. She

4.4 (left) Elena Karina. *Sky Trumpet.* 1980. Porcelain with luster glazes, high fired with stain and oxide accents, lusters fired at cone 022, 10″ h × 18″ diameter. From Susan Peterson *The Art and Craft of Clay* (Englewood Cliffs: Prentice-Hall, 1992). Photo Bill Scott.

4.5 (right) Arnaldo Pomodoro. *Sfera con Perforazione (Sphere with Perforations).* 1966. Bronze, one-half cast, diameter 23¹/₂″ (60 cm). Photo Mario Carrieri.

4.6 Michelangelo. *Bound Slave.* Marble. Galleria dell'Accademia, Florence. Photo Scala/Art Resource, New York.

inspires in us a desire to explore whether these openings are hollow in their depths, and if so, what the passages look like inside.

Sometimes artists create the illusion of revealing a hidden inner form. In *Sphere with Perforations* (Fig. 4.5), Arnaldo Pomodoro has "opened" a gleaming bronze sphere to show its secret core, mysterious interior forms of which the exterior form gives no hint. On another level, sculptors often feel that in removing excess stone from a block they are revealing a form that was hidden inside all along. This process of bringing the interior form to light is illustrated in Michelangelo's unfinished *Bound Slave* (Fig. 4.6). It is not known whether Michelangelo intended to finish bringing the inner form out of the marble or whether the piece is intended as a statement of the outer forces almost totally constraining the inner life and freedom of a human being.

Another expression of the contrast between interior and exterior forms appears in pieces in which one form is physically separate from but contained within another. When all or part of the interior form can be seen through the exterior form, the relationship between the two and the discovery of the inner form can be quite exciting. A classic example is the traditional Japanese "package," which a farmer or wood-cutter would bring to the workplace from home (Fig. 4.7). Through the

4.7 *Tamago no tsuto (The Egg Package).* Rice straw, 16" (40 cm). Collection Hideyuki Oka.

4.8 Shiro Kuramata. *How High the Moon.* Steel mesh prototype. Photo Mitsumasa Fujitsuka.

horizontals and verticals of the exterior reed form, we can see the elegance of what many designers consider the perfect natural form: the egg.

In architecture, glass walls may allow us to see the interior forms, such as stairwells and furniture, encased within the exterior framework of the building. Similar effects are sometimes created in sculptures with exterior forms that either contain visual openings or are transparent. Shiro Kuramata has imitated the form of a traditional upholstered armchair (Fig. 4.8) but has used steel mesh whose transparency reveals the framework of the chair as well as the exterior surface. The transparency creates some interesting spatial ambiguities as we try to sort out the relationships among the parts of this work.

In contrast to works in which we are invited to compare inner and outer forms, some pieces present an outer form that is hollow, implying an inner form that cannot be seen. There may be a sense of a force bulging outward, forcing the walls of the piece into outer shapes by pressure from within. Or in the case of jewelry, masks, or medieval body armor, a piece may be made to fit over the form of a body. When shown without a body inside, the outer form is both interesting in itself and reminiscent of the inner form it once enclosed. The suits of armor made for Henry VIII from 1511 to 1545 (Fig. 4.9) reveal his physical evolution from the slenderness of youth to middle-aged paunch.

PRIMARY AND SECONDARY CONTOURS

In any form with surface elaboration, a distinction can be made between the *primary contour* of the piece—the shape of its outermost extremity—and its *secondary contours*—the forms that are developed on its surface.

4.9a, b, c, d Tournament and field armors for Henry VIII. c. 1520, 1515, 1540, 1535–40. Steel with various decoration. The 1515 armor is silver and engraved. The Board of Trustees of the Royal Armories (a–c); Royal Collection © 1992 Her Majesty Queen Elizabeth II (d).

(a)

(b)

(c)

(d)

4.10 (left) Column of Trajan, Rome. A.D. 113 Marble, 125′ (38 m) high. Alinari/Art Resource.

4.11 (right) Hagesandros, Athanodoros, Polydoros. *Laocoön.* 2nd or 1st century B.C. Marble, 6′ (1.84 m) high. Vatican Museums, Museo Pio Clementino.

The cylindrical outline of *Trajan's Column* (Fig. 4.10) is its primary contour; the low relief carvings spiraling around it to tell the story of Trajan's campaigns constitute its secondary contours.

In many cases there is no clear distinction between primary and secondary contours but rather an ever-changing interplay between them. In the famous Greek statue *Laocoön* (Fig. 4.11), the primary contour is the complex outline of the piece; the secondary contours are the details of the snake and the bodies of Laocoön and his sons. But what is not apparent from a photograph is that the primary contour of the sculpture will change as the viewer moves around it, seeing different areas created by the "secondary contours" as outermost.

The words "primary" and "secondary" do not have any hierarchical significance, either. Neither is automatically more important. In *Laocoön* the real excitement lies in the relationships between secondary forms—parts of the snake to parts of the humans, arm to arm, leg to leg.

POSITIVE AND NEGATIVE FORMS

Another set of polarities that arises in three-dimensional work with form is the distinction between *positive forms*—solid areas that occupy space—and *negative (or implied) forms* or *voids*—the shapes of spaces that are enclosed or delineated by positive forms. The difference between the

two is apparent in Barbara Hepworth's *Pierced Form* (Fig. 4.12). Here the positive form is sculpted white marble; the negative form is the space opened within it. The viewer is invited to experience both. Although the negative form cannot be seen, its shape is almost totally defined by the marble, and the two complete each other as a single unit. For Hepworth, this sense of unity between mass and void grew out of her personal experience of the wholeness of life. She writes:

> All my early memories are of forms and shapes and textures. Moving through and over the West Riding landscape with my father in his car, the hills were sculptures; the roads defined the form. Above all, there was the sensation of moving physically over the contours of fullnesses and concavities, through hollows and over peaks—feeling, touching, seeing, through mind and hand and eye. This sensation has never left me. I, the sculptor, *am* the landscape. I am the form and I am the hollow, the thrust and the contour.

Although negative forms actually consist of empty space, they can be as active and important in a piece as the positive forms. In Le Corbusier's *Notre Dame du Haut* (Fig. 4.13), the negative window forms in the thick walls are highly active, for they are both channels for light and intriguingly varied volumes in themselves. A void in a piece of

4.12 Dame Barbara Hepworth. *Pierced Form.* 1963–64. Pentelic marble. The Tate Gallery, London/Art Resource, New York. Copyright Alan Bowness.

4.13 Le Corbusier. *Notre Dame du Haut* (interior south wall). 1950–55. Ronchamp, France. Photo GEKS.

4.14 Erwin Hauer. *Inversion of Volumes.* 1965. Bronze, 24 × 8 × 8" (61 × 20 × 20 cm). Collection Fondazione Marguerite Arp, Locarno, Switzerland.

4.15 Hanno Ahrens. *Fait-do.* 1988. 54 × 11½ × 29". Photo © David Lubarsky 1988, all rights reserved; courtesy the artist.

sculpture allows the exposure of inner surfaces, creates spatial relationships among forms that would not otherwise occur, and invokes playful or curious attempts by viewers to look through the piece. In Erwin Hauer's *Inversion of Volumes* (Fig. 4.14), the opening of a void in the lower area creates lovely interplays of rounded positive and negative forms. Note that the artist has created a visual game in which the viewer may discover that the upper portion is a re-creation of what has been carved away below—the positive of the negative, if you will.

Voids may also imply an invisible force. Consider Hanno Ahrens's *Fait-do* (Fig. 4.15). The central void gives the impression of a force bearing down, filling the negative space. Two more voids seem to be countering this pressure from below, in the areas left between the central form and the two half-circular forms to either side. They are small but visually strong because no light reaches them; they are therefore quite dark.

STATIC AND DYNAMIC FORMS

Certain works have a stability of form that can be called *static,* in the sense of appearing stationary, nonmoving. One of the most static forms is the pyramid (Fig. 4.16). Because the base is so much broader than the top, no inner force could conceivably cause the form to move or fall over. But although these silent, permanent forms seem grounded in eternity, to stand at the base and gaze up to the summit and the vastness

4.16 The Great Pyramids at Giza, Egypt. After 2700 B.C. Photo Hirmer Fotoarchiv.

of the sky beyond also inspires awareness of another aspect of reality: infinity.

Like pyramids, architecture with straight walls and ground-hugging proportions gives a sense of visual stability. Even a strongly vertical work, such as Anne Truitt's *Nicea* (Fig. 4.17), can suggest a certain stability by the quietness of its contours. Static does not necessarily mean boring, however. By subtle use of different values of paint, a small recessed base, and controlled lighting, Truitt creates an elegant and beautiful impression of beveled edges in what is basically only a weighted rectangle.

Although many static forms are straight-sided geometric solids, some have curving edges and may even represent living beings. The energy of life is obvious in *Gudea Worshiping* (Fig. 4.18), and yet the

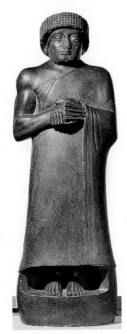

4.17 (left) Anne Truitt. *Nicea.* 1977. Painted wood, 84½ × 10 × 8″. Courtesy Andre Emmerich Gallery, New York.

4.18 (right) *Gudea Worshiping.* Telloh, c. 2100 B.C. Dolerite, height approximately 42″ (107 cm). Louvre, Paris. Photo Hirmer Fotoarchiv.

figure does not appear to be in motion. Rather than presenting a stop-action image of a moving person, the sculptor of this ancient piece presents us with a still image of a still figure. Feet, hands, and shoulders are at the same position on both sides. Nothing suggests physical movement.

By contrast, *dynamic* forms are those characterized by motion, change, or energy that will lead to motion and change. Victor Horta's door handle (Fig. 4.19) is a highly *dynamic* form, for it appears to be in a state of constant motion. Although made of metal, it has the flowing quality of a plant form, as do many similar Art Nouveau pieces from the same period.

Even buildings can be shaped into dynamic forms as was architect John Lautner's *Arango House* (Fig. 4.20) overlooking Acapulco Bay. The walls and massive concrete roof of this house curve with such apparent ease that the structure seems to have the energy to continue the established flowing visual motion.

Or compare Michelangelo's *David* (Fig. 4.21) with *Gudea Worshiping* (Fig. 4.18). While the latter seems to be fixed in an attitude of worshipful concentration, David's watching Goliath approach bespeaks

4.19 Victor Horta. Door handle in the Hotel Solvay, Brussels. 1895–1900. Photo courtesy The Museum of Modern Art, New York.

4.20 John Lautner. *Arango House,* Acapulco. Living room. Photo Erven Jourdan, Los Angeles.

4.21 (left) Michelangelo. *David.* 1501–04. Marble, height approximately 18′ (5.49 m). Galleria dell'Accademia, Florence. Photo Alinari/Art Resource, New York.

4.22 (right) John De Andrea. *Joan.* 1992. Lifesize, polyvinyl resin polychromed in oil. Courtesy ACA Galleries, New York.

a reserve of energy like a coiled snake ready to strike. Although he is moving only slowly, if at all, nothing in his body is passive or at rest. The two sides of his body are asymmetrical, suggesting a readiness to spring into action, foreshadowed by the swelling tension in the sinews of his anchored foot, clenching lower hand, and neck. The dynamism of this form is understated, but a perceptive observer can read tremendous power waiting within it.

REPRESENTATIONAL, ABSTRACT, AND NONOBJECTIVE FORMS

A final range of effects that can be created using form involves degrees of likeness to known objects. Distinctions among these kinds of forms are not easily made, but the terms and ideas are useful, for they indicate different attitudes toward form on the part of the artist.

Representational or *figurative* forms are those that refer directly to an object from the three-dimensional world of our experience. The highest degree of representationality is sometimes called *super-realism.* An example of this attitude toward form is John DeAndrea's nude *Joan,* (Fig. 4.22), a body casting that faithfully reproduces the contours of a specific human body in all its naked imperfection. The artist is uncompromising in details.

Though we may not be aware of it, we are more accustomed to forms that are slightly *idealized*. That is, contours and proportions are directed toward an idea of what the object would look like in its imagined or inner perfection, rather than its less-than-perfect superficial appearance. In sculpture, the ideal may exist in the mind of the artist, who may extract qualities from a variety of human models to serve his or her vision rather than trying to represent a single model realistically. Michelangelo's *David,* for instance, is clearly a representation of a young man. The master has chosen not to reproduce every detail of a living human body, however. David—known biblically as the chosen of God— is presented as an idealized conception of the perfect body, strong, lithe, and without blemish. He is seen as a giant among men, and the statue itself is a colossal 18 feet (5.49 m) high. The sculpture is still regarded as a classic representation of male beauty almost five hundred years after its creation.

In some cases, the ideal in the artist's mind is an emotion rather than a specific form. Here realism in outer form is subordinated to representation of what that emotion would look like if projected to its fullest through a being the viewer can identify with.

Another variation from reality occurs in representational works that are highly *stylized*. In these pieces, the form has been simplified

4.23 No Two Horns, Hunk-papa Lakota. *Horse Effigy Batons.* Approximately 3′ long. Photo Henry Groskinsky.

and altered to conform to a particular historical style or to stress a particular design characteristic. If you look back at *Gudea Worshiping* (on page 87), you can see that even though this figure is recognizable as a man, his contours have been reduced to the simplified outline of a standing, draped figure, and his robe falls straight to his feet with only a few stylized folds. In a more realistic piece, the draping would be detailed, following the more complex forms of the human body. In addition to simplifying contours to create a strong design, the Mesopotamian sculptor used the stylistic conventions of the times: a direct frontal pose, large eyes, and thick eyebrows. Despite all these stylizations, this ancient piece conveys the impression of a unique and genuine personality as well as elegance in design.

At the next remove from superficial reality are *abstract* works—those in which the artist has reduced a real form to its bare essence. No Two Horns's Lakota horse-effigy batons (Fig. 4.23) use only a head and one foot or a tail to suggest an entire horse. Constantin Brancusi's *White Seal ("Miracle")* (Fig. 4.24) has no eyes, mouth, or flippers, but Brancusi's genius in abstracting the essential qualities of "sealness" leaves no doubt as to what the creature is. These qualities seem to include its streamlined contours and a form that—while ideal for gliding underwater—appears bulky on land. Despite its awkward manner of ground travel, the seal still has surprising facility at balancing on small surfaces, so this marvelous seal form poised on a little stone appears both wonderful and believable. As we noted in Chapter 2, the more the artist leaves out, the more the viewer must bring to the work in order to understand and appreciate it.

Works that do not refer at all to any object from our three-dimensional world are called *nonobjective* or *nonrepresentational*. This approach to three-dimensional art can be traced back to the Constructivist Movement that developed in Russia between 1914 and 1922. As explained in the Realistic Manifesto of Naum Gabo and his brother Antoine Pevsner, this new approach to art set aside the old attempts to imitate nature through descriptions of human figures and other tangible objects. Rather, the Constructivists sought to explore the characteristics of materials themselves and of the intangible realities of space and time. This "nonobjective world" beyond sensory experience is suggested by pieces such as Pevsner's *Developable Column* (Fig. 4.25). Its nonobjective form seems to be in perpetual motion through time and space. Without suggesting any known object, it draws us into a sense of movement through space and evokes interest in the texture and colors and lines of the bonded brass and bronze rods.

Nonobjective forms are sometimes unfamiliar shapes growing out of the artist's inner imaginings; sometimes they are elaborations of geometric shapes, suggesting the orderly mathematical structures that form the building blocks of life. While viewers will judge representational works partly on the basis of how well they re-create the sense of a known object, nonobjective forms may invite viewers to move beyond mental associations and experience directly the impact of form, line, texture, value, color, space, or time.

4.24 Constantin Brancusi. *White Seal ("Miracle").* 1924–36. Marble, height 43″. Base of two stone sections, height 21⅝″. Solomon R. Guggenheim Museum, New York. Photo Robert E. Mates © The Solomon R. Guggenheim Foundation, New York.

4.25 Antoine Pevsner. *Developable Column.* 1942. Brass and oxidized bronze, height 20¾″ (53 cm), base diameter 19⅜″ (49 cm). The Museum of Modern Art, New York. Purchase.

SPACE

Space is a very real and important element of three-dimensional design, but it is difficult to conceptualize. *Space* is the three-dimensional field with which the artist works. It may include unfilled as well as filled areas, or what are referred to respectively as *negative* and *positive* areas. The positive area is the part of the work that physically occupies space; the negative area is all unfilled space that is activated by the piece. Although a good artist works with both kinds of space at once, viewers' experiences of negative space are so subtle and subjective that it is hard to define and measure. The use of two-dimensional photographs further limits understanding of spatial concepts, for these subtle experiences change as the viewer moves.

Within these limitations, this chapter will explore some of the ways in which artists work with space. These include delineated shapes in space, activated surrounding space, confined space, spatial relationships, scale, and illusionary space.

DELINEATED FORMS IN SPACE

In addition to occupying space physically, positive forms may carve negative forms out of the unfilled spaces within and around them. In David Smith's *Cubi XII* (Fig. 5.1), the angle from which the photograph was taken reveals triangular forms framed within the sculpture. We can also discern a series of partial forms where the surrounding space meets the sharp edges of the piece. For instance, at the edges of the two small balanced cubes in the upper right, unfilled space seems to thrust inward at 90-degree angles as a sort of counterforce to the triangular spaces pushing outward from within. Below the broader but thinner block jutting out farthest to the right is a notched form in space. If you follow the edges around the piece, you will be struck by the dynamic forms meeting these edges in space. In a sense, these strong forms created in unfilled space help to maintain the tense visual balance of the blocks, giving cohesiveness to the precariously balanced structure.

Delineated spaces, those forms carved out of space by positive forms, may serve a variety of aesthetic functions in a work. In Naum

5.1 David Smith. *Cubi XII.* 1963. Stainless steel, 9′ 1⁵/₈″ × 4′ 1¹/₄″ × 2′ 8¹/₄″ (278.5 × 125.1 × 81.9 cm). Hirshhorn Museum and Sculpture Garden, Smithsonian Institution. Gift of the Joseph H. Hirshhorn Foundation, 1972. Photograph Lee Stalsworth.

5.2 Louise Bourgeois. *Needle (Fuseau)*. 1992. Steel, flax, mirror, and wood; 109 × 101 × 56″. Robert Miller Gallery, New York.

Gabo's *Linear Construction* (Fig. 3.19), the elegant delineated space in the center is the focal point of the work. He explains that in such sculpture:

> space is not a part of the universal space surrounding the object; it is a material by itself, a structural part of the object—so much so that it has the faculty of conveying a volume as does any other rigid material.

Often delineated spaces are visually interesting or appealing in themselves, whether the viewer is conscious of "seeing" them or not. To make these unfilled forms more visible, three-dimensional works are often photographed against a plain background. In the photograph of the work shown in Figure 5.1, the delineated spaces are filled with details of the nearby trees, a situation that can realistically be expected to occur in an outdoor setting. Louise Bourgeois's *Needle* (Fig. 5.2), by contrast, is presented against a plain wall, so that both the half-oval space defined by the large curved needle and thread and the shadows falling on the wall behind are clearly presented for our attention. Here the positive outline is almost secondary to the unfilled shape which it defines, and which is repeated in the oval shadows of the wooden balls.

ACTIVATED SURROUNDING SPACE

Somewhat different from the carving of identifiable forms out of space is the tendency of some works to activate an area larger than their own physical confines. This happens when the visual statement made by the piece draws the viewer's attention to a broader area or charges the surrounding atmosphere with a subtle yet active energy. The *spatial presence* of a work is something that can only be sensed; it usually cannot be seen unless it is limited to the contours of the piece. Judgments about the size of a work's presence are quite subjective; they depend not only on the work but also on the awareness and personality of the viewer.

One way of activating surrounding space is to draw the viewer's attention to *eye lines* through space. In Henry Moore's *Madonna and Child* (Fig. 5.3), the mother's gaze fills an area extending far off to her right, while the child's mild gaze projects outward to his left. It is as if they are seeing different areas in time as well as space. Without this treatment of the eyes, the space activated by the sculpture would be considerably smaller.

5.3 Henry Moore. *Madonna and Child.* 1943–44. Hornton stone, 59″ high. Church of St. Matthew, Northampton, England. © The Henry Moore Foundation.

5.4 George Rickey. *N Lines Vertical.* 1967. Stainless steel, 98 × 9¼ × 5¼". Museum of Contemporary Art, San Diego. Gift of Mr. and Mrs. Norton S. Waldridge.

In *Wind Chant* (Fig. 2.18), John Matt activates surrounding space by filling it with "music." The open lines of the sculpture invite space to flow through the harplike section in lyrical curves suggested by the curving line in the piece. The presence of *Wind Chant* may therefore be perceived as a mystical presence—a suggestion of unseen winds playing subtle music beyond human perception. Matt describes this aspect of the piece he has created:

> The music that I feel when I see that piece is like sound in three dimensions. The sound covers a large or small space, depending on where the piece is shown. The image itself is like a scale, a note; it almost reminds me of a harp, a stringed instrument with a sounding board. There is an aura encompassing it, an airiness about it, a very lyrical nature—it suggests the vocabulary we usually associate with music.

George Rickey's *N Lines Vertical* (Fig. 5.4) activates a large area in yet other ways. First is its use of pointing lines, for their sharp outward thrust directs the viewer's vision infinitely outward; the lines given in the sculpture seem to be only the beginning of implied lines that continue far out into space.

A second reason for the great presence of Rickey's sculpture is the sharp points of the piece. They would tend to hold viewers at some distance in healthy respect for the possibility of being pricked. A third presence-enlarging factor cannot be appreciated in a still photograph: The piece moves with the wind. The rotation of the sharp-pointed lines through space would activate an even larger space that seems to belong to the sculpture. Psychologists have found that people tend to do the same thing: They subconsciously establish a certain distance around their bodies as their "personal space." If you have ever intruded on the personal space of someone who is feeling angry or sharp-edged, you will know what the phrase *activated space* can mean.

The spatial presence of a work is not necessarily a hostile environment, of course. But to the sensitive, it may engender a certain respect. Stonehenge (Fig. 5.5) has such colossal spatial presence that even from a distance, people are touched and awed by it. Its great size and mysterious appearance against the vastness of bare plain and sky endow it with presence that radiates almost infinitely.

By contrast, some large works are designed to welcome people, enticing them, rather than creating an outward-expanding spatial presence. *Participatory sculpture* is meant to be touched, climbed on, or swung from by viewers. Public sculpture may weigh tons, but if its contours are low and rounded, people may treat it like familiar furniture, leaning against it and perching all over it. Some people are drawn to sit on public sculpture even if they have to go to some trouble to do so. The pair eating lunch on Clement Meadmore's *Upstart* (Fig. 5.6) had to hoist themselves far above normal sitting height to attain their perch, apparently unintimidated by the looming bulk of this large piece.

In the world of virtual reality, the activated space may seem quite large, but it exists only in the monitors recording the viewer's

5.5 (above) Stonehenge. c. 2000–1500 B.C. Height of stones 13′6″ (4.11 m). Salisbury Plain, England. Photo Fritz Henle/Photo Researchers.

5.6 (left) Clement Meadmore. *Upstart.* 1967. Welded Cor-Ten steel, height 20′6″ (6.25 m). Fabricated at Lippincott, Inc., New Haven. Collection Bradley Family Foundation, Milwaukee.

5.7 University of North Carolina, Department of Computer Science. Walk-through treadmill. From Steve Aukslakalnis and David Blatner, *Silicon Mirage* (Berkeley: Peach Pit Press, 1992).

movements and feeding back visual information. The University of North Carolina's Department of Computer Science building was designed with the help of a virtual-reality system (Fig. 5.7). As the building was being designed, people could "walk through" it on a treadmill, view it from all interior angles, and turn down corridors by turning the handlebars of the treadmill. They discovered that the walls were too close together in one area, and the design was easily changed before construction began.

Introduced as an aid to high-tech applications, virtual reality as an art form is thus far largely unexplored territory. The three-dimensional illusions created will exist in an entirely different environment than any solid works—there will be no acid rain to corrode the works, no snow loads, no fading of colors, no breakage potential, no problems with gravity.

CONFINED SPACE

Some three-dimensional pieces are developed within clearly defined boundaries. Within these boundaries, the artist controls not only filled areas but also the remaining unfilled areas.

In an installation piece, the artist attempts to incorporate an entire room of a gallery or museum into the aesthetic experience. The characteristics of the existing space must be dealt with in order to create a controlled environment with no elements that distract people from the intended experience. For instance, heating pipes and floor joists overhead may be busy visual distractions from the lines of a work, or they may be used creatively as places from which to hang things. Low ceilings may not allow enough visual room for the upward thrust of some pieces. High ceilings may create a space bigger than the work can

5.8 Joseph Cornell. *Suite de la Longitude.* 1955–57. Box construction of painted wood, papers, glass, marbles, cork, metal rings, ink wash, and pencil; 13¼ × 19¾ × 4⅜″ (34 × 50 × 11 cm). Hirshhorn Museum and Sculpture Garden, Smithsonian Institution. Gift of Joseph H. Hirshhorn, 1966. Photograph Lee Stalsworth.

control; a false ceiling or other visual barrier may be needed to stop the eye and shrink the space. Noise from adjacent areas may intrude on the mood the artist intends; some artists use sounds as part of an installation to cover background noise and/or to create the desired atmosphere.

In a relief work, the panel from which figures are raised defines the spatial world of the images. In Joseph Cornell's boxes, such as *Suite de la Longitude* (Fig. 5.8), the space with which the artist is working is confined within the dimensions of the glass-fronted box. The shadows on the back wall reveal how shallow this space is. Note that Cornell makes reference to further confinements within the box: marbles confined within glasses, like planets confined within their orbits, and orbitlike rings whose freedom of movement is limited by the rod from which they hang. Here the confinement of aesthetic space is a paradox, for we associate the images of globe and planet-like spheres with the vastness of outer space, yet everything is small-scale and contained. Cornell draws us in close by piquing our curiosity with what looks like old scientific writing; one discovers it to be French, so viewers with some knowledge of French may be held near to the work even longer as they try to understand the writing.

Instead of standing on the outside looking in as we do with Cornell's work, viewers may find themselves within the confined space of a work. Sometimes the artist's intent seems to be to emphasize the feeling of confinement, either physically or psychologically. Tony Smith's *Smoke* (Fig. 5.9) so monopolizes the space within the Corcoran Gallery of Art that it practically forces viewers to walk beneath its own bulk. Not only does it crowd onlookers; it also seems to be overpowering the delicacy of the gallery itself, pushing outward at its Grecian columns and upward into the space of the second-floor balcony.

How will those who walk through such a work respond? Our experience of being confined within a controlled space is highly

5.9 Tony Smith. *Smoke.* 1967. Plywood (to be made in steel in an edition of three), 24 × 34 × 48' (7.32 × 10.37 × 14.64 m). Photographed at the Corcoran Gallery of Art, Washington, D.C. Courtesy Paula Cooper Gallery, New York.

subjective. If we find ourselves sharing a space with an object we don't like, the space will feel too small, crowded, since we cannot put enough distance between ourselves and the object. Confinement within certain spaces may seem like welcome refuge, however. A place we love to come home to surrounds us with an intimate environment of our own choosing. Urban plazas are often designed to lure people into the shops opening onto them by suggesting a sense of enclosure, a friendly oasis set off from the disorder of city streets. Toronto's Nathan Phillips Square (Fig. 5.10) is "protected" by the twin towers of its City Hall, rising like cupped hands, and by the viewing platform surrounding the plaza on three sides, providing a band of shelter for those just stepping off the street or exiting from mass transit. The life-filled plaza is so popular that it is booked every day of the year for events ranging from drum-majorette demonstrations to rock concerts. The atrium within the Ford Founda-

5.10 Nathan Phillips Square, Toronto. Photo Peter Goodwin, Records and Archives, City Hall, Toronto.

5.11 Kevin Roche, John Dinkeloo & Associates. Interior, Ford Foundation Building, New York. 1967. Photo Ezra Stoller © Esto, Mamaroneck, New York.

tion Building (Fig. 5.11) is a restful change from the busy street scene outside. The contrast in environments when one steps down into this parklike space is dramatic—it is highly unlikely that one would perceive its confinement as unpleasant.

While our focus is directed inward in some spatially confined works, such as Cornell's box (Fig. 5.8), some works of this type invite us to compare the confined space with what surrounds it, to find either contrasts (as in the Ford Foundation atrium) or similarities, as in Eero

5.12 (top) Eero Saarinen. Interior *TWA Flight Center,* Kennedy International Airport, New York. 1962. Ezra Stoller © Esto. All rights reserved.

5.13 (right) Eero Saarinen. Exterior, *TWA Flight Center,* Kennedy International Airport, New York. 1962. Ezra Stoller © Esto. All rights reserved.

Saarinen's *TWA Flight Center* (Fig. 5.12). Designed to suggest the excitement of air travel, the building surrounds participants with soaring interior spaces shaped by concrete structures whose winglike appearance is even more evident in the outer form of the building (Fig. 5.13). The interior "confined" space refers us not only to the outside of the Flight Center but also to airplanes on runways beyond, in an extended comparison of inner and outer space.

SPATIAL RELATIONSHIPS

Another aspect of space with which the artist works is the spatial relationships between forms, between forms and the setting, and between the forms and the viewer.

Landscape designers and architects may work together to bring outdoor structures, walkways, and plantings into harmonious relationship with buildings and users of buildings, and both landscape design and architecture into spatial harmony with the greater environment. Andrea Blum's *Sunken Network System with Mirrored Arbor* (Fig. 5.14) is like a masonry park tying together masonry buildings for mixed-income housing. Terrazzo walking paths with dark-grouted intersection lines span the most likely diagonal walkways people might choose across the open space, repeating by their angles the angularity of the buildings.

5.14 Andrea Blum. *Sunken Network System with Mirrored Arbor.* 1990. Fillmore Center, San Francisco. Cast concrete, water, lights; 13,000 square feet × 18″ above grade and 18″ below grade. Photo Ben Blackwell.

5.15 Japanese garden. Courtesy *House and Garden Guide.* Copyright © 1968 by Conde Nast Publications, Inc.

Subtly distinguished by their different hue are darker concrete areas with benches for sitting, brick-encircled trees, and water-filled troughs that are illuminated from within at night. People's movements from one place to another are guided along the terrazzo paths, but not totally constrained by them. Blum declares of her public-space designs, "The more interaction you want, the less you impose. I want to open things up, to suggest one possibility among many."*

Architecture and interior design control passageways and viewing points by corridors, furniture placement, and openings in walls. Japanese gardens like the one shown in Figure 5.15 lure people to walk along winding paths, pausing at specified intervals to look at tableaux created from natural and manufactured forms. They do so by calculated placement of stepping stones, visual barriers and openings, and use of visual accents. When such designs are successful, we are not aware of being manipulated. Other gardens, such as the formal garden at Blenheim Palace (Fig. 5.16), allow continual appreciation of the entire panorama. Although the pathways control the way we can walk through the garden, the absence of visual obstructions allows us to gauge continually where we are in space in relationship to the whole garden, as well as to the vista beyond.

Space planning is often influenced by economic and political constraints. The increase in real estate costs in cities has led to construc-

* Andrea Blum, as quoted by Nancy Princenthal, "Elasticizing Urban Spaces," *Art in America,* April 1992, pp. 131, 136.

tion of taller and taller buildings on small plots of land, sometimes at considerable sacrifice to the quality of life perceived by the person on the street. Zoning requirements about setbacks have sought to ensure "sunrights," but overall planning of spatial relationships among buildings is often lacking. Architectural critic Paul Goldberger describes the kind of thinking necessary to create pleasing spatial relationships within urban settings:

> A city, physically, represents a kind of social contract. There must be a common agreement as to the way in which buildings work together, the kinds of uses to which they will be put and the physical form that they will take. . . . Light, a sense of space, quiet, visual variety, modest scale—we may not be able to quantify the effects of these things, but we can know that we can have no civilized city without them. They are disappearing fast. . . .

On a smaller scale, effective installation of three-dimensional works of art requires consideration of their spatial relationships to each other and to their setting. Their placement nearer or farther, to one side or the other, higher or lower, has a direct impact on how well pieces work. Museum curators find it more difficult to set up a show of three-

5.16 Blenheim Palace Park, Oxford, England. 18th century. Garden renovated in 1920s with landscapist Achille Duchene. Photo courtesy British Tourist Authority.

5.17 Erwin Hauer. *Project California Condor.* 1978–1983. Plastic laminate, 9 to 10' (2.75 to 3.05 m) wingtip to wingtip. Collection the artist.

dimensional works than of two-dimensional works like paintings, for if one three-dimensional piece is moved, it affects not only the things on either side but everything within the space. Since three-dimensional works interact with one another and with what is around them, many artists prefer to take on the time-consuming job of arranging their pieces themselves.

When Erwin Hauer displayed his condor sculptures at the Choate School (Fig. 5.17), he was careful to keep them all in the highest space available rather than under the mezzanine shown in the fore-ground, for these high-flying creatures of open spaces would have seemed crowded beneath the low ceiling. The condors are placed in varying relationships to one another and to the ground, each assuming a different pose, creating an impression of the movements of take-off and landing as one looks from one bird to the next. The space-embracing wings and pointing wingtips of the condors activate the areas around them; one can almost feel the air pressure created by motions of the heavy wings.

As the viewer moves through the space activated by the condors, the visual relationships of form to form and filled to unfilled spaces changes constantly. So does the viewer's spatial relationship to the forms. Seeing a sculpture of a condor at a distance is quite different

from a close encounter with one of these imposing birds, much less being surrounded by six of them. Life-size, the sculptures have wingspans of up to 10 feet (3.05 m). Some of Hauer's condors (though not those in this exhibit) are set on platforms that revolve very slowly, constantly changing the spatial relationships among the condors and between the viewer and the long wings.

The viewer's spatial relationship to objects within the three-dimensional field may be carefully controlled by the artist. In Hauer's placement of the condors, the inward-turned focus of the condors themselves and their placement to either side of a central corridor tend to compel the viewer to use this corridor as a path through the work.

SCALE

The effective use of space also involves consideration of *scale*—the size of an object in relationship to other objects and to its surroundings. We human beings tend to judge sizes relative to our own size and to the sizes we have learned to associate with the objects in our three-dimensional world. Some works may challenge our notion of our own size and importance in the three-dimensional field, however.

Some representational works are presented in life-size scale. Hauer's condors awe us with their realistically great size, perhaps making us feel smaller than usual because we are not accustomed to such large birds. When works offer realistic representation of humans in life-size scale (as in John DeAndrea's nude in Fig. 4.22), even without the distance of a wax-museum or display case barrier, we may feel strangely excluded from their spatial field since, being lifeless, they ignore us.

A work may be presented in miniature scale, either relative to human scale or to the scale of the actual object being represented. Miniatures often make us feel like giants. They are so much smaller than what we expect that we swell in relative size. Dollhouses make children feel very large, and grown up, for they can play at controlling the movements of figures within extremely scaled-down domestic settings. Historic dollhouses such as the Nuremberg Baby House of 1639 (Fig. 5.18) fascinate people of all ages, for unimaginable care has gone into the replicating of every detail from cradles and kitchen utensils to a birdcage and a household journal in tiny scale.

The largest end of the scale spectrum is *monumental works*. They may be nonobjective works so large in relation to human scale that they dwarf us, such as Stonehenge (Fig. 5.5), or larger-than-life representations of familiar objects. In the past, monumental sculptures conveyed the idea of the heroic grandeur of the human spirit. In Michelangelo's *David* (Fig. 4.21), a man preparing to slay a giant was himself represented as an 18-foot-tall giant. More recently, artists like Claes Oldenburg have elevated mundane objects from our everyday lives to monumental scale. Claes Oldenburg and Coosje van Bruggen's *Spoonbridge and Cherry* installed at Walker Art Center in Minneapolis (Fig. 5.19) is so large that the stem of the cherry alone is twelve feet high. People who are tempted

5.18 (right) Nuremberg Baby House of 1639. Germanisches Nationalmuseum, Nuremberg.

5.19 (below) Claes Oldenburg and Coosje van Bruggen. *Spoonbridge and Cherry.* 1985–88. Aluminum, stainless steel, paint, 29'6" × 51'6" × 13'6". Collection Walker Art Center, Minneapolis. Gift of Frederick R. Weisman in honor of his parents, William and Mary Weisman, 1988.

to climb on the "bridge" (despite a sign requesting them not to) take on the size of ants walking on a real spoon. It is possible to read into this kind of unexpected use of scale a political statement about the materialism of our times. But in this case, its intent is more playful than political, and water sprays from the cherry stem as a fountain.

SPATIAL ILLUSIONS

We are so accustomed to dealing with space in our three-dimensional world that we have learned to make certain assumptions about the spatial implications of what we see. For instance, if several identical objects are presented at varying distances from us, we see them as being different sizes but automatically override that visual impression with the mental assumption that they are probably all the same size. Artists can use these assumptions to advantage in situations that call for fooling the viewer about the size or relative distance of objects.

In Japanese gardens like the one shown in Figure 5.15, certain artistic conventions create the illusion of nature's peaceful spaciousness within what is actually a small space. This technique of spatial illusion was developed in response to Japan's dense population occupying a limited amount of land, most of which is mountainous and unsuitable for building. Within the walls of the small garden, one can experience a world of a different scale, in which rocks become mountains and areas of sand or water become the ocean. This reduction of scale is not just symbolic. Many illusionary devices are used to make the space appear larger than it is. For example, trees with relatively few leaves, such as white birches, are planted close to a house; viewing the garden through their open branches helps to push it back in space. Use of trees, screens, or boulders to obscure parts of the garden from immediate view also creates an illusion of depth, and the use of stepping stones of varied sizes winding around these barriers to discover new vistas makes paths appear longer and wider.

The art of stage design makes considerable use of spatial illusion, for the designer must often use the small actual space of the stage to create the impression of a much larger area. One illusionary device commonly used in stage design is *forced perspective*—the exaggeration of *linear perspective,* the apparent converging of parallel lines toward the horizon. In David Hockney's stage set for Act II of Mozart's *The Magic Flute* (Fig. 5.20), the columns and staircase sides appear to recede into a space far longer than the actual shallow space of the stage. At this point in the opera, the hero cannot speak to the heroine because he is undergoing initiation rites. She doesn't know this and instead thinks he is indifferent. "I feel as if it is a wound to my soul," she cries. Hockney's setting emphasizes her grief, as if the freedom of the open sky is far away and she is in the depths of despair. Space is not just a matter of visual tricks in set design; it can be used to present metaphors for the content of the play.

Hockney did not use another painterly device to exaggerate the illusion of spatial depth: *atmospheric perspective,* where areas represented

5.20 David Hockney. *A Great Hall.* 1977. Model from Metropolitan Opera production of Mozart's *The Magic Flute,* Act II. Photographs on cardboard, tissue, and wire; 16 × 21 × 12″. © David Hockney.

as being closer to the viewers are painted with sharper details, value contrasts, and color intensity than those that are to appear farther away through atmospheric haze. Instead of capitalizing on this natural optical phenomenon, he has painted the columns and sky in uniform colors, making them appear slightly surrealistic, as if the drama were the stuff of dreams.

In many works, the artist's use of space is thus a subtle vehicle for the content of the piece. Ideas or emotions may be expressed not only by creating metaphorical spatial illusions but also by developing delineated shapes in space, drawing attention to the interaction between forms and the surrounding area or to spatial relationships among forms, confining a form—or the viewer—within a defined space, or altering the scale of the familiar.

CHAPTER 6

LINE

We tend to identify line as a stroke on a two-dimensional page, yet line exists also in our three-dimensional world. Branches, grasses, late-afternoon shadows, icicles, telephone poles, cables, fences, waterways, and jet trails all appear as lines. In general, a *line* is an area whose length is considerably greater than its width.

In three-dimensional art, whole works may consist of lines. Lines also may appear within forms or even implied in space. Depending on their character, lines can steer our attention in a particular direction or perhaps help to convey the emotional effect the artist intended. To a certain extent, these experiences are subjective. The degree to which an area is seen as a line depends on the viewer's distance and awareness, and the emotional qualities ascribed to different kinds of lines may not affect everybody in exactly the same way. Nevertheless, line can be a powerful and direct tool in the hands of the artist.

LINEAR WORKS

Many everyday objects have a strong linear quality. In the Japanese gardener's scissors shown in Figure 6.1, the gracefully symmetric shear handles appear to be a single line turning back into itself, carrying the eye through its flowing curves. The design is actually quite functional, for it can be used equally well by right- or left-handed people and it concentrates the force of the hand-squeeze right where it is needed for nipping off tough plant stems.

Bare trees appear as series of lines in a landscape. Isolated, wooden boards or branches often have a linear effect, as do many things made from lumber and branches. In the Thonet Rocker (Fig. 6.2), wood has been bent into the vinelike curves of Art Nouveau lines. Arms, legs, and frame grow outward together like wild plants continually looking for something to cling to. The lines even terminate in vinelike tendrils curling back on themselves.

Fiber art has a naturally linear quality, since it is composed of threadlike materials assembled by a process such as weaving. Jesús Rafael Soto suspends nylon threads lengthwise, like the warp of a weaving without the crosswise woof. He also has painted them to create the illusion of a three-dimensional cube floating in the air (Fig. 6.3). Notice that where slight gaps occur between the threads, the unfilled spaces become *negative lines* of varying width. As you move around the piece, or it is moved by a slight wind, these spaces change and give a continually varying reading of the work.

Three-dimensional pieces made from linear materials like wire often retain a strongly linear quality. Alexander Calder's *The Brass Family* (Fig. 6.4) uses line almost as a two-dimensional drawing does—as outlines wherein we obligingly fill in full-bodied three-dimensional figures with our imagination.

The linear nature of the human figure seen from a distance is often called into play by choreographers, who turn dancers into moving linear sculptures. In *Ciona* by Pilobolus Dance Theater (Fig. 6.5), the

6.1 Gardener's secateurs. Japan. Photo Yasuhiro Ishimoto.

6.2 Gebrüder Thonet, company design. Rocking chair. c. 1860. Beechwood, cane, 37⅝" high, 22¾" wide, 42½" deep; seat height 17¼". Manufacturer: Gebrüder Thonet, Vienna, Austria. The Museum of Modern Art, New York. Gift of Café Nicholson.

6.3 (left) Jesus Rafael Soto. *Cubo Virtual.* 1988. Nylon with acrylic, 12 × 4 × 4″. Exhibition at Humphrey Gallery, May 1990.

6.4 (right) Alexander Calder. *The Brass Family.* 1927. Brass wire and painted wood, height 66³/₈″ (168.6 cm), width 40″ (101.6 cm), depth 8″ (20.3 cm). Collection Whitney Museum of American Art, New York. Gift of the artist.

6.5 Pilobolus Dance Theater. *Ciona.* Photo Tim Matson, Thetford Center, Vermont.

organic lines suggested by the dancers' variously joined bodies are accentuated by high-contrast lighting that makes the figures thinner and less recognizable as individual human forms. The difference made by the high-contrast lighting can be appreciated by its absence in the group shot at upper left; here the bodies look more like muscular human forms and less like linear constructions.

Sculptor Alberto Giacometti elongates the human body into a single thin line in this *Tall Figure* (Fig. 6.6). From any distance and in any light, this figure's proportions—80 inches (20.32 cm) in height contrasted to only 5 inches (12.7 cm) at its greatest width—will look like a line isolated in space. Indeed, it affects us with a poignant sense of loneliness—of unhappy withdrawal from the other denizens of this planet; the lonely figure even seems to be drawing away vertically from the horizontal surface of the planet itself.

Our distance from certain works plays a big part in whether we perceive them as linear. Seen from the ground, a street looks like a wide slab; from the air, we can see its length in relationship to its width and thus recognize its linear quality. From a distance, Eero Saarinen's *Jefferson National Expansion Memorial* (Fig. 6.7) in St. Louis thrusts a line high into the sky. But seen from its base, it is a massive form, an arch 630 feet (192.15 m) high with legs broad enough to carry forty people at a time in a lift up to the observation room at the top. Robert Smithson's *Spiral Jetty* (Fig. 6.8) does not reveal its spiraling line until one is far enough away to get the sort of perspective shown in the photograph. Many such *earthworks*—large-scale, three-dimensional projects involv-

6.6 Alberto Giacometti. *Tall Figure.* 1947. Bronze, 80 × 6 × 5" (203 × 15 × 13 cm). Hirshhorn Museum and Sculpture Garden, Smithsonian Institution. Gift of Joseph H. Hirshhorn, 1966.

6.7 Eero Saarinen. *Jefferson National Expansion Memorial (Gateway Arch),* St. Louis. 1966. Courtesy St. Louis Convention & Visitors Commission.

6.8 Robert Smithson. *Spiral Jetty.* 1970. Black rock, salt crystals, earth, red water (algae); coil 1500' (477 m) long, approximately 15' (4.6 m) wide. Great Salt Lake, Utah. Photo Gianfranco Gorgoni, courtesy John Weber Gallery, New York.

ing physical alterations of the earth's surface for aesthetic purposes—are designed to create a monumental line across the landscape.

LINES WITHIN FORMS

In addition to being used in primarily linear works, lines also commonly appear within forms. Sometimes lines are simply applied to the surface. Maija Grotel applied clay slips to the surface of her vase shown in Figure 6.9 to create a pattern of diagonal lines thrusting up in one direction and then the other. These diagonal thrusts are emphasized by the strong shadows formed beneath them, for they rise from the surface as a low relief. A softer counterpoint to these lines is not so immediately apparent: Horizontal lines encircling the piece reveal the potter's hands at work pulling the vase up from the initial lump of clay on the wheel. Instead of smoothing them Grotel has subtly emphasized them as a secondary voice in the composition.

6.9 Maija Grotel. Ceramic stoneware vase. 1947. 20 × 9½". Collection Cranbrook Academy of Art Museum. Photo courtesy Maija Grotel Research Fund.

6.11 Lynda Benglis. *Tasco (Diablo II).* 1991. Aluminum on stainless-steel mesh, 62 × 97 × 37". Courtesy Paula Cooper Gallery, New York.

6.10 Etienne Hajdu. *Adolescence.* 1957. Marble, 35½ × 11⅞ × 2¼" (90 × 30 × 6 cm). Hirshhorn Museum and Sculpture Garden, Smithsonian Institution. Gift of Joseph H. Hirshhorn, 1966.

In some cases, the lines naturally appearing in the material are revealed and used aesthetically. The grain of wood often adds linear patterns to a work. In sculpting *Adolescence* (Fig. 6.10), Etienne Hajdu used the fissures within the marble to suggest growth and change. The dark lines are almost like an X-ray view of the circulatory system carrying the hormones that activate the changes of puberty. The organic quality of these lines presents a lively contrast to the more formally controlled outer contours of the figure.

Lines are often created by *edges*—by the lines along which two planes or pieces of material meet—as well as by the distinction between the outer contours or *outlines* of a piece and its surroundings. When people say that a piece has "nice lines," they are usually talking about its edges. What allows us to see edges as lines is differences in *value*—in relative lightness and darkness. In carved sculptures, deep undercuts create shadows that define the edges bordering them. In Lynda Benglis's *Tasco (Diablo II)* (Fig. 6.11), the edges where the aluminum pleats reach their farthest extension become thin lines that catch the light in a different way than the reflective surfaces of the inner pleats. Another series of lines develops in the shadowed crevices where two sections of this fantastic winged form push together.

IMPLIED AND DIRECTIONAL LINES

Certain lines are not physically present in a work but can nevertheless be subtly perceived. These *implied lines* may appear as *eye lines* between figures or between a figure and something at which it is gazing. In the ancient bronze *Thorn Puller* (Fig. 6.12) we can perceive a strong eye line

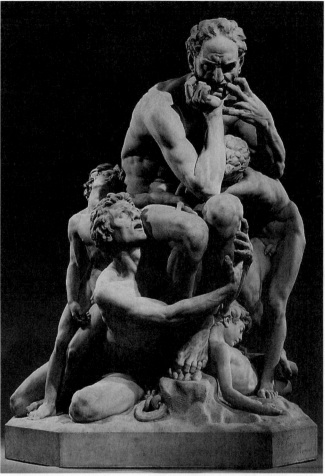

between the boy's eyes and the bottom of his foot where the offending thorn must be.

We may also perceive implied lines as continuations or completions of lines given in a work. The sculptural group *Ugolino and His Sons* (Fig. 6.13) contains a very dramatic eye line from the largest son to his father. But the entire composition is built upon a series of lines formed by arms and legs that tend to flow together into larger implied lines. For instance, the forward arm of the largest son leads the viewer's eye up to the father's knee and back across the father's other thigh and down through the son's neck. Alternate visual paths might be traced from the largest son's arm up through the father's knee to the elbow resting on it, up the forearm to the head, or up the upper arm, around the shoulders, and down the opposite arm to the outer leg of the son on the right and thence down into the arm of the smallest child at the bottom, which leads the eye back up into the center. Seen this way, the group becomes a swirl of implied lines leading from one anguished figure to another and tying them all together visually.

Lines may have a strong *directional* quality—the characteristic of pointing the viewer's eye in a certain direction, sometimes creating

6.12 (left) *Thorn Puller (Spinario).* Bronze, height 28³/₄″ (73 cm). Capitoline Museum, Rome. Photo Alinari/ Art Resource, New York.

6.13 (right) Jean-Baptiste Carpeaux. *Ugolino and His Sons.* After a model completed in Rome 1860–61. Marble, 6′5″ (1.95 m) high. ³/₄ view from left. The Metropolitan Museum of Art, New York. Purchase, The Josephine Bay Paul and C. Michael Paul Foundation, Inc. and the Charles Ulrick and Josephine Bay Foundation, Inc. gifts and Fletcher Fund, 1967.

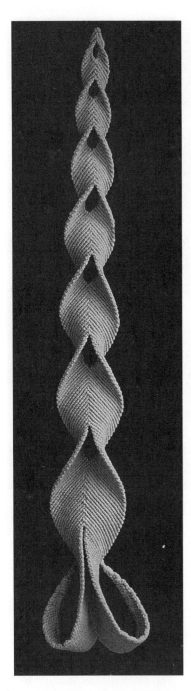

6.14 Joan Michaels Paque. *Moebius Extension.* 1977. Knotted and woven synthetic fiber, approximately 8′ (2.44 m) long. Collection Dr. and Mrs. Robert Monk, Waukesha, Wisconsin.

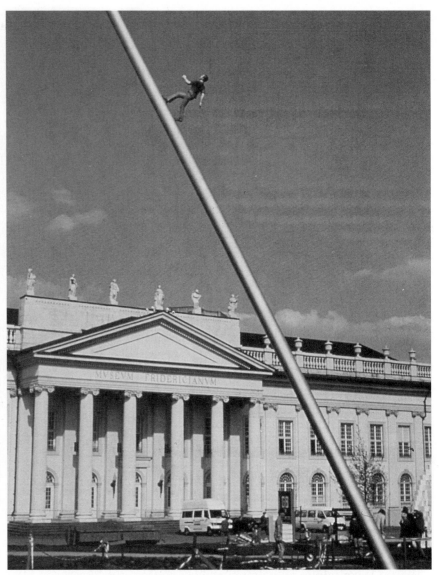

6.15 Jonathan Borofsky. *Man Walking to the Sky.* 1992. Fiberglass, aluminum, painted steel, 73′9″ high. Installed in front of the Fridericianum Museum, Kassel, Germany. Collection City of Kassel. Photo Laurent Lecat, courtesy Paula Cooper Gallery, New York.

implied lines thereby. Joan Michaels Paque's *Moebius Extension* (Fig. 6.14) draws together the edges of the woven forms as pointers, each leading the eye to the next point above. If you follow these directions from bottom to top, a perceptual line is being created up the center of the piece that strengthens and completes the faint line that repeatedly appears where the weaving patterns join along the midline and then disappears into the shadows.

In Chapter 5, we noted that space may be activated by implied lines that direct the eye into unfilled space surrounding a three-dimen-

6.16 Nancy Holt. *Sun Tunnels.* 1973–76. The Great Basin Desert, Utah. Concrete pipes, 22 tons each; tunnel lengths 18' (5.49 m), height 9'2¹/₂" (2.8 m), total length 86' (26.23 m). The tunnels are aligned with the sun on the horizon (sunrises and sunsets) on the solstices. Photo John Weber Gallery, New York.

sional piece. In *N Lines Vertical* (Fig. 5.4), for instance, the lines given point the eye into the distance beyond. This effect is even more obvious in Jonathan Borofsky's *Man Walking to the Sky* (Fig. 6.15). Not only is the diagonal pole itself a pointing line, but the man walking on it also directs our eye along the line and into its projected but invisible projectory in the sky. He strides so swiftly and earnestly that we read quickly to the end of the pole and wonder: What will happen when he gets to the end of it? Why and how is he walking on a steeply diagonal pole? What conclusion might we draw here about the direction, meaning, and endpoint of our own fast lives? Or, if we think about the mechanics of the piece, we can see that even a line may have great weight. We must inevitably wonder how the piece is anchored and counterbalanced to support the weight of the pole over time.

Awareness of directional and implied lines makes it possible to see Nancy Holt's *Sun Tunnels* (Fig. 6.16) as being "about" lines. For one thing, the sun's rays pierce the holes in the concrete pipes, forming lines of sunlight into the pipes themselves. If you were to look through one of the pipes, you would see a defined line into the surrounding landscape—directed "tunnel vision." Furthermore, the pipes are placed to honor the sunrises and sunsets during the solstices in this Lincoln, Utah, setting. At dawn and dusk on the days marking the height of winter and summer, the sun itself beams directly into one of the tunnels, creating a line of pure light.

QUALITIES OF LINES

Individual artists' use of line is highly varied, as is the background each viewer brings to perception of a work of art. Nevertheless, art does touch us emotionally in ways that are somewhat predictable. Linear elements in works tend to evoke certain responses, depending on the characteristics of the lines.

6.17 Michael Heizer. *Isolated Mass/Circumflex.* 1968 (deteriorated). #9 of Nine Nevada Depressions. Massacre Dry Creek Lake, Vya, Nevada. Six-ton displacement in playa surface, 120′ × 12′ × 1′. Commissioned by Robert Scull.

Our eye tends to move very quickly over simple, smooth lines like those of *Man Walking to the Sky;* we scan or *read* complex lines like those of *Ugolino and His Sons* (Fig. 6.13) or rough edges like those of Giacometti's *Tall Figure* (Fig. 6.6) more slowly. These natural tendencies lead us to think of lines themselves as being "quick" or "slow," no matter with what speed they were actually made. Michael Heizer's earthwork *Isolated Mass/Circumflex* (Fig. 6.17) appears from a distance to be such a smooth and simple line that it seems a quick gesture. This impression belies the work involved in its creation, for it is actually a trench dug across 120 feet (36.6 m) of Nevada desert.

Rough or jagged lines or lines that go in many different directions convey a feeling of emotional upheaval. The ragged lines of the marble fissures and head area in Hajdu's *Adolescence* (Fig. 6.10) suggest an emotional turbulence that contrasts with the smooth outlines of the torso.

Curving lines remind us of flowing motion. Single lines that curve, perhaps flaring and thinning as they round corners, may evoke

a poignant sense of beauty, even in so mundane an object as the Japanese gardener's shears (Fig. 6.1), for they tend to mold our awareness itself into a flowing line. No matter how brief the experience, it may be a welcome change from the scattered, frenetic pace of modern life.

The use of many curving lines, as in Antoni Gaudí's *Casa Milá* Apartment House (Fig. 6.18), may evoke a sense of romance or playfulness. We usually associate living quarters with straight horizontal and vertical lines, so this building's many curves—in and out, up and down—are a whimsical surprise to the imagination.

Horizontal lines often carry a restful, secure feeling, perhaps through association with the earth's horizon line and our horizontal position when sleeping. The straight horizontal lines that predominate in David Rockefeller's office in the Chase Manhattan Bank (Fig. 6.19)

6.18 Antoni Gaudi. *Casa Milá* Apartment House, Barcelona. 1905–07. Photo MAS, Barcelona.

6.19 CMP Interiors. Office of David Rockefeller. 17th floor, One Chase Manhattan Plaza, New York. 1961. Photo Alexandre Georges/Chase Manhattan Archives, New York.

convey an elegant sense of calmness. Even the chairs are squared off and low to the ground, adding to the feeling of stability. The message is that one can rest assured this bank is solid, trustworthy, and comfortable with wealth.

Lines that are predominantly vertical do not convey this feeling of stability unless they are anchored in strong horizontal lines. Rather, they suggest defiance of or escape from the earth's gravitational pull. Strong verticals such as the supporting pillars inside a high-ceilinged cathedral or the exterior lines of Gaudi's Church of the Sagrada Familia (Fig. 3.21) are designed to give worshipers a sense of being spiritually uplifted above dense worldly concerns.

Diagonal lines invoke feelings of drama or energy. David Hammons's linear installation (Fig. 6.20) is charged with nervous energy. Not only are there many thin diagonal lines, all seemingly in motion, but they are broken also by tufts of human hair and popcorn—and occasionally eggshells. For all the delicacy of the materials, there is an extremely active intensity in the multiplicity of diagonal broken lines.

Combining different kinds of lines is like composing music for a whole orchestra. If the sounds of different instruments are not blended harmoniously, the result is cacophony. The artist may intentionally produce this visual chaos. But in Toshio Odate's *Pride of New England* (Fig. 6.21), differing line qualities are blended into a unified whole that both draws the viewer's attention and issues an invitation to quiet contemplation. Trained as a Japanese *shoji* screen maker, Odate uses line to create three kinds of space-defining screens in this piece: the

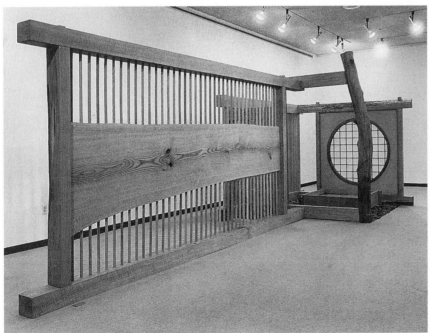

6.20 (above) David Hammons. *Untitled.* 1981. Recreated at P.S. 1, 1990. Human hair, rubber bands, popcorn, eggs, and wire. Photo Dawoud Bey, courtesy Jack Tilton Gallery.

6.21 (left) Toshio Odate. *Pride of New England.* 1982. Red oak plank, 18' (5.49 m) long, 3'6" (1.07 m) wide.

long section featuring a handsome 18-foot (5.49 m) slab of red oak, a section of vertical slats (that barely can be seen beyond and to the right of the slab in this photograph), and an opaque panel featuring a translucent rice paper circle with wooden lattice. The slab of oak becomes a directional line leading to the circle panel and the low box set among rounded stones before it that suggests a place for seated meditation. Along the oak slab, the vertical dowels and the negative lines formed by the spaces between them are small enough to emphasize the horizontal by contrast, rather than fighting with it for dominance. The horizontals and verticals are repeated in the panels and framework at the far end. And the subtle curve of the oak slab is repeated in the circular line around the rice paper, the roundness of the stones, and again in the curve of the natural tree trunk. Lines in nature are rarely perfectly straight, but through balanced use of repetition and contrast, Odate unifies the straight lines of manufactured lumber with the curving lines of organic forms.

CHAPTER 7

TEXTURE

The *texture* of a work is the surface characteristics we could feel if we touched it—its hardness, softness, bumpiness, smoothness, sharpness, furriness, or whatever. Our interest in these tactile qualities is part of what draws us into exploring a piece. When we cannot or do not touch an object, impressions of what it would feel like are conveyed to us visually. As we will discover, our eye can be fooled about texture. Artists may therefore work with *visual texture*—the apparent, rather than actual texture of a surface.

The textural characteristics of a work may not be the first thing we notice. We tend to scan a three-dimensional object quickly with our eyes, streamlining its contours, and then perhaps coming in closer to see what it is made of and how. We see distant hills as having smoothly rolling outlines; we do not notice the differences in height and form of individual trees that reveal a jagged textural effect when examined more closely. In certain works of art, however, we are not given a chance to ignore the texture. Louise Nevelson's *First Personage* (Fig. 7.1) demands our immediate attention to the contrasting surfaces of the two pieces of wood. Our eye registers at once what the surfaces would feel like if

we touched them—the torso-like right side would be relatively soft to the touch, while the "back" side warns us not to put a hand near its sharp points. This strong contrast between the invitation of the soft contours and the KEEP AWAY signals of the back points seems to be the subject of the piece, a visual puzzle for us to explore and ponder.

Almost all works of three-dimensional art have an actual surface texture that can be felt. Those we will examine in this chapter tend to make the viewer extremely aware of their textural effects. Although texture cannot be isolated from other elements of design, such as color, form, or line, much attention may be drawn to the natural texture of materials, worked textures, or visual textures that differ from the actual textures of the piece.

NATURAL TEXTURE

Artists often find it suits their purposes to use materials exactly as they come from nature. An extreme example of this approach is Walter De Maria's *New York Earth Room* (Fig. 7.2), which is just what it says: a room filled with dirt. The artist has placed a glass partition in the doorway of the museum to hold the dirt in and to allow people to see the depth of the dirt layer. The interest of this conceptual piece lies in seeing so much of a decidedly organic material in an urban setting (how did he cart it all into this museum?), and in contrasting the soft, granular texture of the dirt with the hard, smooth texture of the walls. In addition

7.1 (above) Louise Nevelson. *First Personage.* 1956. Wood sculpture, height 94″ (2.38 m). Brooklyn Museum. Gift of Mr. and Mrs. Nathan Berliawsky, 57.23A-B.

7.2 (right) Walter De Maria. *New York Earth Room.* 1977. New York. 250 cubic yards (191 cubic meters) of earth and earth mix (peat and bark) weighing 280,000 pounds (127,000 kg), covering an area of 3,600 square feet (335 square meters) of floor space to a depth of 22″ (56 cm). Installation commissioned and maintained for visitors at 141 Wooster Street, New York, by Dia Center for the Arts. Photo John Cliett © Dia Center for the Arts.

to textural contrasts, the room and the dirt within it differ considerably in color and also in smell, an element of design that usually receives relatively little attention. The piece offers no judgments about the worth of texture, smell, or color—it just presents the contrasts to the viewer's awareness, using such large amounts of dirt and wall that they cannot escape notice.

Sometimes natural textures are used not to call attention to their own identity but rather to refer to other similar textures. The Hawaiian artisan who created the ritual figure shown in Figure 7.3, conveyed the texture and color of human skin by using feathers, human teeth with dogs' teeth. The wet, shimmering surface of the human eye is captured with pearl shells. Usually we must be familiar with the texture of both the natural material being used and the texture it is representing to appreciate such pieces fully. But how familiar are we with what the surface of the eye feels like? We dare not touch this sensitive surface; we know its texture more by what it looks like than by how it is perceived through the touch sensors in the fingers.

Many textures that we consider natural have already been worked to a certain extent. We think of rough-sawn wood as a natural surface, but it is already a step removed from the initial bark surface of its origin: the tree. In her site-specific piece, *Split Tongue Pier* (Fig. 7.4), Jody Pinto draws our attention both to the flat machine-cut surface of

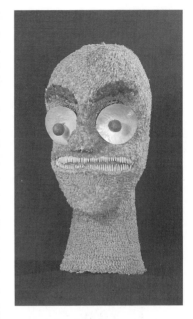

7.3 (above) *Image.* Feathers, wicker, dog teeth, pearl shell, wood; height 24½" (62 cm). Museum fur Volkerkunde, Vienna. Collected on Captain Cook's third Hawaiian voyage, 1778–79.

7.4 (left) Jody Pinto. *Split Tongue Pier.* 1980. Temporary sculpture project for Swarthmore College campus, Pennsylvania. Rough spruce and pine, 48' (14.64 m) long × 2' (0.61 m) wide. Photo Drew Vaden, Hal Bromm Gallery, New York.

7.5 Sheila Hicks. *Ephemera Bundle.* 1975. Silk, 20.2 × 20.2 × 7.6 cm. © The Cleveland Museum of Art. Gift of Mildred Constantine, 92.250.

the rough spruce and pine used in the pier jutting out over a gorge and to the natural textures of the trees in the environment. Both register in our mind as WOOD. Their textures are so closely related that the pier seems at one with the trees, rocks, bushes, grasses, and dirt of the natural environment. And yet their textures are different enough that the contrast is of aesthetic interest. If the pier had been made with whole tree trunks, the effect would have been quite different.

Certain pieces seem to offer a single natural texture for our exploration, yet a subtle form of contrast or variation is often present to engage our awareness. Sheila Hicks's *Ephemera Bundle* (Fig. 7.5) appears at first glance to be a tangle of soft, curly silk yarns. Yet closer inspection reveals continual variations among tautly spun linear strands, loosely spun curly strands, thinly straying single fibers, and even bits of coarsely woven cloth. We even have the impression of interior texture here—the suggestion that there are layers upon hidden layers of these textures wrapped around each other from the core outward.

WORKED TEXTURE

The surface of a material may be manipulated, or worked, by the artist to create a great variety of textural effects. Materials may be carved, blasted, polished, ground, hammered, built up, or woven together for a number of different reasons. Perhaps the most obvious of these are to shape the material to the desired form and to simulate the texture of an actual three-dimensional object. To create a portrait of Georgia O'Keeffe (Fig. 7.6), Marisol uses the natural texture of weathered wood and rock to convey the qualities of solidity and strength that we associate with these materials; the actual head of a stuffed antelope emphasizes the message that this grande dame of American painting was very much at home among the creatures and landscape of the Southwestern desert.

Yet to make the portrait more recognizable as Georgia O'Keeffe, Marisol has carved a likeness of her wise, discerning face into the wood. The textural lines created by the chipping away of the wood become character lines that further describe her venerable subject.

Even in nonobjective works, textural manipulation may be used not only to shape form but also to emphasize it. In *Helixikos #1* (Fig. 7.7), Hans Hokanson makes us very much aware of the chiseled grooves seemingly used to carve the spiraling open form out of a more solid

7.6 Marisol. *Portrait of Georgia O'Keeffe with Antelope.* 1980. Wood, stone, plaster, charcoal; 55 × 55 × 42½". Courtesy Sidney Janis Gallery, New York.

7.7 Hans Hokanson. *Helixikos #1.* 1968. Natural wood, elm, wax; length 23" (58 cm), width 40" (102 cm), depth 24" (61 cm). Collection the artist. Photo Peter Moore/ Grace Borgenicht Gallery, New York.

block of wood. We would like to trace these grooves with our fingers; as our eye follows this intention by moving forward across the figure, the chisel lines lead us in the direction the double spiral seems to be moving, thus enhancing the sensation of movement.

Rather than emphasizing form, texture sometimes may be used to deny it. From a distance, Ursula von Rydingsvard's *Land Rollers* appears as a series of 14-foot-long cedar logs on the edge of a hill (Fig. 7-8). But as one comes closer, deep gashes slashed and chiseled into the wood draw attention away from the whole forms and into their scarified surfaces. They seem worn by time and circumstance—scarred by painful wounds, which they nonetheless withstand, just as von Rydingsvard and her family survived eight years in forced-labor camps in Germany.

Textures may also be manipulated to provide contrasts, either within a work or between the work and its surroundings. In *Jaguar Woman* (Fig. 7.9), Isabel Case Borgatta works with the contrast between

the smoothness of stone when it is sculpted and polished to look like soft facial skin, and the roughness we more usually associate with stone here used for the fabric and jaguar. Deep pits give the optical impression of spots; this texture also bestows an abstract sense of strength and wildness upon the beast, who is thought to carry great spiritual power.

Some works invite us to compare the textures of a work and its setting. What could be a greater contrast to the hard, rectangular, masonry surfaces of a city than the waving stalks and heads of a wheat field? Think of walking in the field shown in Figure 7.10, feeling it brush against your skin, hearing the swish of the green leaves or the rasp of the ripe heads. The incongruity of such experiences in the midst of congested Manhattan allowed Agnes Denes to make a social and environmental point: "to call people's attention to having to rethink their priorities."*

Surfaces may be worked to create a surface that is aesthetically pleasing. Marble and wood sculptures that are extremely smooth invite us to caress them with hand and eye, enjoying the sensual flow of the contours. When metal is smooth and highly polished, this manipulation

7.10 Agnes Denes in her wheat field in Battery Park landfill. 1982. Photo John McGrail, *Time* Magazine.

* Agnes Denes, as quoted by Robin Cembalest, "The Ecological Art Explosion," *ARTnews,* Summer 1991, p. 101.

7.11 Ernest Trova. *Study: Falling Man (Carman).* 1965. Polished silicone bronze and enamel, 4′8¼″ × 6′6″ × 2′8¾″ (1.44 × 1.98 × 0.83 m). Hirshhorn Museum and Sculpture Garden, Smithsonian Institution. Gift of Joseph H. Hirshhorn, 1972.

7.12 Mbwaka woman with scarification on her back. North-central Zaire. Photo Casimi d'Ostoja Zagourski, 1926. Zagourski Collection, Eliot Elisofon Photographic Archives, National Museum of African Art, Smithsonian Institution.

of the material also gives it an extremely reflective quality. The highly polished silicone bronze surface of Ernest Trova's *Study: Falling Man (Carman)* (Fig. 7.11) offers a gleaming accent to the contours of the human form and picks up reflections of whatever is near the piece, adding to its visual interest. The shiny, slick surface also contributes to the illusion of speed—a visual image of man not only as a car, but a very fast car. Our eye would move more slowly across a rough surface, and we would tend to ascribe this slowness to the object itself: We would not expect a rusty car to move very fast.

The manipulation of the surface of an object to enhance its beauty is intimately bound to cultural and historical definitions of beauty. Our culture tends to value soft but smooth skin, with surface ornamentation confined to clothes, jewelry, cosmetics, and textural manipulation of the hair. But some peoples have preferred raised textural effects in the skin itself, as in the body scarification shown in Figure 7.12. The complex details of such body sculpture may be emphasized by the use of oils and cosmetics. Those who have learned to cherish the smooth skin of youth may have a negative reaction to this form of body art. We can easily imagine what it would feel like to run a hand across these raised textures—or to endure the initial pain of the scarification process—and our immediate reaction may not be a pleasant one. It may be difficult for us to appreciate the point of view of those who consider this worked texture beautiful on a human body or who take pride in being thus adorned. In addition to the fact that beauty is in the eye of the beholder, not all art intends to be beautiful. Though the love of beauty is often a motivating factor, many artists are motivated by the quest for a public or a private truth.

Finally, textures may be worked to create a paradoxically natural effect. The many intricate textures of Norma Minkowitz's *Inner Rhythms*

(Fig. 7.13) flow across the cape like organic forms. Yet they are the result of extremely detailed crochet work that totally alters the straight nature of the single fibers used. Minkowitz explains that in her wearable art she works with fiber to create lines reminiscent of fine pen and ink drawings: "I like to work with fiber as if I were sketching in pen and ink. The pieces become like imaginary landscapes."

Frank Stella has used industrial metals to suggest textures that are decidedly organic, like colonies of creatures growing on something that has fallen into the sea. *Zimming,* shown in Figure 7.14, is an abstract work. No actual living creatures are portrayed, yet the effect of organic life is so strong that we could imagine coming back to see the piece later and finding that it has moved and changed, perhaps even bringing new forms into view.

7.13 (left) Norma Minkowitz. *Inner Rhythms.* 1980. Fiber (cotton), 32 × 29″ (81 × 74 cm). Collection Christine Carter. Photo Bob Hanson.

7.14 (right) Frank Stella. *Zimming.* 1992. Stainless steel, bronze, and aluminum; 16 × 13 × 12″. Photo Steve Sloman/ Knoedler & Company.

VISUAL TEXTURE

As we noted earlier, many works present an optically perceived *visual texture* that does not correspond with the actual texture of the material. A familiar example is the carving of stone to look like softer textures. As shown in Plate 5 of the color section, Charles Henry Joseph Cordier has beautifully captured the textures of skin in cast bronze and draping fabric in sculpted jasper. The skin looks realistically supple and the fabric as if it would move when touched. Of course if you *were* to touch the bust, your hand would register a different tactile sensation than what

your eyes perceived. You would feel the cool hardness of jasper and bronze. The perceptual effect depends not only on the sculptor's skill but also on a historical tradition of portraying transient moments and materials in the enduring media of stone and metal. They have been used for human portraits for so long that we have learned to associate these materials with soft visual textures.

Visual textures may be used not only to capture the likeness of soft objects in more permanent form but also for other reasons. Sometimes the optical illusions are designed to amaze the viewer with their clever simulation of actual textures. The success of Marilyn Levine's *Two-Toned Golf Bag* (Fig. 7.15) depends on its perfect replication in stoneware of the textures of worn leather and metal fittings. At this extreme, visual textures become *trompe l'oeil* (prononunced "tromp loy"), or "fool the eye" imagery.

Another way in which visual textures have been used is to make objects more visually pleasing or acceptable. Early in the Industrial

7.15 (above) Marilyn Levine. *Two-Toned Golf Bag.* 1980. Stoneware with nylon reinforcement, 35 × 10½ × 7" (89 × 27 × 18 cm). O.K. Harris Works of Art, New York.

7.16 (right) Rose Engine Lathe. German, c. 1750. Science Museum, London. British Crown Copyright.

7.17 David Smith. *XI Books III Apples.* 1959. Stainless steel, 94 × 35 × 16¹/₄". Storm King Art Center, Mountainville, New York. Gift of the Ralph E. Ogden Foundation, 1967.3. Photo Jerry L. Thompson.

Revolution, many people preferred the ornate hand-wrought styles with which they were familiar to the simpler lines more natural to machine-made products. Attempts to satisfy the older aesthetic led to creations such as the German Rose Engine Lathe shown in Figure 7.16. Its elaborate, vinelike visual texture is designed to camouflage the presumed ugliness of its function as a machine. Indeed, it appears almost too fragile to stand up under the stress of continual motion.

Visual textures are not necessarily an attempt to fool the eye, however. In some cases, they grow out of the complexities of reality. David Smith scoured the steel surfaces of *XI Books III Apples* (Fig. 7.17) to create interesting light-reflecting patterns which happen to have the optical softness of velvet, a nice contrast to the hardness and the hard edges of the steel forms. It is interesting that Smith himself used textural metaphors to describe the creative impetus of the artist. He wrote, "I know now that sculpture is made from rough externals by rough characters or men who have passed through all polish and are back to the rough again." In a sense, art grows out of the textural qualities of the artist's life—the polishing and grinding and reworking, the soft places and the hard, the affinity for nature or for the accretions of civilization, the love of the beautiful surface and the scratching beneath the surface to reveal what lies within.

CHAPTER 8

LIGHT

Light is a rather subtle element of design but nonetheless a very dramatic tool when used consciously. In three-dimensional design, light develops a range of values as it falls across a piece, creating highlights, shaded areas, and shadows stretching beyond the work. These effects will vary considerably depending on the angle and intensity of the light source and whether the lighting is natural or artificial. The effects of light on a piece will also depend on its surface texture and the degree to which its surfaces curve away from the light.

In addition to using the light cast upon a piece as a design element, artists may incorporate reflections into their work. Light itself may even be the medium with which the artist is working.

VALUE

The light reflected from a surface determines its color. Color is such a rich element of design that we will devote the entire next chapter to it. *Value,* or degrees of lightness and darkness, is a characteristic of color.

8.1 Gaston Lachaise. *Standing Woman.* 1932. Bronze (cast 1932), 7'4" × 3'5⅛" × 1'7⅛". The Museum of Modern Art, New York. Mrs. Simon Guggenheim Fund.

If you look around you, you can see that surfaces seem to change in color as they curve away from a light source. A wood desk might appear yellow on top where it catches the light and dark brown on sides away from the light. These differences are actually changes in value: Brown is a dark value of the hue we call yellow. It is useful to separate value from the other characteristics of color we will be studying in the next chapter, for value has a number of specific functions in three-dimensional art.

To study values, we observe the darkness or lightness of areas in relation to each other. It is easy to see value differences in black-and-white photographs, for they reduce color differences to a range of values from black through grays to white. In real life, we tend to assign objects a global color label, thus ignoring the actual differences that can be perceived in various areas of their surfaces. If you saw Gaston Lachaise's *Standing Woman* (Fig. 8.1) in the Museum of Modern Art, you might mentally label its color as bronze and thereby overlook the fact that its

8.2 10-step gray scale.

polished surface reflects light as near-white highlights and then develops darker values ranging to near-black in areas where light is blocked. The underside of the chin, for instance, is in deep shadow because the protrusion of the face prevents the overhead lighting from reaching this area. The *highlights*—brilliantly lit areas that appear as luminous spots—occur in areas that receive the most direct illumination.

Gradations in value from black to white can be talked about in terms of a *gray scale,* such as the one shown in Figure 8.2. Here, the range from black to white is represented as ten equal steps. In reality, the range of values is almost infinite; many slight changes in value could occur between each of the ten steps shown. Values nearer the white end of the gray scale are assigned higher numbers. On a ten-step gray scale, white is 10 and black is 1. Since we perceive values in relationship to what lies around them, the gray scale is often shown with middle gray circles to illustrate how our perception of this mid-gray changes depending on its surroundings. It appears far darker on the high end of the scale in juxtaposition to white, and far lighter in juxtaposition to black, but it is, despite these appearances, in reality the same value throughout.

Although we may be only subconsciously aware of values, artists use them consciously for a variety of purposes. One function of value is to provide clues to three-dimensional form. From our experiences in the three-dimensional world, we have learned to associate gradual value shifts with rounded surfaces. Value changes are far more abrupt across sharply angled surfaces, for they juxtapose areas that catch the light and areas in which illumination is blocked. In the *Standing Woman,* the slowly changing range of gray values across the thighs helps us to perceive their full roundness; the sharper curve of the breasts away from the overhead light is indicated by the much more rapid transition from high values to low values. These areas of high-value contrast created by exaggerating the curves of a muscular female figure add dramatic emphasis to the contours of the piece.

In addition to emphasizing forms, value contrasts may be used to create patterns of light and shadow that are interesting in themselves. The visual appeal of Barbara Hepworth's *Two Segments and Sphere* (Fig. 8.3) is enhanced by the series of semicircular shadows its forms cast. These shadows subtly repeat and vary the theme of sphere and slices of a sphere introduced by the three forms themselves.

In designing this *Artichoke* lamp (Fig. 8.4), Poul Henningsen was clearly aware that arranging thin curving planes of steel around an illuminated core would create such a range of values. These variations in value, from near-black at the base where the light is blocked to near-white on the brightly lit undersides, become one of the most compelling visual features of the lamp.

Patterns of value contrasts may not only tie a work together but also unite it visually with its surroundings. In Frank Lloyd Wright's *Kaufman House* (also known as *Fallingwater;* see Figure 8.5), the extremely cantilevered forms of the house create dramatic contrasts between brightly lit surfaces and areas of dark shadows that echo the value patterns and forms of the deeply undercut natural rock shelves below.

8.3 Barbara Hepworth. *Two Segments and Sphere.* 1935–36. White marble, height 12″ (30 cm). Collection Mrs. L. Florsheim, Chicago. Barbara Hepworth Museum (Tate Gallery), London. Copyright Alan Bowness. Photo: Innervisions. All rights reserved.

8.4 Poul Henningsen. *The Artichoke Lamp.* 1958. Tin steel. Manufacturer: Louis Poulsen & Co. A/S. Courtesy Danish Design Council.

8.5 Frank Lloyd Wright. "Fallingwater," Edgar Kaufmann residence, Mill Run, Pennsylvania, 1937. Photo William C. Hedrich/Hedrich-Blessing HB-04414 D3. Courtesy Chicago Historical Society.

8.6 Larry Bell. *The Iceberg & Its Shadow.* 1975. ³/₈″ clear and gray glass coated with Iconel and quartz. 56 panels, 60″ w, heights from 57″ to 100″. Modern Art Museum of Fort Worth, Fort Worth, Texas. Albert and Vera List family, on loan to MIT.

Such devices helped Wright to create houses that seemed intimately related to their natural environments.

Values may be used to help us make spatial sense of a piece or to heighten its spatial effects. In Larry Bell's *The Iceberg & Its Shadow* (Fig. 8.6), the slight optical darkening that occurs when the tinted but transparent glass panels overlap allows us to judge how the panels relate to one another in space. Barbara Hepworth relates this function of value to "stereognosis," the ability to perceive three-dimensional form through the sense of sight. In a sense, values allow us to grasp the three-dimensionality of a form with our eyes rather than our hands. Hepworth writes:

> The importance of light in relation to form will always interest me. In sculpture it seems to be an extension of the stereognostic sensibility, and through it I feel it ought to be possible to induce those evocative responses that seem to be part of primeval life, and which are a vital necessity to a full apprehension of space and volume. There is an inside and an outside to every form. When they are in special accord, as for instance a nut in its shell or a child in the womb, or in the structure of shells or crystals, or when one senses the architecture of bones in the human figure, then I am most drawn to the effect of light. Every shadow cast by the sun from an ever-varying angle reveals the harmony of the inside and outside. Light gives full play to our tactile perceptions through the experience of our eyes, and the vitality of forms is revealed by the interplay between space and volume.

In addition to describing forms, value contrasts allow us to see surface textures. Consider the difference in apparent texture of a surface under dim and bright lighting. On an overcast day, Alberto Giacometti's *Monumental Head* (Fig. 8.7) would appear to have a much smoother surface than the extremely rough texture revealed by the patterns of light and shadow on a bright day.

NATURAL LIGHTING

Any piece that is placed outside will be subject to the vagaries of changing light conditions. Although these are not under the control of the artist, in some cases they can be planned for. And in any case, changes in angle and intensity of natural lighting may enhance the liveliness of the aesthetic experience, for the changes in lighting make the pieces themselves ever-changing in mood and visual impact. To appreciate an outdoor work fully, one should come back again and again to see it under many different lighting conditions. In bright overhead sunlight in the Museum of Modern Art Sculpture Garden, Lachaise's *Standing Woman* (Fig. 8.1) glistens as though the figure had just emerged from the water. On a gray day she appears far softer, with her muscle structure less prominent. To appreciate her more fully, one should also see her in the warm sidelighting of dawn or dusk, in a dense mist, or bearing new-fallen snow.

The greater the intensity of natural lighting, the stronger the value contrasts created. Under very bright sunlight, Frank Lloyd Wright's *Kaufman House* is a dramatic series of very light exposed and very dark undercut areas, as shown in Figure 8.5. Under overcast lighting conditions, both the house and the waterfall appear as a more medium range of tones.

Changes occur not only in intensity but also in the angle of natural lighting. The sun moves from east to west each day at an angle that is most directly overhead in the summer and closest to the horizon in winter. The shift from morning to afternoon sunlighting means that shadows will shift from one side of a piece to the other. When the position of shadows is of aesthetic importance, the artist must observe where they will fall during the day to determine the most desirable placement of the piece.

Shadows cast by objects other than the work of art may also influence its placement. Buildings themselves may cast shade on a sculpture. Often artists try to avoid the uniform values created by total shade. On the other hand, shadows created by the surroundings may in some cases enhance the work. For example, the architectural firm of Woo and Williams was commissioned to design a new Jordan Pond House to replace the old one that burned in Acadia National Park on Mount Desert Island in Maine. A much-loved tradition was to be preserved: afternoon tea on the lawn. In siting the new structure, the architects wanted to take advantage of the view up the pond and through the valley to the mountains beyond. They found that the shadow cast by the cliffs west of the pond created a dramatic dark line that spread across

8.7 Alberto Giacometti. *Monumental Head.* 1960. Bronze, 37½ × 12 × 15" (95 × 30 × 38 cm). Hirshhorn Museum and Sculpture Garden, Smithsonian Institution. Gift of Joseph H. Hirshhorn, 1966.

8.8 Kyu Sung Woo and John G. Williams, with the assistance of Prof. Michael Kim of the Harvard Graduate School of Design. *Shadow study of Jordan Pond Valley,* Acadia National Park, Mount Desert Island, Maine. Woo and Williams, Cambridge, Massachusetts.

the valleys as a mobile aspect of the landscape. Using a contour model of the area and special lighting to approximate the path of the sun, they were able to construct a "shadow study" (Fig. 8.8) that showed where the shadow shape would fall in the valley and across the Tea Lawn south of the pond during the afternoon tea. Using the shadow study, they oriented the new building not toward the most obvious view but rather toward the changing drama of cliff and shadow, and were able to keep the Tea Lawn itself beyond the reach of the shadow.

Urban planners also use shadow studies, for "sun rights" are now demanded by many city dwellers in cool climates. New high-rise buildings are therefore required to be recessed from the sidewalk. Post Office Square in Boston (Fig. 2.12) was specifically designed to bring as much light as possible into an area that had previously been darkened by the shadow of a parking garage. Aside from trees, overhead sun blocks are avoided in the park. Even the "roof" over a colonnade is an open lattice-work that lets light pass through to ground level.

ARTIFICIAL LIGHTING

The controlled use of artificial lighting is not subject to the daily changes in natural lighting. Used well, it can considerably improve the aesthetic success of a work of art. In Chapter 2 we saw how the mood of Daniel French's *Abraham Lincoln* (Figs. 2.9a and b) was dramatically changed by the addition of artificial lighting. In the natural light coming from below, the face appeared soft and perhaps a bit haggard, with light inappropriately concentrated around the chin. When illuminated by artificial spotlights from above, dramatic shadows developed beneath the eyebrows and mouth, considerably altering the appearance of the statue.

Whereas daylight tends to flood an object with light from a particular direction—the sun's position—artificial lighting can range from a small, intense spotlight to banks of floodlights, arranged wherever the artist feels they are most effective. Illuminated by overhead sunlight at midday, the Lincoln Center for the Performing Arts (Fig. 8.9)

Plate 1 CHARLES EAMES. *"Do Nothing Machine"* (*Solar Toy*). 1957. Aluminum and silicon disks, solar cells. Base approx. 3–4′ (0.92–1.22 m), height approx. 2½′ (0.76 m). For Alcoa.

Plate 2 Color wheel of pigment mixtures.

Plate 3 Peter Michael Adams. *Dotoh.* Coffee table, 1983. Laminated and carved walnut, oil finish, 1′6″ × 4′2″ × 2′4″ (0.46 × 1.27 × 0.71 m). Photo Dan Bailey.

Plate 4 Louis Comfort Tiffany. Necklace. c. 1900. Mexican fire opals, green enameling, and pearls against a gold ground; 8³/₄″ × 4¹/₄″ × ⁷/₁₆″ (22.2 × 10.8 × 1.11 cm). Virginia Museum of Fine Arts, Richmond. Gift of Sydney and Frances Lewis. Photo Grace Wen Hwa Ts'ao.

Plate 5 Charles Henry Joseph Cordier. *Bust of a Nubian.* 19th-century France. Silvered bronze and jasper on porphyry, height 38¹/₄″ (97 cm). The Minneapolis Institute of Arts.

Plate 6 George Segal. *The Parking Garage.* 1968. Plaster, wood, metal, electrical parts, and lightbulbs. 10′ × 12′8″ × 4′ (3.05 × 3.84 × 1.22 m). Collection of The Newark Museum, Newark, New Jersey. Purchased 1968 with funds from the National Endowment for the Arts and Trustee Contributions.

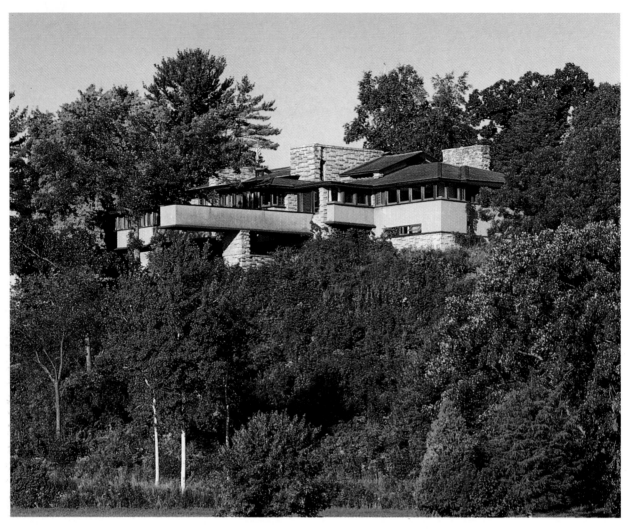

Plate 7 Frank Lloyd Wright. *Taliesin.* 1925. Spring Green, Wisconsin. Photo Thomas A. Heinz.

Plate 8 Topiary garden, Levens Hall, near Kendal, Cumbria, England. Courtesy of the British Tourist Authority (M94/25).

Plate 9 *Peplos Kore,* Acropolis, Athens, c. 530 B.C. Acropolis Museum, Athens. Photo Nimatallah/Art Resource, NY.

Plate 10 *Virgin and Child.* Unknown artist. Walnut, painted and gilded, height 13¹/₈″ (37.3 cm). The Metropolitan Museum of Art. Gift of Mr. and Mrs. Frederick B. Pratt, 1935 (44.85.3).

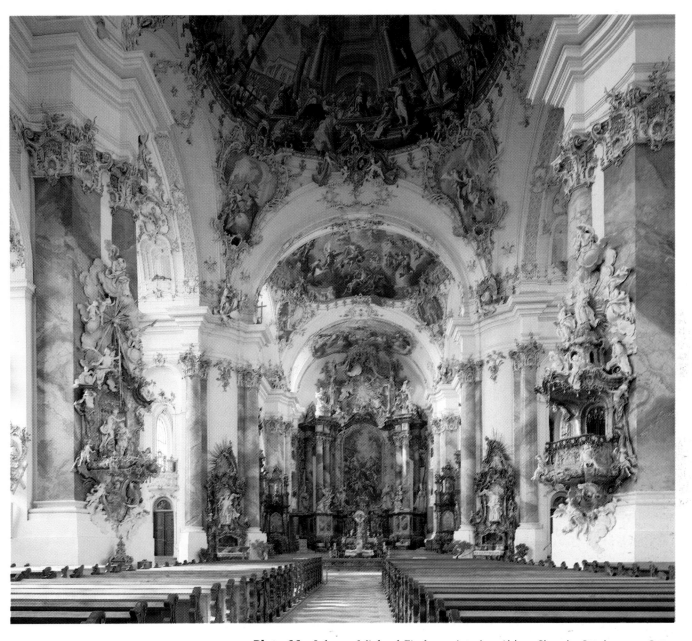

Plate 11 Johann Michael Fischer. Interior, Abbey Church, Ottobeuren, Germany. 1736–66. Photo © Marco Schneiders, Lindau.

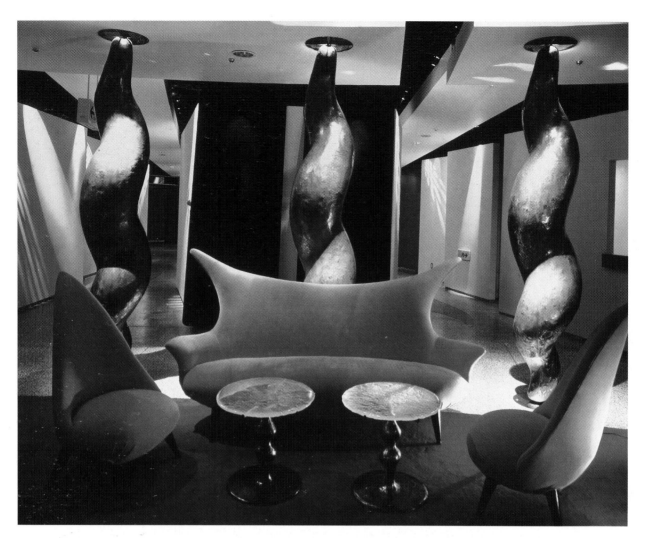

Plate 13 Larry Totah. *Odeum Karaoke Club,* Tokyo. Columns: copper metal spray over molded fiberglass. Tables: cast glass tops over bases of copper plate over cast bronze. Velvet upholstery. Totah Design Studio, Santa Monica, CA. Photo by Nacasa and Partners, Inc.

Plate 12 Sandy Skoglund. *Fox Games.* 1989. Multimedia installation of purchased furnishings, painted bread, and polyester resin handmade sculptures. Dimensions variable, approx. 30' × 20' × 12' high. Denver Art Museum Collection.

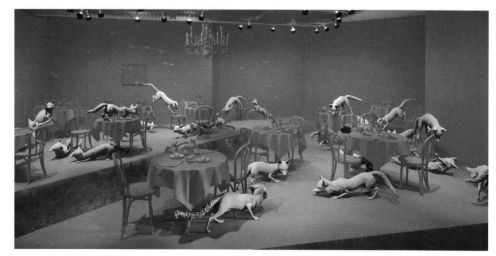

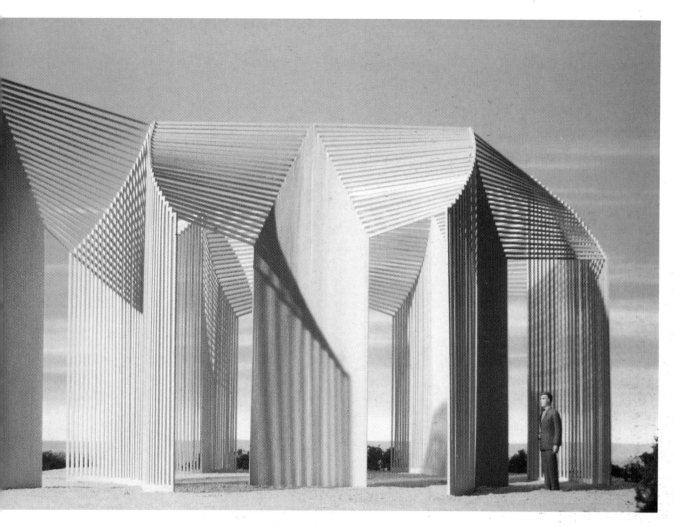

Plate 14 Linda Howard. *Cathedral Series VIII, Gothic.* 1984. Proposed for steel painted white, scale 24′ × 30′ × 40′ (7.32 × 9.15 × 12.2 m). Courtesy the artist.

Plates 15 and 16 Robert Walker. *Vertical Wedge Form.* 1977. Cast acrylic, 16″ × 16″ × 2″ (41 × 41 × 5 cm). Private collection.

Plate 17 George Segal. *Blue Girl on Park Bench.* Courtesy of Sidney Janis Gallery, New York.

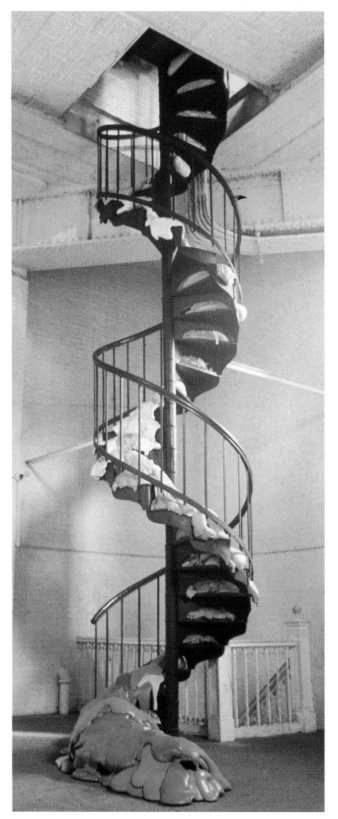

Plate 18 Toshiko Takaezu. *Blue Small Forms.*
1988. Porcelain-thrown. Left: 6¹/₂″ × 6¹/₂″ × 6″.
Right: 6″ × 6″ × 7¹/₂″. Courtesy of The
Montclair Art Museum, Montclair, New Jersey.

Plate 19 Marjorie Strider. *Blue Sky.* 1976.
Urethane foam and pigment, height 20′ (6.1 m),
width 8′ (2.44 m), depth 5′ (1.53 m). Temporary
installation at the Clocktower (work destroyed).

Plate 20 (opposite page) Saskia Weinstein.
Interior, with rug and built-in furniture by Saskia
Weinstein, window panels by William Gray Purcell
and George Elmslie. Photo by John Hall.

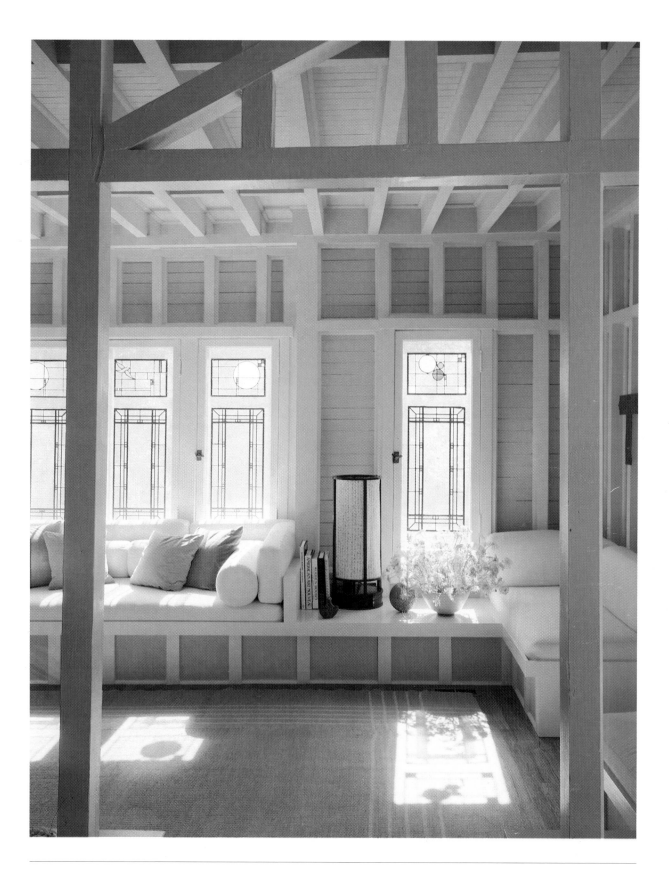

Plate 21 (opposite) George Segal. *Depression Bread Line.* 1991. Sculpture for FDR Memorial, Washington, D.C. Courtesy Sidney Janis Gallery, New York.

Plate 22 John Lewis. *Urn.* 1979. Blown glass, 7″ × 7″ (18 × 18 cm). Courtesy the artist.

Plate 23 Lawrence Ajanaku. *Odogu (Ancient Mother)* headpiece and costume. Headpiece: wood frame, applique, and yarn, 19½″ × 20″ (49.5 × 51 cm). Costume: 41½″ (105.5 cm). Nigeria, Ogiriga village, Okpella people. Collection UCLA Fowler Museum of Cultural History.

Plate 24 John Ferren. *Construction in Wood: Daylight Experiment* (Façade). 1968. Painted wood, 6′ ½″ × 4′ × 1′ 2″ (1.84 × 1.21 × 0.35 m). Hirshhorn Museum and Sculpture Garden, Smithsonian Institution, Gift of the Artist through the Joseph H. Hirshhorn Foundation, 1972. Photograph by Lee Stalsworth.

Plate 25 Interior in southern Spain. Michael Dunne/Elizabeth Whiting & Associates, London.

Plate 26 Bessie Harvey. *Tribal Spirits.* 1988. Mixed media. H 45″ × W 26″ × D 20″. Dallas Museum of Art, Metropolitan Life Foundation. Purchase Grant.

Plate 27 Dale Chihuly. *Green Cobalt Sea Form Set with Red Lip Wraps.* 1985. 4′7″ × 10′2″ × 7″. Glass. Photo by Dick Busher.

8.9 Lincoln Center for the Performing Arts, New York. 1962–69. Left to right: New York State Theater, Metropolitan Opera House, Vivian Beaumont Theater and Library and Museum of the Performing Arts, Philharmonic Hall (now Avery Fisher Hall), seen by daylight. Buildings and the Guggenheim Bandshell in Damrosch Park arranged around three interconnecting plazas. Photo Bob Serating/© Lincoln Center for the Performing Arts, New York.

8.10 Lincoln Center for the Performing Arts, New York. 1962–69. Night view, illuminated by artificial floodlights. Photo Morris Warman/Lincoln Center for the Performing Arts, New York.

features dark, cavernous arches between brightly lit columns. Attention is also drawn to the lines leading to the fountain in the central plaza. The darkness of the arches almost holds the viewer away, as though the fronts of the buildings were solid. By contrast, artificial floodlighting of the buildings' interiors by night (Fig. 8.10) transforms them into pools of light, warmly beckoning the viewer into the delicate intricacies within. The effect is so changed that the second picture almost appears

to be a photo negative of the first, with black areas transformed into light areas and vice versa.

The use of artificial light to create value contrasts can emphasize spatial and textural qualities of a piece. Leonard Baskin's *Oppressed Man* (Fig. 8.11) would appear far flatter under uniform lighting conditions than it does in the carefully arranged artificial lighting used in the photograph shown. The sense of the weightiness of knowledge—represented by the owl, which also is known as a symbol of impending death in some cultures—is dramatized by lighting from above that makes the bottom part of the owl seem particularly strong, pressing downward. This is not a man whose thoughts are rising. Rather, his thoughts are sitting on him, heavily. Note that the darkness of the background is used to accent the whole piece by contrast with the highlights on the contours. Often museum photographs are trimmed or taken against a white wall so that there is nothing to be seen but the figure itself. But inclusion of background and careful manipulation of lighting can enhance the photographic impact of a piece.

A truly great work of art cannot be diminished by any kind of lighting. But even a great work can be enhanced by skillful artificial lighting. Millions have been touched by the beauty and pathos of Michelangelo's *Pietà* (Fig. 8.12). Yet photographer Robert Hupka manipulated artificial lighting as well as camera angle to take a series of photographs of the work such as the one shown in Figure 8.13 that make its emotional statement even more compelling. The high value contrast

8.11 (above) Leonard Baskin. *Oppressed Man.* 1960. Painted wood, 31 × 12⅜ × 14" (78.7 × 31.4× 35.6 cm). Collection of Whitney Museum of American Art, New York. Purchase 60.30.

8.12 and **8.13** Michelangelo. *Pietà.* 1498–99. St. Peter's Basilica, Rome. Photo © 1975 by Robert Hupka, from his book *Michelangelo: Pietà.* New York: Crown, 1975.

in areas such as the folds of Mary's robe heightens the drama of the sculpture. And to lose Mary's face in the shadows draws attention away from the surface characteristics of her figure and allows us to focus more on the quality of her presence—the tremendous love and sense of loss but yet an eternal serenity that transcends the pathos of suffering.

REFLECTED LIGHT

Another way in which artists may use light consciously is to create areas in which reflections may occur. Dull or rough surfaces absorb all light striking them, but shiny, smooth surfaces may reflect light back to the viewer, making the objects seem to glow with inner life. Highly polished flat surfaces will also mirror their surroundings; curving polished surfaces will present a distorted reflection of whatever passes before them. The smooth curves of Lino Sabattini's silver-plated flower vases (Fig. 8.14) are enlivened by an ever-changing play of abstracted images as life moves around them. Many objects in our three-dimensional world have this reflective quality, yet we rarely stop to enjoy the patterns that develop on their surfaces.

Mirrors, polished glass, or water may also be used by artists as reflective surfaces. Henry Moore's *Lincoln Center Reclining Figure* (Fig. 8.15) has been placed over a reflecting pool with obvious awareness that when the water is calm, it will provide a mirror for the piece. The

8.14 Lino Sabattini, designed for Argenteria Sabattini, Italy. *Houn Ohara.* 1974. Silver-plated flower vases, height 14″ and 10½″ (36 cm and 27 cm).

8.15 Henry Moore. *Lincoln Center Reclining Figure* in reflecting pool. Lincoln Center Plaza North, New York. 1965. Bronze. Photo Bob Serating/© Lincoln Center for the Performing Arts, New York.

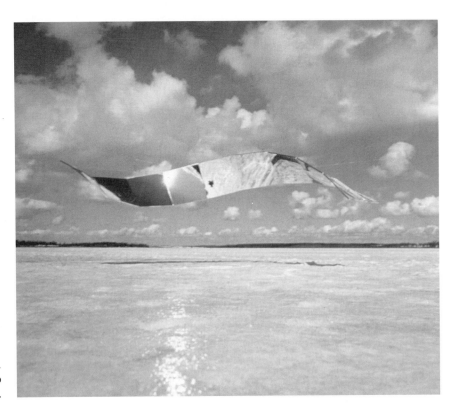

8.16 Francisco Infante. Serial Work. 1978–89. Photo courtesy International Images.

8.17 Linda Howard. *Star Burst.* 1993. Brushed aluminum, 20' high × 9' wide × 8' deep. Schoenbaum Collection, Charleston, West Virginia.

reflections in the water below become an active part of the sculpture. Reflections of the sky in the water give the sculpture and its reflections the appearance of floating in a displaced sky.

Light glancing off the surface of a highly polished work may dazzle the eye of the beholder. In Brancusi's *Bird in Space* (Fig. 1.8), this dazzling light helps to create an ephemeral sense of the quick flash of a bird through the sky. The panels of Francisco Infante's installation over a frozen expanse of water (Fig. 8.16) reflect sunlight brilliantly when the panels are in a certain relationship to the sun. At other angles, the kite panels reflect the light on the snow's surface, placing it oddly in the air among the clouds.

In sculpting *Star Burst* (Fig. 8.17), Linda Howard ground wavy lines to a high sheen along the aluminum surfaces for a slightly different purpose. Her intent is to use light to visually dematerialize matter into a semblance of the energy patterns that actually underlie the apparent solidity of things. The shimmering surfaces almost disappear from view in bright sunlight. At the same time, the shadows cast by the strips balance the disappearing tendency by reinforcing the physicality of the structure. While the sculptural form is created by elements rotating through space, even more compelling than the form is the illusion of energy patterns. These are created by the wavelike *moiré* patterns of the interweaving of brighly lit elements, shaded segments, and unfilled spaces, repeated with ever-changing variations throughout the work and even beyond the sculpture to the shadow patterns cast on the ground.

Howard explains that she is using light in an attempt to give visual form to the ideas of contemporary physics and Eastern philosophies:

> I am deeply concerned with the paradox that exists between our experience of physical reality and our scientific knowledge of conceptual reality, with finding connections between these apparent opposites. Light is an important element in my work, for it brings out both sides of the paradox. Ambient light functions may either dematerialize structure into an almost totally ethereal experience of light and energy, reinforce structure, or sometimes even add illusionary structural elements. I want to dematerialize structure because I have always been struck by the ambiguity of matter. It seems physically hard but contemporary physics says that all matter is composed of energy, which simultaneously manifests itself as discrete particles and as waves. I'm working with that balance between our knowledge of matter as anything but solid and our actual experiences with its seeming solidity.

LIGHT AS A MEDIUM

In addition to its many ways of dramatizing works of art, light itself may be the medium with which the artist works. In a sense, natural light is being harnessed as a medium in Le Corbusier's Notre Dame du Haut (Fig. 4.13), for as it pours through the windows it creates highly active forms.

Contemporary technologies have made it possible to build sculptural forms and lines using nothing but directed light. Lasers, for instance, create thin beams of colored light that can be thrown against the sky.

In other light sculptures, light is shaped by some outer shell. In Andrea Blum's *Sunken Network System* in San Francisco, the water troughs are illuminated at night and become lines of light through the plaza (Fig. 8.18). Dan Flavin's *Untitled (To My Dear Bitch, Airily)* (Fig. 8.19) uses straight but offset blue and green fluorescent tubes of light to create an installation piece in which light is the medium. We see three kinds of light: the gaseous light contained within the tubes, the aura that surrounds them, and their reflections on the polished floor of the gallery. The increasingly distorted and ephemeral quality of the reflections seems to extend the work into a strangely unfamiliar reality in which light floats, quite insubstantially.

Normally light travels in a straight line, but neon tubing and fiber optic strands can conduct light in curving paths. Aiko Miyawaki has shaped flexible steel wire into great loops and then illuminated them from their bases. With these reflective surfaces she creates lovely free arcs of light against the night sky in Barcelona (Fig. 8.20).

Light is also used as a medium in theater, where stage lighting is as important as set design, costuming, makeup, sound, and acting in creating the desired effects. As stage lighting designer Don Murray notes:

> Most good lighting is so integrated with the wholeness of the theatrical event that it doesn't stand out as a thing in itself. But lighting can

8.18 (above) Andrea Blum. *Sunken Network System with Mirrored Arbor.* 1990. Fillmore Center, San Francisco. Cast concrete, water, lights; 13,000 square feet × 18″ above grade and 18″ below grade. Photographed at night by Ben Blackwell.

8.19 (right) Dan Flavin. *Untitled (To My Dear Bitch, Airily).* 1984. Blue and green fluorescent light (as installed at 142 Greene Street), 4″ × 44″ × 86′8″ (0.10 × 1.12 × 26.42 m). Leo Castelli Gallery, New York.

8.20 Aiko Miyawaki. *Utsurohi.* 1990. Flexible steel wires. Installed in front of the Olympic Sports Hall, Barcelona. Photo Shigeo Anzai.

expand or contract the illusionary space of the stage, drawing it down to a pinpoint so that everything else fades into oblivion or creating on a 25-foot-deep stage the sense of vista of the great plains of Nebraska. It can be used to dramatize emotional effects or to subdue them. It can also make colors seem to advance or recede. Lighting's ability to be so flexible is one of its great contributions to theater. Whereas the sets are fixed, lighting is an active, hands-on activity that, like the actors, can respond to the moment.

The impact of lighting on theatrical illusion is quite apparent in Franz Merz's lighting design for Sophocles's *Oedipus Rex* (Fig. 8.21). Here the space of the stage has been divided by lighting into one area of highly concentrated light, beyond which the boundaries of the stage are lost in total darkness. The makeup, costuming, and masks all repeat the high-contrast values, emphasizing the stark black-and-white tragedy of the play. Although all elements work together harmoniously, imagine what a difference it would make if the dramatic lighting were replaced by normal institutional lighting, like that of a supermarket or a classroom.

8.21 Franz Merz. Design for *Oedipus Rex* (Sophocles). Photo German Information Center.

Instead of seeing masklike human faces, masks, and a pool of light against a vast darkness, the audience could be looking at the curtains, the wings, the underpinnings of the sets, and perhaps even at each other. Light, used consciously, is thus a very powerful tool in the artist's control of the aesthetic experience.

CHAPTER 9

COLOR

Color is such a compelling element of design that we have purposely minimized it in discussing earlier works to avoid detracting from the other elements. To get an immediate sense of what color adds to three-dimensional design, compare Figure 9.1 and Plate 1 (color section). In black and white, Charles Eames's *Solar Do Nothing Machine* is obviously a whimsical combination of shapes that spin about like a mock space-age machine when the solar collector is activated. Yet how much more humorous and playful the toy appears when we can see the delightful carnival-like atmosphere created through the use of a great many different colors.

Color is an extremely rich tool the artist can use in many ways, whether working with the natural colors of materials or adding color to them. Before we can talk about colors, however, we must introduce the basics of color theory so that we will have a vocabulary to draw on.

9.1 Charles Eames. *Solar Do Nothing Machine.* 1957. Aluminum and silicon disks, solar cells. Base approx. 3 × 4′ (0.92 × 1.22 m), height approx. 2¹/₂′ (0.71 m). For Alcoa. Lucia Eames Demetrios dba Eames Office © 1988.

COLOR VOCABULARY

Despite the impression that objects "are" certain colors, colors exist not on the surfaces we see but in our brains. Colors exist as invisible energy waves in white light. We pick up these waves of electromagnetic radiation when they are either refracted or reflected. When passed through a prism, light is broken down or *refracted* into the rainbow of the *visible spectrum* (Fig. 9.2). *Reflection* occurs when light strikes an opaque surface. Waves of certain lengths are absorbed; others are reflected. When these reflected waves are conveyed to the rods and cones in the retinas of our eyes, the sensation is translated as a particular color.

To change the color of a material, artists use *pigments* that reflect the wavelengths associated with the desired color. Mixing pigments together produces a slightly darker color, for each subtracts its energy from the light reflected. Pigment mixing is therefore called a *subtractive* method of mixing colors. The exception is adding white pigment to another pigment to create a lighter value, or *tint,* of that color. Adding black produces a *shade,* or darker value of a color.

9.2 The visible spectrum.

Although most color mixing is done by the subtractive method, artists who work directly with light—as in photography, television, video, lighting, computer graphics, and laser art—are using an *additive* method of color mixing. That is, each color adds its energy to that of the others used, raising the value of the mixture slightly. *Optical color mixtures* occur when colors are mixed in the viewer's perception rather than on the surface of an object. Optical mixtures may occur when colors lie so close to each other that their energies interact or when colored forms are transparent, allowing one color to be seen through another and thereby mixing with it visually.

Colors can be classified by three main characteristics: hue, saturation, and value. *Hue* is the characteristic we identify by color names: red, blue, green, yellow, yellow-green, etc. Variations between hues are almost infinite, but a simple model of their interrelationships can be expressed by a *color wheel,* such as the one shown in Plate 2 in the color section. In pigment mixing, all hues can be obtained by mixtures of just three hues. In traditional color theory, these basic hues from which all others can be mixed are red, blue, and yellow, and are called *primary colors.* Mixing two primaries together produces *secondary colors*—green (blue plus yellow), orange (red plus yellow), and purple (red plus blue). Mixtures of a primary and a secondary produced from it create a third set of colors: the *tertiaries* red-purple, red-orange, orange-yellow, yellow-green, blue-green, and purple-blue. Many more hues are created by mixtures falling between these named positions on the color wheel. In light mixtures, the primaries from which all other hues can be mixed are red, green, and blue-violet. Although other color theories posit slightly different basic hues, these will do as an initial vocabulary for our discussion of color.

The third characteristic of the colors we perceive is *saturation* (also called "chroma" or "intensity"). This term is a measure of the relative purity or brightness of a color. When colors lying opposite each other on the color wheel—known as *complementary colors* (such as red and green)—are mixed together, they tend to neutralize each other, producing a grayer version of one hue or the other. Mixed in the correct proportions, they will produce a gray that resembles neither. Gray is shown in the center of the color wheel, for this position places it between

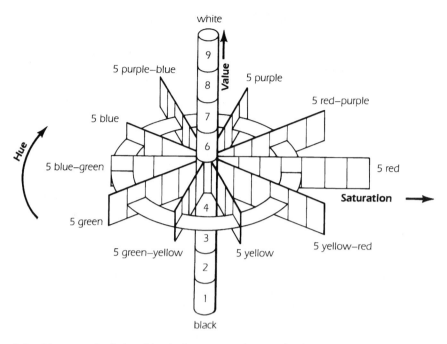

9.3 Diagram of relationships in hue, saturation, and value.

each set of complementaries. Another way to gray a color is simply to add gray or black to it.

Colors are said to be highly saturated when they are very bright. Colors of very low saturation—those that are closer to gray than to the named hues of the outer ring of the color wheel—are sometimes called *neutrals.* They are of interest to decorators and clothing designers, for since they are almost lacking in hue, they can be used next to a variety of more saturated colors without undesired hue contrasts.

Value we discussed in the last chapter: It is the relative lightness or darkness of a color. To represent color relationships in these three dimensions—hue, saturation, and value—colorist Albert Munsell patented a three-dimensional model in which steps of value change along the vertical axis, saturation changes are shown through the horizontal axis, and hue differences are shown around the periphery, as diagrammed in Figure 9.3. Munsell's system has been adopted as an instrument for measuring and naming colors by many official institutions, including the National Bureau of Standards in the United States. Note that Munsell's classification is based on five primary hues (which he terms *principal hues*), rather than the traditional three. Each primary and *intermediate* (secondary) hue is designated by its initials. Colors are then given numbers in which the first refers to the step of value and the second refers to the degree of saturation, with higher numbers indicating a higher degree of saturation.

Hues differ in the number of equal steps required to reach maximum saturation. As shown in Figure 9.3, at value 5, red can take 14 steps before it is as highly saturated as it can be, whereas blue-green reaches maximum saturation at step 8. Hues also differ in the step of

value at which they reach their greatest saturation: Yellow (which is relatively light in its purest form) reaches maximum saturation at step 8 of value, while purple-blue (which is dark in its purest form) reaches maximum saturation at step 3 of value.

The colors we perceive, besides being affected by the pigmentation of a surface, are also a function of the glossiness of the surface, the surrounding colors, and the ambient lighting. A highly polished surface will pick up highlights, which will make colors appear lighter. In a principle known as *simultaneous contrast,* juxtaposition of two colors exaggerates their differences and reduces their similarities. Complementaries intensify each other's saturation if used together—red appears redder next to a green, and vice versa. Butchers often put fake green parsley next to meat to make it appear redder and therefore fresher. Hues optically "subtract" their own wavelengths from hues to which they are juxtaposed, so meat would look a sickly gray on a bright red plate. As for lighting, bright light creates strong value contrasts; an overcast day or dim indoor lighting shifts color perceptions to the middle range of values. Because the redness of late afternoon sunlight, the yellowness of incandescent lighting, and the blueness of fluorescent lighting produce such different color sensations, colors should always be examined under the lighting in which they will be used.

NATURAL COLOR

Although pigments can be carefully mixed to approximate the subtle colors of nature—or natural plant dyes used to the same end—artists often work instead with the natural color characteristics of their chosen medium. It is this use of the *local color* of the material that we are calling *natural color.*

Craftspeople often search for materials that are naturally beautiful and then present them in such a way that this beauty is enhanced. Peter Michael Adams's *Dotoh* (Plate 3) features not only elegant, flowing form but also the sensual visual appeal of laminated walnut. By smoothly sanding and oiling the surface of the wood, Adams has brought out its warm colors and its close-grained striations. The rich colors and smoothness of the surface are like beacons drawing us in to touch and enjoy this coffee table. The beauty of the colors cannot be separated from the other aesthetic and functional aspects of the piece, however. Adams explains the integration of his work: "A successful piece will not only mirror my sensitivity to sight and touch, but give credence to my conviction that functional forms can speak eloquently of sculpture, movement, and sensuousness, and still maintain their practicality."

Could any human improve upon the natural colors of polished opals like those used by Louis Comfort Tiffany in the turn-of-the-century necklace shown in Plate 4? A wide range of hues plays across the surface of each stone, inviting us to a closer examination. The natural pearls and gold are likewise presented unadorned. Such beautiful stones and metals are rarely found in large quantities in nature. Opals occur, not as boulders, but rather as small, precious gifts.

While the striations of Adams's walnut slabs and the gradations in the opals occur randomly, in Charles Henry Joseph Cordier's *Bust of a Nubian* (Plate 5) the creamy body and darker gold bands of color in a block of jasper are used quite consciously to provide decorative detail. The natural lines in the stone become bands of extraordinary richness representing woven patterns in some sumptuous material. In places such as the sleeve on the left in the photograph, the sculptor has even altered the carving to make the occasional irregularities appear to be plausible curves of the fabric. Selection of just the right piece of stone was obviously vital to this artist. The natural colors of the porphyry used for the base add to the impression of opulence. And silvered bronze provided precisely the desired skin color, enriched by a range of lighter values as the polished facial features curve to reflect the light.

In contrast to the richly decorative use of natural color in Cordier's bust, natural color may sometimes be chosen for its simplicity. Aesthetically, this simplicity of color may allow attention to be drawn to other elements of design, such as form. During China's Ming Dynasty, porcelain pots and figures were often high-fired to the subtle white of the clay body itself. With no other colors added to distract the eye, one could fully appreciate the forms of the pieces. At the same time, isolating nature's warm eggshell white brought attention to this white itself as a color.

Natural color may also be used conceptually. In George Segal's *The Parking Garage* (Plate 6), the stark natural white of the plaster is used to make a conceptual statement: The attendant appears to lead a bleached-out existence amid the garish colors of contemporary urban life. Here, the material world becomes the vibrant reality; by contrast, the white plaster human figure is the one element in the scene that appears lifeless. To see a normally dark-skinned African American man depicted as totally white, including his clothing, suggests that he has become invisible to society. Perhaps he is more forgotten than lifeless.

In other works, use of natural color may have the opposite effect—that of linking the work to its surroundings. Architect Frank Lloyd Wright's Wisconsin house, *Taliesin* (Plate 7), expresses his philosophy of the "natural house"—one that appears to be at one with its environment. To tie it in with its site, he has made extensive use of local stone that echoes the pale earth tones of the hill in the background. The wood shingles weather naturally to the dark gray-brown of the shadows across the stone; the wood framing is treated with a preservative that allows it to weather to a pale warm gray. Sand from the river has been mixed with the plaster of the walls to link their color and texture to the earth tones. Even the red-brown accents in the window framing fall within the palette of hues reminiscent of the earth, while the green shrubbery on the patio further blurs the boundary between the house and its surroundings. Both seem to flow together as an organic whole.

In landscape design, the natural colors of plants are used because they are what is available to the designer. Planning a garden is actually a manipulation of colors as well as forms and textures in three-dimensional space. When used consciously, the natural colors of plantings can be extremely effective. The designer of the topiary (sculpted shrubbery)

garden at Levens Hall in England (Plate 8) used a very limited palette to bring out the richness of variations among a few hues. We look from the tender green of the grass to the bronzed greens of the sculpted evergreen shrubs to the varying greens of the leaves of the surrounding deciduous trees. The greens are set off beautifully by the yellows and purples of the flowers and the warm beige of the stone wall in the background. The colors of gardens change dramatically with daily changes in the weather and seasonal changes in foliage. In winter, only the evergreens and the stone wall would retain their summer colors, but imagine their appearance against the ever-changing color of the sky.

APPLIED COLOR

Despite the wide range of effects possible through use of natural colors, artists have often chosen to apply pigments to the surface of their materials or otherwise change the natural color characteristics of the media. Historically, works were colored to bring them closer to physical or mystical perceptions of reality. More recently, artists have chosen colors for other reasons to enhance the impact of their pieces and sometimes even to display colors as ends unto themselves.

Although we tend to think of classical marble statues as unembellished, revealing the elegant simplicity of the natural stone, the marble sculptures of ancient Greece and Rome were in fact originally painted. Researchers have determined that they were not painted on all surfaces, however. As suggested by the photograph of *Peplos Kore* (Plate 9), only certain areas were painted with pigments in hot wax (the long-lasting *encaustic* method). These colored areas served partly as decorative, eye-catching accents to the white of the marble, which was itself accentuated by waxing and polishing. Slight traces of paint remain on the meandering patterns of the tunic, as well as the startling red of the hair, eyes, and lips. Was this figure really painted with these reds or was this an undercoating for another color that has since worn away? We cannot be sure, but the addition of color does seem to bring the statue to vibrant life—particularly the painting of the eyes: Instead of being blank, they make direct eye contact with us.

For an example of a fully painted statue in which most of the detail remains, the fifteenth-century *Virgin and Child* shown in Plate 10 is fairly well preserved. In this *polychromed* (multicolored) wooden piece, the applied colors enhance the realism of the stylized carving, help us to distinguish skin from fabric, and create details such as the border of the robe that are not indicated at all in the carved form. Note that unlike a two-dimensional painting, in which values must be painted explicitly to create modeling effects, classical polychromed sculptures were typically painted in solid colors, with the contours of the form itself creating a range of values as surfaces catch or are hidden from the light. The varying hues seen in the draped fabric across Mary's legs can be attributed to the aging of this fifteenth-century piece, as the upper layer of paint flakes away to reveal undercoats and the raw wood itself.

Color may also be added for its decorative appeal to the senses. Lush or pleasing colors may be food for the eyes and perhaps the spirit.

Consider the veritable symphony of colors used in the Baroque interior of the Benedictine abbey church in Ottobeuren, Germany (Plate 11). The effect of the golden ceiling areas and pastel marble columns, set off by the pure white of the woodwork, quite overwhelms the worshiper with the splendor of the heavens. Behind the altar, the deeper tones enhance the sense of shrouded mysteries. The viewer's consciousness is drawn both upward by the golds and inward by the muted tones of the altarpiece, creating an architectural environment that encourages exploration of these two dimensions of the human search for the divine.

Another motivation for adding color to a work is to attract attention. Color is the hook that draws the viewer's eye to *Fox Games*, an installation by Sandy Skoglund (Plate 12). Without this color combination the piece wouldn't have the impact that it does. With the color added, the piece evokes questions, a playfulness that makes us become intellectually and emotionally involved. The completely red interior, plates to chandelier, makes us reconsider objects that might be otherwise ignored because of their familiarity. The gray foxes become a counterpoint to the red of the room, adding to the mystery.

Instead of just using paints to create a lush sensual environment, Larry Totah used white and colored lights to bathe the walls and selective spots on columns and furniture of the Odeum, a Tokyo karaoke club (Plate 13). Washes of primary colors play one wall off another and lead us down the hallway into a warm and intimate space.

Sometimes color is used to give visual strength to a form. Linda Howard chose to paint the steel pieces of her *Cathedral Series VIII—Gothic* (Plate 14) white for this reason. She explains that compared with her earlier scoured aluminum works, such as *Star Burst,* shown in Figure 8.17, the multi-unit pieces require a more positive surface for aesthetic balance:

> The elements have become thinner, more delicate in proportion to the structure, and more complicated, creating a whole architectural environment. So I had to switch to white to strengthen these elements visually. I was already making a kind of filigree, and the play of reflected light through the pieces would be too great if they were ground aluminum. The structure would be too weak, visually, and too busy. To hold the balance between airiness and solidity I had to go back to white and simplify the individual elements. It's very important to me to hold the balance—to maintain that line, whatever it is, between illusionary and real.

At the same time that painting the steel strengthens the visual impact of the structure, the use of white is sufficiently neutral to allow full appreciation of the complex interplay of lines—constructed lines, shadow patterns, and the lines created by negative areas filled by the sky. And white is often associated with purity, a quality that seems appropriate for leading the eye toward the sky.

In the works we have examined thus far in this section, applied color is secondary to the forms, enhancing them in some way. But in some cases, color itself is the primary consideration; the forms involved are only secondary. In Robert Walker's *Vertical Wedge Form* (Plate 15),

for instance, abstract bands of color flow within a simple geometric form. It is the varying optical mixtures of the inner planes of dyed acrylic polymers that are the focus of the work. As an indication of how these translucent color mixtures can change as one moves around the work or the light is shifted, consider Plate 16, which is the same piece, but illuminated from the right rather than the left. Walker explains his choice of simple forms to contain these fascinating, ephemeral colors:

> For one thing, I like the contradiction of forms visually—the hard edge of the sculpture compared to the flowingness of the interior color forms. And that's also a necessity of the optical quality of the material. I'm dealing with a transparent material and creating a plane that you have to see through. If the form of that plane is abstract or distorted, it would distort the internal image. My focus is the internal color image, and I'm trying to provide a relatively simple external form through which to view the internal form. In other words, I've tried to provide a simple geometric shape that your eyes can perceive easily. Since it's simple to comprehend, it allows your eyes to focus on the interior forms.

Within the nearly rectangular outer form, Walker uses optical combinations of three "virtually pure" transparent color dyes to capture the ephemeral beauty of the fleeting patterns that nature so often presents but that we so seldom really see.

EFFECTS OF COLOR: PHYSIOLOGICAL AND PSYCHOLOGICAL

To varying degrees, artists also use colors to control the emotional responses of viewers—to express a certain emotion rather than a literal depiction of the *local color* of an object. In our culture, colors have certain common emotional connotations: Yellow is linked with cheerfulness (though also with cowardice), red with passion (including aggressiveness), blue and green with peaceful meditative states (but also with depression), purple with mysticism, black with death, and white with purity. To a certain extent, these associations are culturally learned—in China, white is the color associated with death. But considerable research has been done on the actual effects of colors on our physiological processes, and thus our emotional state. In general, hues in the red range do tend to be stimulating, whereas blues and greens tend to have a calming effect, though these effects may be reversed over time. Violent prisoners are initially calmed by being placed in pink rooms, but after about fifteen minutes, their fury returns. Blue initially lowers blood pressure and pulse rate, but the opposite effect may later replace this initial one.

In traditional usage, reds, oranges, and yellows are referred to as *warm* colors, while blues and greens are called *cool* colors. These temperature associations are probably based partly on learned visual association of reds with fire and blues and greens with the coolness of water and shade trees, and partly on innate physiological responses to differences between colors. Experiments show that red seems to accelerate tissue healing, whereas blue decreases hormonal activity and retards

wound healing. This stepping up and slowing down of metabolism may slightly raise or lower the body temperature, thus validating the "warm" and "cool" labels. People actually feel colder in a room painted a cool color than in one painted a warm color.

Spatially the warm colors seem to advance, giving the impression of reducing the apparent size and weight of objects. When walls are painted in cool colors, they expand the apparent size of a room since they seem to recede. High-visibility orange helps hunters to distinguish one another from the deer not only because this orange is a highly saturated color but also because this hue can be sharply focused by the eye; blue is far more difficult to bring into focus.

While the wealth of research on such effects of color is valuable and fascinating, it is not yet sufficiently refined to account for the great range of colors within each named hue. And factors other than hue may offset the already subtle effects of the colors themselves. In art, these factors include the size of the colored area, the value and saturation of the hue, its "contamination" by other hues, the forms on which it is presented, manipulation by the artist of other elements of design, and the viewer's current emotional state and learned associations with color.

Consider blue. In George Segal's *Blue Girl on Park Bench* (Plate 17), the blue girl seems suspended in time, quietly waiting, focusing inward rather than outward. Is she depressed? Lonely? Bored? Trying to control her anguish? Meditating? Why is she sitting on the very end of the park bench? What do you feel in looking at her? If you feel a sense of isolation and sadness, or conversely, a sense of peace, how can you determine whether that response is your existing emotional state or what the artist intended? We see our inner state reflected in the outer world, so our judgments of how things "are" are highly subjective.

We may have a different set of reactions to a very similar blue— the glazes that Toshiko Takaezu has used on the two pots shown in Plate 18. These intense colors, one somewhat more purple than the other, are rare in ceramics. Toshiko, who makes her own glazes, says:

> I just happened to develop it by chance. It is one of my favorite colors. I like the intense blue, and I use it in rugs and in clothes as well. It gives me a wonderful feeling, a very happy feeling, I think because there is something very cool and soothing. It could be that I associate it with water. When I go back to Hawaii, the ocean is that way, and sometimes the water is purple. I must have taken from the landscape, from natural things, but I don't know where I got it.*

Now consider the emotional effects evoked by the use of blue in Marjorie Strider's *Blue Sky* (Plate 19). Here we see blue sky oozing playfully down a spiral staircase, in gay disregard for its proper place high over our heads. Toward the top of the staircase, the blue becomes paler, emphasizing the distance by the principle of *atmospheric perspective* (things seen at a distance have less value contrast and less distinct edges than things seen nearby). At its deepest value, the blue is that

* Toshiko Takaezu, personal communication, July 13, 1993.

of children's clay or fingerpaints, a plastic, not-quite-real, just-for-fun quality. Or is this just one person's interpretation? Art critic Donald Kuspit describes a different range of emotional responses to the work:

> Irrepressible, irresistible, this flow seems a comic hallucination, but it also evokes primordial terrors. It is at once a science-fiction fantasy of doom and our own consciousness as it swarms over and swamps things. Strider's ooze is at once the reflex response of mind to a reality gotten out of hand—gone berserk—and a monstrous suppuration from an invisible wound. If Strider's ooze is seen as static "form," it is a dumb heap; if it is seen as a flow, it acquires powerful being, an insidious ability to insinuate itself everywhere.

Is life so simple that we can identify only one gross reaction in ourselves to each of its events? Are we either happy or sad? Or do many emotional states flow through our awareness as a complex and ever-changing mirror of inner and outer patterns? Can blue be said inevitably to represent any one of these states?

COLOR COMBINATIONS

Not only do single colors vary in their emotional effects, colors are also varied by their juxtaposition to other colors. In general, color combinations have been traditionally classified according to whether the colors are closely related or contrasting. When hues are closely related, visual interest is usually created by adding certain slightly contrasting notes to the existing harmony. In a contrasting color scheme, contrast is the rule rather than the exception.

These relationships are judged according to the relative position of hues on the two-dimensional color wheel. But as we have seen in Figure 9.3, a more sophisticated model of the actual complexities of color variations is three-dimensional. Since there are no easy ways to account for relationships among colors that differ in value and saturation as well as hue, artists often combine colors more intuitively than intellectually until they achieve the effect they desire. Public tastes in color combinations change over time. At the turn of the century, the combination of blue with green was considered awful, whereas today color tastes show great diversity. Nevertheless, we will briefly review the standard models of color combinations to explore their characteristics.

The most closely related colors are those that all stem from a single hue but vary in value and/or saturation. This combination is called a *monochromatic* color scheme. As an example, the room shown in Plate 20 is a series of yellow-greens that are almost identical in hue. In this example of a monochromatic color scheme, even the values of the rug, built-in furniture, walls, and ceiling are quite similar. The effect is one of quiet coolness, allowing the subtle hues of the window panels by William Gray Purcell and George Elmslie to be appreciated. Monochromatic color schemes often include small areas of other colors as accents, such as the stained glass in the windows, the peach of the pillows, and the black of the lamp in this room.

(a) monochromatic scheme.

(b) analogous scheme.

(c) complementary scheme.

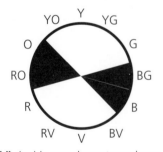

(d) double-complementary scheme.

9.4 Color schemes.

Although it is fairly safe to assume that monochromatic colors will not clash with each other, we cannot assume that the effect will necessarily be restful or pleasing. Imagine this room in values of red, with an abundance of highly saturated reds and pinks. What would be difficult to live with as a home environment, however, might make an exciting color scheme for a single piece of three-dimensional art. To use a monochromatic color scheme in a situation where one expects more hues may make a powerful psychological statement. George Segal has tinted the faces and adjacent areas of his men standing in a Depression bread line (Plate 21) a sickly green, with just a hint of red in the otherwise neutral black of the coats and bricks. It seems that they are bathed only in green light in a sort of netherworld of depression. Instead of being individuals, they become representative of the suffering masses as a whole through this monochromatic color treatment.

Analogous color schemes combine colors that lie next to each other on the color wheel. John Lewis's *Urn* (Plate 22) uses blues, blue-greens, greens, and a small amount of yellow-green. As Figure 9.4 illustrates, this is a progression of adjacent hues. The effect of the combination is a pleasing, quiet harmony.

Analogous color schemes do not always have calm effects. The yellow-orange and orange-pink used together on Lawrence Ajanaku's Nigerian Okakagbe costume *Odogu (Ancient Mother)* (Plate 23) are so highly saturated that they seem almost to vibrate. The black-and-white bands allow a bit of space between them, like taking a sip of water between tastes to clear your palate, but they also keep the orange and pink as bright as possible by not allowing them to affect each other. Placed side by side, each would seem to fade somewhat by simultaneous contrast as they optically subtracted their own wavelengths from each other. Emphasizing the brightness of the colors heightens the sense of pageantry. And imagine the added effect of movement as the wearer of the costume dances down the street in the masquerade procession.

Hues that are at farther intervals on the color wheel are in general somewhat more contrasting than closely analogous hues. However, we tend to perceive less contrast between hues when their value is high or their saturation is low. The orange, yellow, and green of John Ferren's *Construction in Wood: Daylight Experiment* (Plate 24) blend harmoniously. Although the colors are quite clear (highly saturated), they are all relatively high in value. What we are seeing in juxtaposition are pale color shadows reflected off the painted backs of the wood columns, rather than pigmented surfaces. All the surfaces we can see from the front are actually painted white to act as pure reflectors for the sunlight that comes from behind and then is bounced off the orange, green, or yellow backs of the columns. If we were to look at the piece in reverse, seeing the darker values of the painted backs of the columns rather than their paler shadows, we might see greater contrast between the colors.

Hues are said to show the greatest degree of contrast when they lie opposite each other on the color wheel, as *complementary colors* (Fig. 9.4). Closely juxtaposed, complementaries intensify each other's brightness. The intensity of the contrast may create a feeling of excitement. The Spanish interior shown in Plate 25 conveys a feeling of exuberance

by juxtaposing the complementaries blue-green and orange, both in the fabric used and in the painting of walls and door frames. Another series of contrasts occurs between very dark values, such as the deep brown of the window and chair legs and the black of the planter, and lighter values, such as the lampshade and the walls of the closer room. In being unafraid to combine colors normally considered clashing, the designer has created an atmosphere that surrounds people with a sense of vigorous health.

Some other contrasting color schemes can be identified as *double-complementary* (two adjacent hues and their complements), *split-complementary* (one hue plus the hues on either side of its complement), *triad* (three hues equidistant from each other on the color wheel), and *tetrad* (any four hues that are equidistant on the color wheel), as shown in Figure 9.4. Such combinations are said to be both stimulating and balanced, since they include both cool and warm hues.

When colors far distant from each other on the color wheel are used together, their physical distance within a piece and their relative amounts will affect their degree of harmony or contrast. In Charles Eames's solar toy (Plate 1), the spaces between circles of different hues allow us to see each one separately to a certain extent. Furthermore, even though all parts of the spectrum are used, blues, purples, and reds tend to predominate, giving the color scheme an analogous flavor. Yellow and green appear only as brief accents that help to give the whole piece an upbeat carnival atmosphere without destroying its lively harmony.

There is a limit to how far we can analyze intellectually why a particular way of using colors works well. We cannot ignore the power of an artist's instinctive sense of color. Bessie Harvey is a self-taught African American folk artist, working from the heart rather than academic formulas, and yet her *Tribal Spirits* (Plate 26) is very successful in whimsically combining every color in the spectrum to create a monumental wholeness. Harvey's colors would seem rather gaudy if isolated, but the amounts she has used, touches of red coming up the piece through areas of blue and green, yellows passing up and down, somehow all seem to work together. Or perhaps it is the flashes of white appearing here and there throughout the work that unify the juxtaposition of so many different colors. She is working so intuitively that it is difficult to say just why the piece feels so right.

In today's wide-open world of art, artists are free to use the rich tool of color any way they want, so long as they can make it do what they intend. The "rules" of color combining are useful as general guides to the understanding of color, but the subtleties and possibilities reach far beyond.

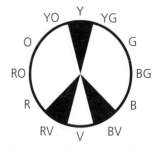

(e) split-complementary scheme.

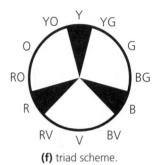

(f) triad scheme.

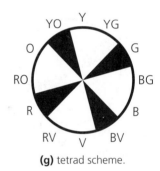

(g) tetrad scheme.

9.4 Color schemes, *continued*

CHAPTER 10

TIME

Thus far we have only talked about elements of design as occupying space. But there is another dimension to experience, and that is time. Aesthetic experiences occupy time as well as space, from subtle or uncontrolled or even illusionary movement through time on the part of the viewer or the work of art, to clearly defined sequences of change through time. Accustomed as we are to being entertained—or bored—by temporal arts such as television and movies, we nonetheless maintain a childlike fascination with things that move and change as we watch. The time element is therefore a dynamic tool at the artist's disposal for involving people with a work of art.

ILLUSION OF MOVEMENT

Before we examine actual movement through time on the part of the viewer or the work, we should note that certain works, though stationary, are designed to appear to move and change through time. Rather than appearing to be a single moment frozen in time, works such as Rodin's *St. John the Baptist Preaching* (Fig. 10.1) enable us to read succes-

10.1 Auguste Rodin. *St. John the Baptist Preaching.* 1878–80. Bronze, 6′ 6³/₄″ high, at base 37 × 22¹/₂″ (irregular). The Museum of Modern Art, New York. Mrs. Simon Guggenheim Fund.

sive stages of motion as a time sequence. Rodin created this effect quite consciously, explaining that "movement is the transition from one attitude to another." In a sense, we "see" Saint John walking, for Rodin shows us one movement flowing logically into another. Our eyes are drawn by the saint's left hand pointing down to his left foot, where his weight seems momentarily planted. Reading upward toward his gesturing right hand, we see a gradual shift in weight toward his right foot, with his left shoulder raised to take the weight off the left foot so it can be swung forward again. This is not a single frame from a motion picture; it is more like a composite of several frames, each represented by a certain part of the body and read in sequence. Rodin contrasts the effect with that of a stop-action photograph:

While my Saint John is represented with both feet on the ground, it is probable that an instantaneous photograph from a model making the same movement would show the back foot already raised and carried toward the other. Or else, on the contrary, the front foot would not yet be on the ground if the back leg occupied in the photograph the same position as in my statue. . . . It is the artist who is truthful and it is photography which lies, for in reality time does not stop. . . .

Another way of representing the illusion of time-spanning motion in a single stationary work was explored by the Futurist painter and sculptor Umberto Boccioni. As a Futurist, he was interested in representing the fast pace of life in a modern industrial society. In painting, a succession of similar images overlapping was often used to give this impression. But few artists tried to translate the Futurist manifesto into sculpture. Boccioni's *Unique Forms of Continuity in Space* (Figures 1.2 and 1.3) does, however, manage to convey the impression that we are seeing a person striding rapidly through space and time. We see a forward-pressing leading edge to the left, but also slightly separate forms suggesting blurred after-images of previous movement. The forms streaming backward are not literal descriptions of motion, as in *St. John*. Rather, they are visual metaphors for speed and for describing the optical continuity of perceiving several quickly successive images at once, like the extra legs seen on a galloping horse.

VIEWING TIME

A more common way that the time dimension enters a work of three-dimensional art is the time it takes to explore the piece. This aspect of time is highly variable, of course. Some people will walk right by a work without paying much attention to it. But to appreciate a piece of three-dimensional art fully, we must take the time to view it from a distance, come in close, and move all around it.

Mark di Suvero's *Gorky's Pillow* (Fig. 10.2) is over 23 feet (7.01 m) long and 9 feet (2.74 m) wide. To see it from all angles, we must walk over 64 feet (19.52 m) around its perimeter. We could also walk beneath it and around the hanging forms to examine them individually. Their playful quality invites lengthier participation—climbing on and seeing what happens, and perhaps even trying out the bell. If the sculpture has drawn the attention of children, we might stay even longer to watch their ways of enjoying it.

To a certain extent, the length of time people will spend in exploring and appreciating a piece is an indication of the artist's success. Guillaume Bijl has gathered real bottles of wine, soda, produce, and various other supermarket items to make us walk through a supermarket as an aesthetic experience in time (Fig. 10.3). What do we do in a supermarket? We walk along the aisles looking at the food, reading labels, perhaps matching coupons, perhaps passing the liquor quickly to get to the sodas, maybe slowing down to compare one tomato with another. When we find this experience presented as an installation piece in a museum, we are likely to walk all the way through it, examining

10.2 Mark di Suvero. *Gorky's Pillow.* 1969–80. Steel (painted), height 15′ 6″ (4.72 m), width 9′ 6″ (2.9 m), length 23′ 4″ (7.11 m). Courtesy of The Oil and Steel Gallery, Long Island City, New York.

10.3 Guillaume Bijl. *New Supermarket.* 1990. Installed in Klaus Littmann Gallery, Basel. Courtesy of the artist.

10.4 Harvey Fite. Portion of *Opus 40.* 1939–76. Environmental sculpture, bluestone rubble. Covers 6.5 acres on the site of an abandoned bluestone quarry, 7480 Fite Road, Saugerties, New York. Photo Howard F. Dratch, Saugerties, New York.

the items on the shelves, always wondering "Why? Is there something special I am supposed to notice?" Bijl refers to himself as "an artist without a studio," creating replicas of our civilization from its own artifacts. "I am like a bemused visitor from outer space," he says, "observing the consumer society and placing fragments of it within the circuit of galleries and museums."*

The length of time one spends with a three-dimensional work is partly a function of the physical size of the piece. Harvey Fite's *Opus 40* (Fig. 10.4) is an environmental sculpture covering 6½ acres. Not only is it large in scale, it also controls the viewer's movements through time and space by stone steps, walls, and terraces. As they disappear intriguingly out of view, they lead the viewer up and down into deep-walled enclosures and around and through the structure as if it were a building. The only point of moving through it, however, is to explore it. The experience stretches across a considerable amount of time simply because the work is so large. Similarly, a piece small enough to be held may also engage our attention for a long time span, for we can turn it over in our hands repeatedly until our curiosity is satisfied and our appreciation of the experience complete.

* Guillaume Bijl, as quoted by Brigid Grauman, "The Conspicuous Consumer," *ARTnews* January 1993, p. 117.

10.5 *Trajan's Campaign against the Dacians,* detail of *Trajan's Column.* A.D. 106–113. Marble, height of frieze band 4'2" (127 cm). Fototeca Unione at the American Academy in Rome.

Even greater control of viewing time is commanded by narrative pieces such as *Trajan's Column* (Fig. 10.5). It presents the story of the emperor Trajan's adventures in a series of carvings that wind around the immense marble column. To "read" the story, one must keep walking around the column, reading upward from the bottom.

CONTROLLED TIME

In contrast to pieces in which it is the viewer who moves through time, certain works are themselves designed to move and change through time. They are referred to as *kinetic art.* A now-classic example is Josè

de Riviera's *Brussels Construction* (Fig. 10.6). Its single line flows continuously not only through space but also through time, for the plinth on which it sits is motorized to revolve slowly. As viewers watch from a single perspective, the line curves in and out, up and down, gracefully changing its relationships with other parts of the same line.

George Rickey, whose *N Lines Vertical* (Fig. 5.4) moves with the wind, points out that the three-dimensional world in which we live is often a world of motion rather than of frozen tableaux:

> The artist finds waiting for him, as subject, not the landscape, but the *waving* of the branches and the *trembling* of stems, the piling up or scudding of clouds, the rising and setting and waxing and waning of heavenly bodies, the creeping of spilled water on the floor, the repertory of the sea—from ripple and wavelet to tide and torrent.

Even the movement of the sun across the sky affects art in time, as it creates lighting and shadow effects. Architect Arata Isozaki has captured this slow movement as art in his huge sundial that casts its shadow on the cylindrical courtyard enclosure of the Team Disney Building (Fig. 10.7). The wall of colored stucco is marked in such a way that the shadow actually does accomplish its function of measuring time.

Those works of art that are designed to move through a predetermined sequence of events exist in what can be called *controlled time.* An example of a time-controlled piece of kinetic art whose very simplicity is part of its humorous intent is Rikuro Okamoto's *Moving Rock #11* (Fig. 10.8). This visually realistic replication of a boulder does something we never expect a rock to do: It moves at a snail's pace back and forth across its stainless steel pad, propelled by a small hidden motor. The sudden realization that this seemingly inert mass is not stationary is the hook that draws people into enjoying the piece.

Works such as *mobiles* (changing sculptures activated by the wind) and folk art *whirligigs* such as the bicycling man shown in Figure

10.7 Arata Isozaki. *Team Disney Building,* detail of sundial in courtyard. Photograph © Peter Aaron/Esto. All rights reserved.

10.8 Rikuro Okamoto. *Moving Rock #11.* 1979. Plastic resin mixed with sand; aluminum, stainless steel, and motor. 36 × 76 × 40″ (0.91 × 1.93 × 1.01 m). Photo by Ruth Bermant, Purchase, New York.

10.9 *Whirligig: Uncle Sam Riding a Bicycle.* 1880–1920. Artist unknown, Northeastern United States. Carved and polychromed wood, metal. From the permanent collection of the Museum of American Folk Art (promised bequest of Dorothy and Leo Rabkin). Helga Photo Studios, New York, New York.

10.9 can move only in pre-established directions, though the speed at which they do so will depend on the wind that propels them. In this whirligig, the propeller paddles catch the wind, and as they rotate, activate wires that move the man's legs as though he were pedaling the cycle. The faster the wind blows, the faster he will seem to be pedaling. Even at rest, the piece creates the illusion of movement through the rippled carving of the flag and the flaring of Uncle Sam's coattails, as if blown by the wind. Indeed, the top part of the whirligig is movable, and will always head into the wind.

10.10 Alexander Calder. *Rigoulot, the Strong Man,* weight lifter, from *Calder's Circus.* 1926–31. Wire, cloth, metal, thread and tape on painted wood base. Dimensions variable: $7^7/_8 \times 10^1/_2 \times 7^3/_4''$. Collection of Whitney Museum of American Art.

It may be the artist who directly provides the impetus for controlled movement of a piece through time. Alexander Calder designed an entire miniature circus of wire figures with moving parts, such as *Rigoulot, The Strong Man* (Fig. 10.10). For 30 years Calder delighted groups of his friends with staged performances in which he not only moved the figures through their daring routines but also supplied the flamboyant voice of the ringmaster. He and his wife even served peanuts at intermission. The figures are marvelous, but to see Calder himself moving them was the height of entertainment for all ages. The wonderful humor of these shows is preserved in a priceless short film.

Another form of controlled time exists in works designed to last only a specified amount of time. Like the subtly moving rock, mobiles, and whirligigs, Jean Tinguely's *Homage to New York: A Self-constructing and Self-destroying Work of Art* (a moment from whose life is shown in Fig. 10.11) is designed to follow a set sequence of events through time. But unlike the other pieces, Tinguely's machine could carry through the routine only once. It existed for only one performance, in which this zany machine created and then destroyed itself. This category of controlled kinetic art is called a *kinetic sculpture performance*. Self-destruction is not mandatory.

10.11 Jean Tinguely. *Homage to New York: A Self-Constructing and Self-Destroying Work of Art.* Self-destroyed March 17, 1960. Assemblage of piano, machine parts, bicycle parts, weather balloon, fireworks, etc. in the garden of the Museum of Modern Art, New York. Photo © David Gahr.

Some conceptual art pieces operate within a similarly limited time framework: a brief static or kinetic display, sometimes observed only by the artist, with nothing saved for posterity except perhaps some photographs of the event. Christo's *Valley Curtain* (Fig. 2.4) was supposed to hang for only a few weeks and then be dismantled, a process that began somewhat prematurely. It can be argued that such works faithfully imitate life, for our experiences are fleeting rather than carved in eternal stone. We cannot hold on to a single moment; if we do not appreciate it as it flows by, it is gone forever.

Even though *performance art* also occupies a limited place in time, it nevertheless allows the artist to engage an audience for awhile and perhaps leave a more lasting impression. Joyce Scott, who is both a sculptor with beads (see Figure 12.13) and a performance artist, says she intentionally uses performance as a medium for "making things happen rather than leaving the viewer alone":

> For me, the performance pieces became important because I was sure my work wasn't always being interpreted as I wanted it to be. There were some things that I wanted to be really specific about, like my views on racism and sexism. Luckily, I am humorous, and I try to do it as if my ideas are not any more important than anyone else's— probably even stranger than anyone else's. But I think that they are not so alien that people do not want to listen to them.*

10.12 Joyce J. Scott. In *Generic Interference, Genetic Engineering,* performance piece. Courtesy of the artist.

In Scott's performance piece *Generic Interference, Genetic Engineering,* she plays a variety of roles—including that of fast-talking Gene 3000 (Fig. 10.12) to ask people to consider the potentially damaging consequences of genetic choice. She explains:

> In a culture that is homophobic, ethnophobic, female-phobic, fat-phobic, short-phobic, old-phobic, we'll be sure to use this megapower to turn it against those who are not in power. The show deals on many levels with that kind of issue: What is there about us that we feel so negotiable that we would technologically give it up or play with it in such a manner? In my readings about genetic research, the soul and spirit are very seldom, if ever, mentioned. When we're talking about genetically engineering people, could we be tampering with something that we don't ever get back? Could we be tampering with something that sets us apart as humans? That's what artwork is about—it's about human beings looking at themselves.*

FREE TIME

Whereas controlled-time pieces can only move within a certain pattern pre-established by the artist, works that exist in what we are calling *free time* are shaped partially by factors beyond the artist's control. These pieces will therefore vary somewhat randomly and unpredictably through time. "Free" is a relative label, though, for all art, no matter how minimal, implies a degree of control on the part of the artist in

* Joyce Scott quotations are from personal interview with the author September 13, 1993.

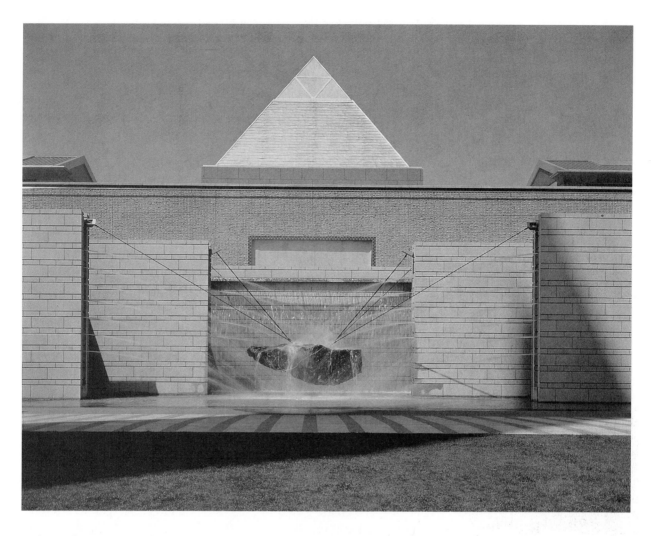

10.13 Arata Isozaki. Suspended rock, Art Tower Mito, Japan. Photograph by Yasuhiro Ishimoto.

order to bring some object or experience to the attention of the viewer.

Some artists work with natural forces that change unpredictably through time, such as water or wind. All outdoor pieces are subject to their eroding effects, with changes measured in months, years, or centuries, depending on the durability of the material. The relentless pounding of water on a 20-ton suspended rock in Arato Isozaki's design for the art center in Mito, Japan (Fig. 10.13) dramatically reminds us of these forces. Many earthworks are relatively short-lived, soon reclaimed by the earth through natural processes of attrition. Some metals used for outdoor pieces rust to a point and then the rust itself forms a sort of protective coat for the material. Some plastics theoretically have a very long lifespan, being highly resistant to corrosion, but they could melt in a fire. Marble, used historically for its great durability as well as its beauty, may be eaten into by acid rain resulting from airborne pollutants.

On a more immediately observable time scale, we can see the movement of water as it flows through channels and around obstructions. James Fitzgerald seems intentionally to have limited his control

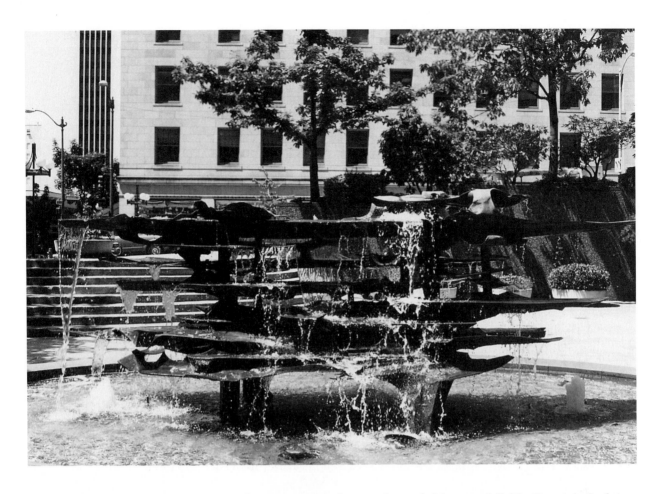

10.14 James Fitzgerald. *Fountain Sculpture.* 1961. IBM Building, Seattle. 5,000 pounds of black bronze, 24′ (7.32 m) high, fountain with 40 tuned nozzles, activated by a 350-gallon pump. Photo by John Schoettler, Seattle, Washington.

over the movement of water through his waterfall-like *Fountain Sculpture* (Fig. 10.14). To create a natural, free-flowing effect, Fitzgerald crafted a series of metal planes, each so flat that there is no obvious downward channel for the water to follow in its response to the pull of gravity. The water therefore spills off a little here, a little there, in quantities that change randomly through time. The shapes of the edges of the planes consistently determine the forms taken by water as it spills over the edges, but variations in the amounts coming over any one point will alter the pattern of the water curtain at that point.

We are fascinated by the continual movement and evanescent beauty of such a phenomenon. And watching the freely changing patterns of water tends to free our minds to flow in simple appreciation of the moment.

Watching a fire has a similarly spellbinding effect. And like Fitzgerald's fountain, fires are both controlled and free in their changes through time. John Willenbecher's *Burning Tetrahedron* (Fig. 10.15) was consumed by flames in a performance controlled somewhat by the shape of the 25-foot-square structure and the protective trench encircling the piece to keep the fire from spreading. The hollow center and gradually diminishing circumference created a chimney effect, allowing a draft of wind to rush upward and thus intensify the fire. But the actual process

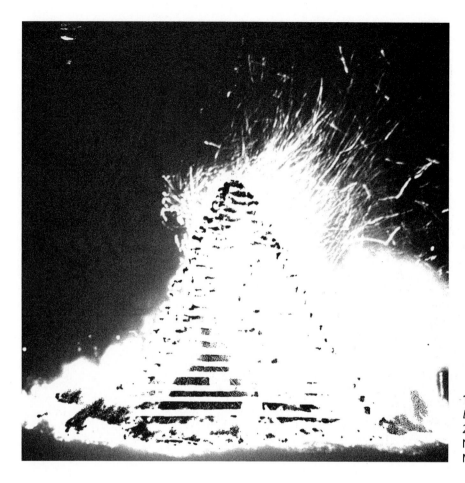

10.15 John Willenbecher. *Burning Tetrahedron.* August 20, 1978. Artpark, Lewiston, New York. Photo by Sarah Milstead.

and timing by which the sculpture took to flames was not predictable. When the brush at the base was first ignited, nothing much happened. Seeing mostly smoke, the crowd in attendance ventured closer. But then flames suddenly filled the center of the structure, instantly transforming it into a dynamic, crackling, heat-radiating presence. Awed, the crowd quickly retreated to watch the slow progress of the fire, whose dramatic effects throbbed with the mutual rhythms of life and death. The form of the piece kept changing, but never did it seem chaotic, for the framework was consumed from the top down, leaving a coherent structure almost until the end. As witness Kirk Varnedoe reported:

> The structure collapsed in three major steps, from the top downward. . . . Each fall was discrete, and separated by long intervals during which inevitability and unpredictability tugged at each other in the spectator's involvement. The end could not be in doubt, yet each event in the process was a surprise; and the stochastic rhythm of change was, during long periods of apparent changelessness, mesmerizing.

While *Fountain Sculpture* and *Burning Tetrahedron* invoke free time through the unpredictability of natural forces, some works involve the unpredictability of human behavior. One quality that sometimes

affects public art is vulnerability to destruction. The miniature dwellings that Charles Simonds builds on New York's Lower East Side (Figs. 1.5 and 1.31) so fascinate the children of these poor neighborhoods that they try to protect them from vandalism. But sooner or later, all are destroyed. The longest-lived, in an inaccessible location, lasted five years. Simonds accepts the temporary nature of his works, for he chooses to construct them in such a way that they cannot be moved and then leaves them for the whole community to enjoy. That they are destroyed is part of the saga of the "Little People," the imaginary ones for whom he builds. Despite the violence to which they are subjected, they survive by moving through the city, always rebuilding. Their determination to survive despite the presence of danger becomes a symbol of hope for the people of the ghettoes who follow their trail.

Another aspect of human behavior that may enter into works is willingness or unwillingness to participate. How long will viewers watch Adrian Piper's installation of a videotape of an African-American man repeating over and over, "I am not a thief; I am not scary; I am not sneaky; I am not shiftless"? The seats for this "show," depicted in Figure 10.16, are hard; the video is small and isolated from the bleachers. Yet this repetition of denials of racist stereotypes in a seemingly sterile

10.16 Adrian Piper. Installation view from the exhibition, *Dislocations.* October 16, 1991 through January 7, 1992. The Museum of Modern Art, New York. Photograph courtesy of The Museum of Modern Art, New York.

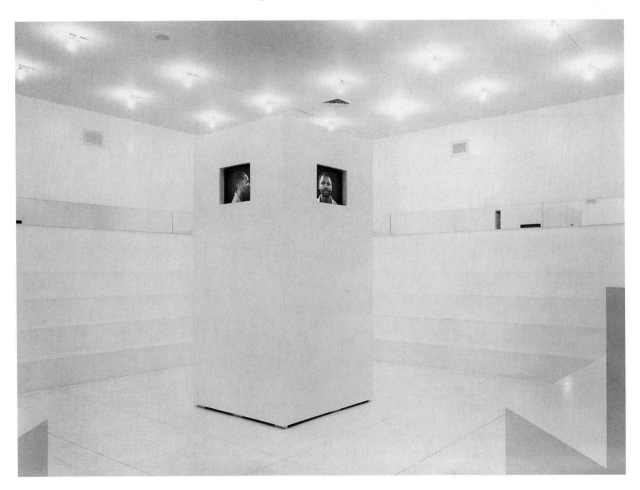

environment clearly registers itself on one's memory. Long after one has departed, the mind replays the scene and the statements again and again, pondering them, considering one's own response to the statements. The experience lasts far longer in time than the number of minutes one sits watching it.

People readily set mobiles into motion or push buttons designed to activate kinetic sculptures to see what they will do. But being asked to become actively involved as part of a work of art may raise some reluctance. Street theater is an example of an art form that depends partly on viewer participation, which can be provoked but never counted upon. When we are faced with a novel situation, who knows how we will act? When invited to participate actively, sometimes we avoid getting personally involved in unusual experiences for fear of appearing foolish to others or of learning something new about ourselves. We humans tend to have a herd mentality; many of us are reluctant to plunge into novel situations until others do so first. Art that operates in free time in which the unpredictable variable is human behavior therefore depends on free people in order to work.

TIMELESSNESS

All art is finite—it exists only a certain amount of time before it decays or otherwise comes to an end. Some works are created in materials designed to withstand the ravages of time, such as marble, but nothing made by human beings is truly permanent. There are ways, however, other than the permanence of an individual piece by which art can transcend chronological time.

One of these is classical appeal. Certain designs last through time because they transcend contemporary aesthetic trends to express more universal standards of beauty or truth. Throughout this book, we have shown numerous very old works that still stand up today as examples of good design. In Chapter 4, for instance, we admired not only Michelangelo's *David* (Fig. 4.21), sculpted back in 1501–04, but also the figure called *Gudea Worshipping* (Fig. 4.18), created in 2100 B.C. We don't think of Michelangelo as a Renaissance artist; we think of him as a consummate artist whose work will always be loved. Some more recent works have also outlasted our society's tendency toward short-lived fads. Mies van der Rohe's lounge chair (Fig. 10.17)—called the *Barcelona Chair* because it was first shown at the Barcelona Fair in 1929—is still being manufactured. It is already referred to as a classic since its beautiful lines, textural contrasts, pleasing proportions, and elegant workmanship have kept it in demand.

In contrast to the long-lived method of transcending time, certain interactive pieces are outside of time in the sense that they can hardly be said to exist until someone becomes involved with them. James Seawright's *Mirror 1* (Fig. 10.18) is a series of mirrors turned toward the center of the piece. The design does not come to life until there is something—or someone—for the mirrors to reflect. Then what one sees will vary greatly, depending on what is reflected. The man in this photo-

10.17 Mies van der Rohe. *Barcelona Chair.* 1929. The Knoll Group, New York, New York.

10.18 James L. Seawright, Jr. *Mirror I.* 1984. An array of 225 mirror-faced blocks, 6 × 6″ (15 × 15 cm), outer dimensions 7 × 7′ (2.14 × 2.14 m). Mirror faces inclined at the precise angles necessary to direct all the faces to the focal point, 12 feet in front of the center of the array. Gift of Mr. and Mrs. Arnold Greenberg, Wadsworth Atheneum.

10.19 Beth Galston. *Lightwall.* 1983. Mirrored Plexiglas strips, projectors, computerized dissolve unit. Size of gallery space: 35 × 35 × 12′ (10.68 × 10.68 × 3.66 m). Installation at Kingston Gallery (collection of the artist).

graph could see only images of the photographer in the mirrors; the photographer could see only the man, reflected as an interesting play of shapes and values across modules that are similar but ever-changing. No two contain precisely the same image. The work does not exist in its "completed" form until someone stands before it, and each time a different person is there to complete the work, it is different.

Finally, much art presents us with the opportunity to transcend time by becoming so fully involved with a work that we forget ourselves, lose track of the passage of time, and experience the vastness of the moment, beyond time. This is an inner experience that cannot be represented in a photograph. But to get some idea of what can happen, consider Beth Galston's *Lightwall* (Fig. 10.19). The installation consists of two panels of mirrored Plexiglas strips, one on the uneven floor and one suspended from above. Four light projectors trained on the strips create reflected linear patterns on the walls that change subtly through time as a computerized dissolve unit changes the lights. When people enter the installation, the reflections play across their bodies. The combined effects have the potential for lifting participants out of their normal consciousness and into a world in which space and time take on entirely different dimensions. Lois Tarlow describes some typical responses:

> Visitors entering the dark room invariably uttered sounds generally reserved for fireflies and falling stars. They approached the strips tentatively, uncertain as to whether they were connected by invisible barriers. Finding easy access, the viewers roamed among the free-hanging mirrors, thereby jostling them and causing the streaks on the walls to lurch about wildly. People spoke in hushed tones. One young man said, "I'd like to live here forever."

PART THREE

CONSTRUCTION METHODS

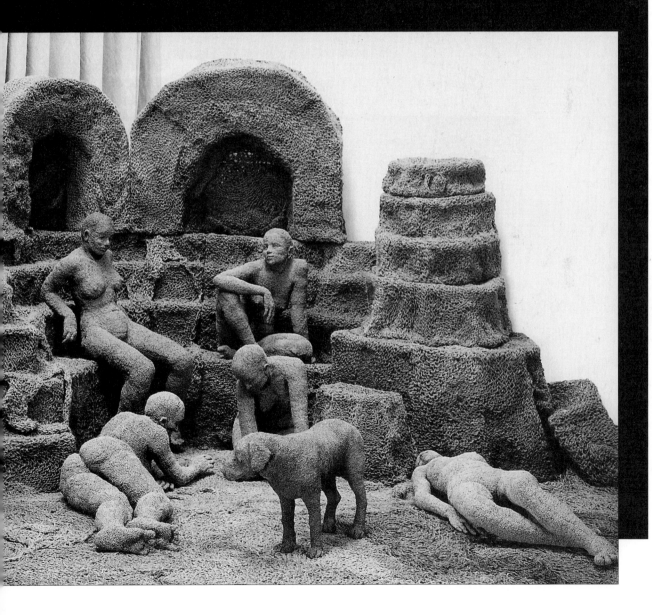

CHAPTER 11

FOUND OBJECTS

A *found object* is any object not originally created as a work of art but appreciated for its aesthetic qualities or personal meaning. Can there be anyone who has not regarded some kind of found object as a treasure? We pick up rounded stones or shells at the beach, enjoying the way they look and feel, and perhaps keep some for luck or display. A colorful feather found on a path seems worth saving, though we may not know quite what to "do" with it. Some of us dig through old dumps for antique medicine bottles, admiring the aesthetic qualities of the hand-blown glass. Weathered old tools may be appreciated for their interesting forms and textures. And semiprecious stones such as amethysts, rock quartz crystals, and onyx are often displayed in their uncut natural state because of the beauty of their colors or transparent clarity.

The appreciation of found treasures seems universal. Through out human history, people have carried this love for the beauty and personal meaning of non-art objects into statements now considered to be art forms. This use of found objects is the first of four major "construction" methods we will be considering.

In some cases, no construction is involved at all; a found object is simply considered worthy of interest in its own right. Sometimes a base is fabricated using art methods and media and then found objects are somehow woven, braided, tied, glued, or otherwise fastened to it. Or found objects themselves may be transformed or assembled to create a piece in which the original identity of the objects is a meaningful or humorous counterpart to the overall form. In any case, the main thing the artist brings to these works is an eye for design in unexpected places and imagination in envisioning how found things could be worked or put together.

INDIVIDUAL FOUND OBJECTS

Nonindustrial societies living close to the earth learn to watch for natural objects that can serve useful functions. Although the objects themselves are found rather than made for the intended purpose, they may be decorated to add an artistic dimension to everyday experiences. The bush people of Southwest Africa find an ostrich eggshell a perfect container for precious drinking water and may carefully engrave and paint ornamental lines on its surface (Fig. 11.1).

Some natural objects are prized simply for their beauty or design interest. When such found objects are not portable, viewers may travel to see them. In the fishing village of Yehliu in Taiwan, erosion of the local sandstone by wind and water has produced fantastic natural sculptures such as the *Queen's Head* shown in Figure 11.2. The "head" consists

11.1 Decorated ostrich eggshell drinking vessel, Luderitz Bay, Nabib Desert, Namibia. Engraved lines filled with red and black pigment, height 5⁷⁄₈" (15 cm). Collection: Volkerkunde Museum der Universitat Zurich.

11.2 *Queen's Head.* Yehliu, Taiwan. Naturally eroded rock formation. Wang Chang-Hwa, *Free China Review*, Taipei, Taiwan.

of harder rock than the more eroded "neck." The resulting formation bears a great resemblance to the sculptures of Alberto Giacometti (see Figures 6.6 and 8.7). Travelers and scholars who have found these natural sculptures refer to them as "national treasures."

Marcel Duchamp is credited with the discovery that manufactured objects such as industrial bottle racks (Fig. 11.3) can be appropriated and displayed as "ready-made" art. Many of us follow his lead by bringing manufactured objects into our homes for uses other than their original functions.

Liza Bruce's London home (Fig. 11.4) is an extreme example of this delight in found objects. In the parlor, on an antique chair that's losing its upholstery, two stuffed baboons sit staring at an aged wheelbarrow holding a classic bust of a woman wearing a large natural sponge on her head. A sofa in the Louis XV style has been recovered with galvanized lead and serves as a tea table next to an African stone bench.

11.3 Marcel Duchamp. Photograph of *Bottle Rack* (no longer extant) from *Boite-en-valise (Box in a valise)*, 1941. The Museum of Modern Art, New York. James Thrall Soby Fund.

11.4 Liza Bruce. Sitting room of her home, London. Photo Simon Upton.

Everything in the house has a personality, a visible sense of history; even the walls have been laboriously stripped back to the original peeling plaster.

ASSEMBLAGES WITH SPIRITUAL CONNOTATIONS

When everyday non-art materials are combined to create a work of art, the result is often called an *assemblage*. Some such works are used for special spiritual functions, for the personal or group meaning attached to each thing adds to the spirit of the whole. A handmade quilt may enhance a family's sense of historical kinship, for each bit of fabric may recall incidents in family history: "This one was from the dress Carrie wore the first day of school; this was John's christening dress; here's a scrap of your mother's wedding dress. . . ." Likewise, to put together found objects representing earth, air, water, and fire brings one into symbolic contact with the universe.

In African tribal cultures, assemblages of found materials are amassed for ritual display and power-enhancing purposes. Objects attached to masks, headdresses, or power figures like the piece shown in Figure 11.5 may carry symbolic social significance—such as indicating wealth and status—as well as invoking the aid of supernatural forces. Cowrie shells connote wealth, for the shells are used as money in many of these groups. Cowrie shells also have intriguing tactile and visual qualities, with a combination of surface smoothness and dark hidden inner recesses that many cultures have linked symbolically with femaleness.

The design of a ritual display or power piece may be informal enough that it can be added to as time goes on and additional materials are found. These range from skulls of small animals, teeth, seed pods, shells, fur, feathers, and claws to mirrors, nails, beads, and shotgun shells, with an emphasis on repetition of many small units. In the accretion of materials, the prevailing feeling seems to be "the more, the better," and many people may bring found things to the piece over time, giving it a variety of textures and forms and a lively organic appearance of growth. Each addition brings a different kind of spiritual power—as well as form and texture—to the piece. The addition of new materials is often accompanied by special chants and spreading of dried blood or the like on the piece to honor and increase the magical powers being drawn into the sculpture. Even if we are not privy to the symbolism involved, we may find such a piece visually and psychologically exciting. It raises questions for which the mind has no answers: Why? How? Where did they get those?

Assemblages may also express devotion. In Naples, devotion to various saints as intermediaries between oneself and heaven is often expressed in homemade roadside shrines. Whatever is available to enhance the love offering is incorporated into the design, from bits of ironwork, plastic, and sculpture, to flowers, candles, and even neon lights. Continual additions to such pieces allow one to maintain a sense of personal contact with the divine. The shrine in Figure 11.6 includes

11.5 Fetish figure. Primitive wood sculpture, African, Zaire, Kongo. Height 23⅛" (58.8 cm). The Metropolitan Museum of Art, The Michael C. Rockefeller Memorial Collection, Bequest of Nelson A. Rockefeller, 1979.

11.6 (left) Roadside shrine, Naples. 1948. Stucco and marble, height 2′ 6″ (0.76 m). 1978 photograph in Rhode Island School of Design Museum. Photo Salvatore Mancini, Providence, Rhode Island.

11.7 (right) Lucas Samaras. *Untitled Box Number 3.* 1963. Pins, wood, rope, and stuffed bird. Overall: 29³/₁₆ × 18³/₄ × 16¹/₄″. Collection of Whitney Museum of American Art. Gift of the Howard and Jean Lipman Foundation, Inc. 66.36a–b.

a skull, perhaps as a reminder that things of the earth are fleeting and that one might better keep one's vision set on the eternal.

The local emotional response to such pieces, be they tribal sculptures or Catholic shrines, stems from a shared spiritual tradition that everyone in the area understands. An outsider untutored in these beliefs may nevertheless experience a certain aura of mystery or sacredness surrounding these assemblages, as though they awaken deep-buried memories from what psychologist Carl Jung called the "collective unconscious." Be that as it may, certain artists can evoke the sense of sacrosanct mysteries without referring to any tradition with which we are familiar. Lucas Samaras's *Untitled Box No. 3* (Fig. 11.7) creates such an effect by suggesting a hidden, secret place. Found materials are used as though collected by a bird to create a nest of sorts, woven of bits of wood and bristling with thousands of pins. The frayed twine hanging below is strangely out of scale for a nest, but its outsized appearance makes it all the more noticeable as something found and brought to this creation. The stuffed bird nestles within, protecting a dark and secret space into which we feel we should not intrude.

11.8 Pablo Picasso. *Baboon and Young.* Vallauris, 1951. Bronze (cast 1955), after found objects, 21 × 13¼ × 20¾″. The Museum of Modern Art, New York. Mrs. Simon Guggenheim Fund.

JUNK SCULPTURE

Our affluent society's tendency to throw away used objects rather than reusing or recycling things has opened fertile new ground for artists. Sometimes in protest against wastefulness, sometimes in delight at finding creative uses for castoffs, a number of artists turn what is considered junk into assemblages that work as art.

In some of these assemblages, the discovery that a castoff looks like something entirely different is both the artist's motivation and the viewer's surprise. In Picasso's *Baboon and Young* (Fig. 11.8), our interest is suddenly captured when we notice that the baboon mother's head is actually a toy car. The relationship between these two forms is totally unexpected, an altogether original perception. That it works so well—with the back tires enlarged as ears—is a tribute to Picasso's imagination, his gift for seeing possibilities in even the most mundane materials.

Sometimes a number of found objects are put together in such a way that the combined image suggests another form. In Richard Stankiewicz's hands, old bedsprings and coiled springs are transformed

into grotesque representations of the lacy veil and tender curls of *The Bride* (Fig. 11.9). Stankiewicz began making junk sculptures when his attempts to turn his yard into a garden unearthed a quantity of old metal things. The artist says he found them so "beautiful" in themselves that he "set them aside as objects to look at . . . , and of course it was only a short step of the imagination to combine various of these things together to make compositions from them." Making abstract peoplelike figures from unwanted machine parts inevitably prompts symbolic associations, as though these grotesqueries are apt metaphors for the human inhabitants of industrial society. As Stankiewicz notes, "Visual puns, mechanical analogies and organic resemblances in machinery provide a large and evocative vocabulary for sculpture." It is a vocabulary that may evoke humor or despair, depending on the intention of the artist and the psychology of the viewer.

Although the junk of our civilization often inspires works with a busy variety of lines, forms, colors, and textures, it is possible to create quietly simple art from found objects. An example of this approach is Varujan Boghosian's *Orpheus,* shown in Figure 11.10. Here a minimum of found objects—an old doll and a vise mounted on a piece of wood— are used to create a wealth of symbolic or psychological associations. With the title as a clue to the content, we can imagine the legendary Orpheus as a figure from the sunlit world traveling into the darkness of Hades to rescue his wife, Eurydice. The vise holding the doll in place may suggest Orpheus's attempt to avoid turning back to look at Eurydice until she reaches the sunlight. Those who are unfamiliar with the myth may experience other associations: the dreamlike sense of a past remembered; the pathos of a once-loved but discarded child's toy, juxtaposed with and even being held captive by an adult's tool, itself hand-worn. In another sense, the vise becomes more than a vise; it becomes part of the body of the doll, or even a pedestal for it. One is struck also by the contrast of the doll's lightness to the darkness of the wood.

While found objects offer great potential for representational allusions, certain artists present junk as abstract sculptures to be appraised solely on the basis of their design characteristics. John Chamberlain scavenges used car bodies from junkyards and then cuts, paints, twists, mashes, and welds the pieces together into sculptures such as *Acme Thunderer* (Fig. 11.11). Chamberlain walks among rows of color-sorted parts in his studio, waiting for his eye intuitively to match pieces that somehow belong together. He explains this way of working:

> If I find two things that go together for me at the moment, then I've got something started. I don't understand it too much myself. I'm more interested in seeing what the material tells me than in imposing my will on it. You have to know when to stop.*

11.9 Richard Stankiewicz. *The Bride.* 1955. Steel, 5′ 9″ × 14″ × 13″ (175.3 × 35.6 × 33 cm). Private collection.

The reflective surfaces and lines formed where the bare metal is exposed continually play off one another. In Chamberlain's hands, old cars undergo a metamorphosis into sculptures of strange beauty; nothing

* John Chamberlain, as interviewed by Ken Johnson for "Of Industry and Intuition," *Art in America,* April 1991, pp. 132, 134.

11.10 (left) Varujan Boghosian. *Orpheus.* 1973. Wood and cloth. 41¼ × 26¼ × 9″. Courtesy of Claude Bernard Gallery.

11.11 (below) John Chamberlain. *Acme Thunderer.* 1989. Painted, stainless, and chromium-plated steel, 9′ 4¾″ × 8′ 8¼″ × 6′ 1¾″. Photo courtesy The Pace Gallery, New York. Photograph by Peter Foe/Fotoworks.

suggests the tragedy of a terrible car accident. This metamorphosis is often the aim of the junk sculptor. To make something from scratch is an act of creation; to reclaim things that no one wanted and turn them into art is an act of salvation.

INSTALLATIONS

In the growing genre of installation pieces, many artists are using found objects to get their message across. These may be purchased ready-made things rather than discarded artifacts. The aesthetics of their use requires an eye for how something might be used in an entirely different context and what it might do if juxtaposed with something else.

11.12 Adrian Piper. *Cornered.* 1988. Video/table/lighting/birth certificates. Video length: 17 minutes. Photo Fred Scruton. Courtesy John Weber Gallery, New York.

Adrian Piper's *Cornered* (Fig. 11.12) incorporates three perhaps new chairs, a table turned on its side, a video set placed as if in a stage setting with a curtain, a video of the artist as a sort of found object, and two birth certificates. In the video, Piper announces that she is black even though she does not appear to be of African descent. "I'm cornered," she says.

> If I don't tell you who I am, then I have to pass for white. The problem with passing for white is not just that it's based on sick values—which it is—it's also that it creates a degrading situation in which I may have to listen to insulting remarks about blacks made by whites who mistakenly believe there are no blacks present.*

The chairs are obviously modern, whereas the birth certificates, their frames, and the table have an older appearance. The table has been placed as if it were a barrier between the viewers, who are to sit in the sterile modern chairs, and the speaker and her background. The economy of means allows a strong impression of spatial planes: Table, video, and birth certificates are each on a separate plane receding from the viewer and backed into a corner. The installation is designed to confront the viewer's possible racist attitudes, and the kind of chairs given for viewers to sit in involve and define them in specific ways. Imagine how different the piece would feel if there were overstuffed armchairs or a

* Adrian Piper, quoted by Ken Johnson in "Being and Politics," *Art in America,* September 1990, p. 156.

chintz sofa to sit on, or if the video monitor were set on top of an upright table. Choice and placement of found objects become important, if subtle, parts of how an installation piece works.

Even though found objects may be individually identifiable in an installation piece, the statement they make together may still leave a lot of room for interpretation. In many cases, knowledge of certain cultures or historical events broadens the field of possible interpretations. In Figure 11.13, Braco Dimitrijevic has gathered as found objects Rene Magritte's painting *Le Beau Ténébreux,* the black hats and coats of Hasidic Jewish men placed atop white pedestals, and apples. There are obvious references to Judaism here, including the apple of the biblical story of Adam and Eve, but what is the relationship of the clothing and apples to Magritte's painting, in which a man's disembodied face appears within a top hat? Magritte once painted an apple, so huge that it fills a room. Does it help to be familiar with that painting? Does it help to know that Magritte wears a suit when he paints? What is the symbolic meaning of the coats and hats to traditional Hasidic Jews? The installation, *Hopes and Ways to Identity* is surrealistic, yet one has the distinct sense that there is some symbolic meaning in this dream. It lies just beyond the level of consciousness, and we are invited to bring all our associations to the task of figuring out what is going on here.

11.13 Braco Dimitrijevic. *Triptychos Post Historicus, or Hopes and Ways to Identity.* 1990. Part 1: Rene Magritte, *Le Beau Tenebreux,* 1950. Part 2: Coats from Mea She' arim, hats gift of David Redberg, Jerusalem. Part 3: apples. Photo courtesy the Israel Museum. Collection the Israel Museum, Jerusalem.

11.14 David Hammons. *Public Enemy.* 1991. Photographs, balloons, sandbags, guns, and other mixed media. Photograph © Scott Frances/ Esto. All rights reserved.

As we unravel the conceptual reasons why an artist has chosen to juxtapose certain found objects, we discover strong political statements in many contemporary installations. In *Public Enemy* (Fig. 11.14), David Hammons places the viewer outside police barricades and sandbags, but within a space littered and enlivened with the debris of a great parade. In a cordoned-off area are photos of the four sides of the statue of Theodore Roosevelt triumphant on a horse, while a Native American and an African American walk alongside on foot. The first impression of celebration is gradually replaced with other emotions, as we discover secondarily that there are guns here—some toy, some real—trained on the figures, and that we are on the side of those who have created and armed the barriers.

A final motivation for the use of found objects is sheer exuberance for life in all its forms. Simon Rodia's *Watts Towers* (Fig. 11.15) is a monumental expression of this all-embracing aesthetic. Trained in tile setting but unschooled in art, Rodia spent 33 years creating his marvelous towers from a framework of concrete and wire mesh, covered with a rich mosaic of found objects: glass from broken bottles, shells, mirrors, tiles, shards of dishes. The airy structures rise almost 100 feet into the Los Angeles sky, assertions of the grandeur and dignity of the spirit no matter how oppressive the surroundings. At close hand, as in

11.15 Simon Rodia. *Watts Towers.* Los Angeles. 1921–1954. Concrete and steel with bits of glass, broken dishes, shells, pieces of mirrors, and other debris from the streets. Height of tallest tower 99' 6" (30.17 m). © Seymour Rosen-SPACES.

the foreground of the photograph, the objects' individual identities can be distinguished. But from a distance, they merge into exuberant abstract patterns of color and form. Whether seen as "naive" folk art or the intentional choice of a formally trained artist, the ability to appreciate the design possibilities of whatever is at hand is a compelling motivation for the construction of works from found objects.

Reference Books on Working with Found Objects

Gerald F. Brommer. *Wire Sculpture and Other Three-Dimensional Construction.* Worcester, Massachusetts: Davis Publications, Inc., 1968. Contains a chapter on assemblage with provocative suggestions for projects and some how-to instruction on physical and visual unification of works made from found objects.

Dona Z. Meilach and Don Seiden. *Direct Metal Sculpture: Creative Techniques and Appreciation.* New York: Crown Publishers, 1966. Includes information on soldering, brazing, and welding of metals to each other, combining metal and nonmetal materials, and creating sculptures from found objects.

CHAPTER 12

ADDITION AND MANIPULATION

Whereas found objects are often used as is, other techniques for three-dimensional construction involve changing the form of the original material. Those to be explored in this chapter are based on manipulating forms directly without significantly changing their physical volume and/or putting units together to create a larger whole. The two remaining chapters will focus on methods of subtracting excess material to reveal a smaller form or creating desired forms through less direct casting processes. These categories are not mutually exclusive, for many pieces are constructed by a combination of various methods. In addition, the same material may also be handled in a number of different ways. Wood, for instance, may be built up in units for *additive* sculpture or carved away by *subtractive* methods.

MANIPULATING MALLEABLE MATERIALS

One very direct method of working three-dimensionally is shaping *malleable* materials by hand or hand-held tools. These are media that are pliable enough to be stretched, flattened, bent, curved, or twisted with-

12.1 Urn incensario with figure seated on monster head, Tabasco, Mexico. Classic Mayan, A.D. 250–900. Unslipped buff earthenware, 16⅛″ (40.8 cm). Indianapolis Museum of Art. The Wally and Brenda Zollman Collection of Pre-Columbian Art. Photo © Justin Kerr 1985.

12.2 Kaliya-Krishna, South Indian, 14th century. Bronze, 2′ 1¼″. Crown copyright. © The Board of Trustees of the Victoria & Albert Museum.

out falling apart. Their ability to be worked in these ways is often referred to as their *plasticity*. In the long run, plasticity is not usually considered desirable, so these media are usually worked in a rather soft state and then hardened for durability.

To create additive sculptures with malleable materials is to build up forms in space. This may be done directly, as in the classic Mayan urn shown in Figure 12.1, with relatively thin expanses of clay modeled with hands and tools and then fired to hardness. The building up of forms doesn't always require kiln firing. An artist may begin with an underlying *armature* of a stiff material such as wood or metal, then cast the piece in metal such as bronze. (Casting techniques will be discussed in Chapter 14.) Certain metals will support extensions from the central mass—see the lovely fourteenth-century Indian bronze shown in Figure 12.2. The traditional way of building up forms additively is to envision and model the major underlying forms in space and then elaborate the secondary contours on the surface.

Clay

Clay is a highly plastic material that has been used for three-dimensional construction since ancient times. This medium is pliable enough to be shaped between the hands when wet, brittle when dry, hard and rela-

12.3 Minnie Negoro throwing on a wheel.
Photo by Beverly Dickinson.
Courtesy of Minnie Negoro.

tively durable when fired, and can be glazed to a variety of finishes. Clays are found as natural deposits resulting from the disintegration of certain kinds of rock, each differing in characteristics such as plasticity, color, texture, and behavior when fired for hardening purposes. Artists who use clay often mix their own *clay bodies* from various types of clay in order to get just the properties they want. Their contact with the clay is quite intimate and direct, for traditional methods of building or throwing a form on a wheel require really getting one's hands into the material. As potter Minnie Negoro (shown at her wheel in Figure 12.3) explains:

> You have to like the feel of this very plastic malleable material. It's a sense on your fingertips, moving in and out. When you can control this, when you have the ability to make the clay move just the way you want it to, it's very personal. And since clay is a material that you can compound yourself of different kinds of clays to make the textural feel you want, that becomes very important. Before it's even fired, when it's still in the raw state, you can get that kind of feel that you like to use. You can have it just as smooth and silky or grainy and rough as you want, and then apply force to it to create the form you have in mind.

Although throwing a pot on a wheel is a very direct method of shaping in the sense that the artist's hands guide the growth of the pot from the bottom up, the skills involved are anything but spontaneous. The procedure of clay compounding, firing, and glazing is highly technical and subject to endless experimentation. And to create a classical,

symmetrically rounded form takes great control, developed over years of practice. Clay directly and honestly mirrors the movements of the human hand.

Wheel-thrown forms may be cut, reshaped, or otherwise manipulated into nonsymmetrical forms. There are numerous other means of working clay in addition to wheel throwing, such as pinch, coil, slab, and direct modeling techniques. These methods may rely heavily on chance and the inspiration of the moment, or they may involve considerable planning and control, depending on the intent of the artist. Peter Voulkos has used pottery techniques imaginatively to create a huge body of vigorous ceramic sculptures. In his 7-foot-high (2.13 m) *Gallas Rock* (Fig. 12.4) he pushed clay to a great height by stacking around a central support about 100 slab-formed and wheel-thrown pieces opened

12.4 Peter Voulkos. *Gallas Rock.* 1960. Terra-cotta, height 84″, width 37″, depth 26³/₄″. Franklin D. Murphy Sculpture Garden, University of California, Los Angeles. Gift of Julianne Kemper, 1973. Courtesy of UCLA Wight Art Gallery.

12.5 Preparing a clay model for a bucket seat for General Motors. Photo © Dick Durrance, 1986/Woodfin Camp & Associates, New York.

"to let the dark out." Although Voulkos works very quickly and spontaneously, his ability to create such a technical tour de force is based on years of experience and experimentation with clay.

Whether they emphasize control or happenstance, artists have often chosen to work in clay because of its immediacy. Sometimes clay is used to capture an idea that will later be translated into some more permanent material. If it does not need to be fired for permanency, clay can be built up as a solid mass, with bits added and molded as needed. Models for new cars—both outer bodies and interiors—are typically developed through a series of clay studies, such as the one shown in Figure 12.5. Rodin did quick clay studies of his models as they moved through his Paris apartment to capture their natural movements, later to be sculpted more permanently in the slow method of carving marble.

Clay is also used as a permanent medium for modeling figures. Andrea del Verrocchio's *Virgin and Child* (Fig. 1.14) was modeled of terra-cotta back in the fifteenth century, but it survives in good shape today. This lovely piece is not very thick, because it is a relief. But when clay is used to model thick forms they must be built hollow or hollowed out with an air hole left to the inner cavity before firing, for a thick piece may burst in the kiln when fired. Clay has little strength under tension. And because of its plasticity, clay succumbs rather readily to the tug of gravity. Projecting forms, such as arms held out from the body, are particularly vulnerable. Large works must be carefully supported by an internal armature to avoid unintentional sagging or breaking. The size of works to be fired is also limited by the relatively small size of most kilns. Fairly large works may be created in sections, hollowed, fired, and then reassembled.

Large ceramic works are not uncommon now that ceramists have begun exploring the far boundaries of what can be done with clay. Tom McMillin uses a forklift to compress clay and rammed earth into wooden forms and then coats them with charcoal so that the large sculptures (Fig. 12.6) become their own kiln as they are fired in place.

12.6 Tom McMillin, in the process of building rammed earth and clay sculpture that will be fired in place with a coat of charcoal. From Susan Peterson, *The Craft and Art of Clay* (Englewood Cliffs: Prentice-Hall, 1992). Photo Susan Peterson.

12.7 Edgar Hilaire Germain Degas. *Statuette: Horse Galloping on Right Foot.* c. 1881. Bronze cast of wax model, height 11⅞″ (30 cm). The Metropolitan Museum of Art, Bequest of Mrs. H. O. Havemeyer, 1929. The H. O. Havemeyer Collection.

Firing (baking to remove moisture and harden the clay) and *glazing* (application of a glasslike liquid that fuses with the clay when fired) require extensive knowledge of complex variables. Most pieces are first fired for several hours at relatively low heat to harden the form but keep the clay porous enough to receive a glaze. This *bisque* ware is then glazed and refired at a higher temperature.

Glazes are used decoratively and also serve the function of making ceramic pieces watertight and nonabsorbent. Glazes also carry pigments to color the surfaces of a piece; they can be brushed, poured, or sprayed on, or the piece can be dipped into a container of glaze. The minerals used to formulate them and their proportions within the formula can be varied for different effects.

In ancient work with clay, pieces were baked directly in the coals of a fire or in covered pits. The contemporary *kiln* is an insulated furnace for firing ceramic pieces that is heated by electricity or by a wood, coal, oil, or gas fire in a separate combustion chamber. Control and even distribution of the heat are critical. *Earthenware,* which uses coarse clays such as terra-cotta to create rough-textured, porous pieces, is fired at a relatively low temperature (about 800° C, or 1470° F). *Stoneware,* made from finer clays, is fired at a higher temperature to form a more glasslike body. *Porcelain,* made from the finest clays, is fired at the highest temperature (up to 1613.4° C, or 3000° F).

Wax

Another highly plastic medium is wax. Warmed slightly for softening, sometimes just by being rolled in the hands, it can take a great amount of twisting, bending, and reforming without breaking. Additional pieces can easily be attached to a form being built up. The artist presses dabs of wax in place or heats both surfaces with a hot tool to allow them to

bond without the misshaping of pressing. Like clay, wax can be smooth- or rough-textured in its final form. Edgar Degas did a series of small wax sculptures, like the horse shown in Figure 12.7, in which the dabs of wax are not fully smoothed into the figure's contours. In addition to creating interesting textures, the wax pieces increase the liveliness of the figure by conveying a sense of spontaneity, as though the work came so recently from the artist's hands that we can still see his thumb-prints. These wax figures were later cast in bronze—for wax melts too easily to hold its shape in warm weather—and the cast retains the fresh quality of the way Degas handled the wax.

Plaster and Cement

Plaster and cement can also be built up directly with the hands and simple hand tools, though they need a supporting understructure to hold projections or curving contours. Some materials commonly used to build up the understructure, or *armature,* include wire, rods, screening, hardware cloth, metal lathe, wood, and foam. Plaster or cement is usually applied to this base in wet layers and finished wet. Rodin's plaster *Young Woman in a Flowered Hat* (Fig. 12.8) shows obvious signs of having been gouged with pointed tools when the plaster was wet to create textures such as strands of hair and herringbone weaving on the hat. These materials can also be allowed to dry and then chiseled or filed away. Pigments can be added to the mixture for color, and filler materials such

12.8 Auguste Rodin. *Jeune femme au chapeau fleuri (Young Woman in a Flowered Hat).* 1865–1870. Plaster. 27 × 13$\frac{1}{2}$ × 11$\frac{5}{8}$″ (0.69 × 0.344 × 0.295 m). Musée Rodin, Paris. Photo Bruno Jarret, Paris.

as sand, fine gravel, or marble chips may be added to the final layer to produce desired textural effects. Plaster has little tensile strength and may crack when it is worked dry or chip afterwards. But its low cost and flexibility makes it an inexpensive choice for pieces to be used indoors or patterns for projects to be cast or otherwise translated into more durable media. Concrete is somewhat more coarse, but this characteristic is appropriate for certain large, simple outdoor forms.

Malleable Metals

Some metals, while not pliable enough to be shaped by the artist's hands alone, are nonetheless malleable enough to be formed by bending, stretching, twisting, and hammering over a hard flat or shaped surface. As metals are worked, they become harder and therefore less malleable, a condition that can be reversed temporarily by heating, a process called *annealing*. Metals and alloys, or combinations of metals, vary in physical characteristics. In metals, *malleability* is the ability to be shaped readily by hammering; *ductility* is a property permitting the metal to be drawn out into wire or threads. *Hardness* is measured by the depth of a scratch that can be made on a metal by a weighted diamond point. The table below summarizes variations in these three properties for some common metals.

Metalsmiths and jewelry makers use a variety of tools and techniques to change thin sheets or rods of the relatively soft metals into desired forms and surface textures. Thin wire can be bent into desired shapes; thicker metals may be struck with a variety of tools, each of which leaves its own shape as an impression in the soft metal. In jewelry, *repoussé*—hammering thin sheet metal from the back, using a variety of punches—creates low relief patterns on the front side. These patterns may be further worked from the front with hammer and punches, a process known as *chasing*. In Figure 12.9, Douglas Steakley is using

PHYSICAL PROPERTIES OF METALS

Hardness	Ductility	Malleability
Lead (softest)	Gold (most ductile)	Gold (most malleable)
Pewter	Silver	Silver
Tin	Platinum	Lead
Aluminum	Iron	Copper
Gold	Nickel	Aluminum
Silver	Copper	Tin
Zinc	Aluminum	Platinum
Copper	Zinc	Zinc
Nickel	Tin	Iron
Platinum	Lead (least ductile)	Nickel (least malleable)
Iron		
Steel (hardest)		

(Information based on Jack C. Rich, *The Materials and Methods of Sculpture,* New York: Oxford University Press, 1947, p. 129.)

12.9 Douglas Steakley shown raising a piece of holloware. Photo Lee Hocker, Carmel, CA.

the process of *raising*—hammering a flat sheet of metal over a stake, compressing it to create a hollow form. The finished piece can then be left with the texture created by the hammer, as in the vase and bowl shown in Figure 12.10, or filed and polished to a high finish.

Even iron and steel can be reformed if heated to a relatively malleable state. Long used to create a limited range of functional pieces, blacksmithing is now used as a fine-art technique as well. L. Brent Kington's *Rocking Horse* (Fig. 12.11) is not only a delightful child's toy but also a beautiful study in flowing line and positive and negative form. The techniques used to shape the steel are ancient—*forging* (hammering over an anvil or other hard surface), chiseling to define contours, and chasing to provide details on the head. What is new here is the increasing freedom artists and craftspeople feel to push their media and methods into previously unexplored aesthetic territory.

12.10 (above) Douglas Steakley. *Vase and Bowl.* Vase: silver-plated brass, height 7¹/₂″ (19 cm). Bowl: copper, raised with oxide finish, height 4¹/₂″ (11 cm). Photo Lee Hocker, Carmel, California.

12.11 L. Brent Kington. *Rocking Horse.* 1972. Steel, forged, chiseled, and chased, length 44″ (112 cm). Westwood Art Center, Cincinnati. Courtesy of the artist.

12.12 Minako Watanabe. *Water.* 1992. Installation, 20' × 20' × 20". Monofilament fishline, silk thread, multiple-layer weave on a 16-harness computer loom, particle board, plywood, fluorescent light. Courtesy of the artist.

FIBER ARTS

Some of the most exciting redefinitions of the possibilities of specific construction methods are occurring in the *fiber arts*. This label covers all work created by interweaving single fibers of some material to create a larger whole. Conventionally, techniques such as weaving, knitting, and basket-making were used solely to create functional objects. In recent years, artists have ranged far beyond the traditional uses and methods of working with fibers. As is true in any area, if creativity is allowed to flow freely, the results will be living, changing, ever-expanding.

Rugs and tapestries were traditionally flat-woven to warm and decorate floors and walls. Some fiber artists are now bringing these techniques off the walls and into three-dimensional space. Woven goods may project outward from the wall or sometimes come off the wall entirely. The richly colored textural fiber walls of Minako Watanabe's *Water* (Fig. 12.12) create an environment of its own. This large installation has an ebb and flow that captures the illusion of undulating water. The open texture of the weave allows the piece to have a lightness of width and depth, and the artist's use of color adds to the illusion of tidal water. When weavers choose to work this large, they move into nonconventional considerations such as the need for special installation.

Crocheting, once limited to clothing and decorative items, offers the inventive artist unbounded opportunities for creating three-dimensional forms. One solution to making a crocheted piece occupy three-dimensional space is to coat it with some stiffening agent such as lacquer, as Norma Minkowitz has done in *The Ghost of Icarus* (Fig. 12.13). Ewa

12.13 Norma Minkowitz. *The Ghost of Icarus.* 1991. Fiber and paint, 22 × 22 × 10″. Courtesy of the Bellas Artes Gallery, Sante Fe, New Mexico.

Pachucka stuffed her crocheted forms to create the extraordinarily lifelike aboriginal scene she calls *Arcadia* (Fig. 12.14). Each of the lifesize women and animals is the result of intricate crocheting of polypropylene yarn. Their surroundings are made from coir, which is the spun hair of coconut. The resulting textural effects could not have been created in any other medium.

12.14 Ewa Pachucka. *Arcadia: Landscape and Bodies.* 1977. Crocheted fiber, mixed media, 8′ × 13′ (2.44 × 3.96 m). Art Gallery of New South Wales. Gift of Rudy Komon Art Gallery, 1978.

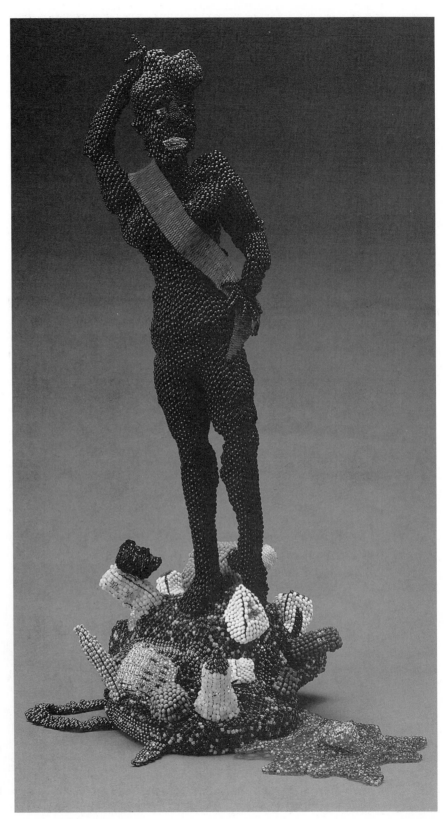

12.15 Joyce J. Scott. *Big Mama.* 1991. Beads, thread, wire, wood, 27 × 8 × 10". Photo: Kanji Takeno. Courtesy of the artist.

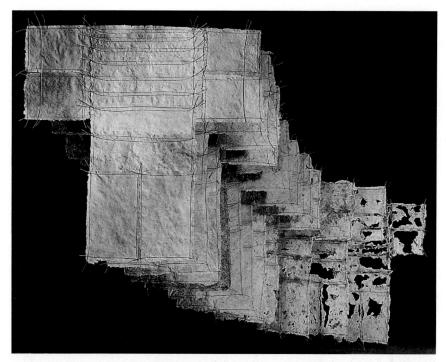

12.16 Hiltrud Schaefer. *Transitoriness and Decay.* 1990–91. Handmade vegetal paper (various sorts of grass, reed, fern, etc.), bleached, hardened, with stitched-on cane sections. In the artist's possession. 2.70 × 5 × 10 m. Courtesy of Biennale Internationale de Lausanne, CITAM.

Beads are usually strung into flat designs, but Joyce Scott threads them onto thin wire in order to shape them three-dimensionally, as in the work shown in Figure 12.15. Paper is likewise traditionally pressed into flat sheets, but Hiltrud Schaefer has fabricated huge sheets of paper by hand and supported them with cane to make a 32-foot-long three-dimensional sculpture suggesting the decay of material objects (Fig. 12.16).

Some fiber arts even negate the classical traditions by which fibers are knitted, knotted, crocheted, pressed, or woven together. In Virginia Gorman's *Ten Walking Jeans* (Fig. 12.17) she has recycled ten pairs of blue jeans by adding a hardening compound. The free-standing openness is a fitting metaphor for the freedom with which she and others are exploring the design possibilities of fibers.

GLASS

Glass becomes highly malleable when it is hot, and hard when it is cool. Despite the fragility of their transparent beauty, manufactured glass objects have been made for thousands of years. The glass itself is traditionally made simply of sand, mixed with soda to lower its melting point, and stabilized by an ingredient such as lime. Although the resulting material can be broken, it does not decay, for it is resistant to water, acids, and gases. Substituting lead oxide for the soda produces glass compounds of great brilliance.

Unlike other materials, the silica in sand does not expand much when it is heated and is almost completely elastic. Under heat, it can be cast or modeled into any shape. Glassworkers use a fire—such as the

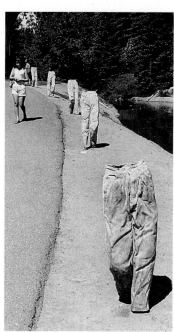

12.17 Virginia Gorman. *Ten Walking Jeans.* 1991. Recycled jeans. Photo Debbie Van Blankenship.

12.18 Blowing a glass tube into a vessel.

flames of gas jets—that is hot enough to melt glass for working but not so hot that the glass melts beyond control. Often they begin with a tube or rod of glass, rolling it for symmetrical flaring as heat is trained on the area being worked. Blowing into a glass tube causes the heated end to expand (Fig. 12.18). The glass rod or tube can be cut with a glass cutter or by being heated and pulled in both directions.

Glassworking often requires two people, one to handle the rod and one to shape the glass at its end. In Figure 12.19, Dale Chihuly waits with a paddle to shape quickly a still-warm glass disk spun out by an assistant. Colors may be added to the glass by dyes or fused onto the exterior as enamels.

Techniques for working and coloring glass have been elaborated upon during the twentieth century in the studio glass movement, making possible such exquisite tours de force as Dale Chihuly's organic sea-like forms, such as the one shown in Plate 27.

12.19 Dale Chihuly and assistant prepare to do final shaping of a glass work in its still-hot malleable state. Photo Phillip Amdal. Courtesy of Dale Chihuly.

12.20 Koichi Ebizuka. *Related Effect S-90LA.* 1990. Wood and coal. Collection Galerie Tokoro, Tokyo. Photo Tadasu Yamamoto.

FABRICATION WITH RIGID MATERIALS

Units of more rigid materials such as wood, metals, plastics, and stone can be assembled into larger wholes. Sometimes these materials are first reshaped to some extent, though their rigidity limits their malleability.

Wood Fabrication

In additive sculpture, woods may be used as lumber milled into standard flat shapes, such as sheets of plywood or 2×4s. Koichi Ebizuka uses milled logs in *Related Effect S-90LA* (Fig. 12.20) but very subtly curves their contours, thus relating them once again to the organic forms of the tree trunks from which they were shaped. Found woods—such as barnboards or weathered driftwood—may be used as the elements have shaped them. Wood can also be steamed to a pliable state and then curved, as in bentwood chairs or the beautifully curving wooden frame

12.21 Edward Livingston. *Cradle.*
© 1973. Walnut, width 24″ (61 cm),
length 43″ (109 cm), height 36″
(91 cm). Sterling Associates, Palo Alto,
California. Photo Edward Livingston.

of Edward Livingston's *Cradle* (Fig. 12.21). Curving wooden forms can also be created by *laminating*—gluing thin, flat sheets of wood together—and then sanding them in such a way that their outer surfaces form curving contours, as they do in H. C. Westermann's *Nouveau Rat Trap* (Fig. 12.22). In this humorous satire on the curvilinear Art Nouveau approach to functional pieces, woods of varying values have been used. These value striations enhance the interest of the design by accentuating the fact that the form has been built up of many sheets of wood rather than trying to make them blend together into a single tone.

12.22 H. C. Westermann.
Nouveau Rat Trap. 1965. Collection
Mr. and Mrs. Robert Delford Brown,
New York. Photo Nathan Rabin,
New York.

12.23 Jackie Winsor. *Bound Grid.* 1971–72. Wood, twine, 6′ 3½″ × 6′ 4″ × 14½″. Fonds National d'Art Contemporain, Paris. Courtesy of the artist.

12.24 Tom Miller. *And the Livin' is Easy.* 1989. Enamel on wood and acrylic on nylon, 5′ 6½″ × 5′ × 4′. Courtesy of Steven Scott Gallery, Baltimore.

Wood is soft enough to be cut readily with tools such as hand and power saws, lathes, and planes. Pieces of wood can then be attached to each other by nailing, gluing, joinery, or bolting. The strength of the joints is critical. In a piece of furniture, the stress of being sat on and pushed around, added to changes in temperature and humidity, may cause joints to come apart. Outdoor pieces must bear not only their own weight but also stand up to wind, rain, and perhaps snow loads and the weight of climbing human visitors. The larger the piece, the stronger the joints must be.

If bolts, rivets, screws, or other fasteners are needed, how will they affect the aesthetics of the design? Sometimes fasteners are totally hidden; sometimes they are used as subtle counterpoints or accents to the primary form. Jackie Winsor takes a third approach: In her *Bound Grid* (Fig. 12.23), the knobby joints created by thick lashing of horizontal and vertical wooden members, and the asymmetrical negative spaces defined between them, become the primary focuses of the piece, rather than the pieces being bound.

Wood is such a common part of our domestic environment that it is often used conceptually by contemporary artists. Tom Miller's *And the Livin' is Easy* (Fig. 12.24) adds wooden watermelon-slice legs and black hands to an old wooden rocking chair and shades it with a smile-embossed, crow-topped umbrella to criticize by exaggeration the racism in folk art depictions of African Americans as people who do nothing but loaf and eat watermelon.

Metal Fabrication

With the growing interest in large-scale outdoor sculpture, many artists have turned to metal fabrication. Many metals have great *tensile strength,* a characteristic that allows thin unsupported pieces to span great distances without sagging or breaking. Metal is also highly durable over time; rustproofing methods can be used for those metals that tend to rust. To sculpt with metals, artists have had to learn industrial techniques not traditionally associated with art. To create his machine-like metal sculptures (see *Wind Chant,* for instance, in Figure 2.18), John Matt became a skilled machinist and equipped his studio as a complete machine shop. To fabricate aluminum strips into works such as *Star Burst* (Fig. 8.17), Linda Howard became a master welder.

Sculptors cut metals using the same techniques as industrial metal fabricators: flame cutting with a torch and mechanical cutting with tools ranging from hacksaws to power bandsaws and shearing machines. The basic techniques for attaching one piece of metal to another are welding, adhesives, and fastening devices such as rivets and bolts. *Soldering* and *brazing* are useful for student projects because they use a minimum of heat from a soldering iron or air-acetylene torch to melt soft solder or brazing rods to fuse joints between relatively thin pieces of metal.

Plastic Fabrication

Another industrial material whose characteristics are being explored by artists is plastics: synthetic materials that vary considerably in characteristics. The possibilities seem almost limitless, and new plastics are being created continually. Specific plastics may be hard or soft, brittle or flexible, transparent or opaque. Some can be cast in molds. Plastics tend to expand in hot temperatures and to lack the strength of metals. But reinforcing fibers can greatly increase their tensile and impact strength, and individual plastics offer special characteristics not found in any other usable materials, such as transparency, corrosion resistance, and light conduction. For example, Larry Bell's *The Iceberg and Its Shadow* (Fig. 8.6) relies on the tintability and optical clarity of clear plastic sheets for its unusual transparency effects.

Modern plastic technologies allow artists to create almost any form they can imagine. Liquid plastics such as epoxies and polyesters can be poured into nearly any configuration or thickness and still be light in weight. Polycarbonates and acrylics can be shaped into large, thick forms with better optical clarity than glass, with a fraction of the weight of glass. Fiberglass-reinforced polyester resin and fiberglass-reinforced epoxies are so flexible that they can take on any shape or curve, as well as being strong enough to be self-supporting and hard enough to take considerable surface abrasion. Foams can span large areas, be formed into huge volumes of any shape, and yet be quite lightweight; some foams are almost indestructible.

Available in many forms such as rods, pastes, tubes, sheets, foams, and films, plastic can be sawed, stamped, sheared, carved, or machine-formed and then assembled by welding, bolting, gluing, riveting, or other mechanical means. For heat-formed shapes, plastic is

heated until it is flexible, bent into the desired shape, and held that way until it is cool. Casting, a common way of shaping plastics, will be described in Chapter 14.

Stonemasonry

While most additive sculpture requires some method of fastening units to each other, artists have in some cases placed units together without bonding them in any way. The hardness and heaviness of stone make it difficult to attach to anything, although stones may be set into mortar to help hold them together. But humans in some stony areas of the world have experimented with additive stone constructions that reach astonishing heights without any bonding agent. Consider the ancient stone construction at Stonehenge (Fig. 5.5). Massive horizontal stone slabs are set across the tops of enormous rough stone pillars. Nothing but gravity holds them in place, yet the structure has remained nearly intact for centuries. No one knows how the great stones were moved into position, but once placed, they have shifted little through time.

Equally astonishing is the mortarless stonework of the Incas at Machu Picchu (Fig. 12.25). High atop a mountain rising above the Peruvian jungle, they constructed buildings and terraces of huge stones that

12.25 Detail of Machu Picchu stonework. Machu Picchu, Peru. Photo Rapho/Photo Researchers.

were cut, ground, and polished. These stones fit together, like a jigsaw puzzle, with such precision that the structures have defied earthquakes and jungle overgrowth for five centuries. So closely are the stones joined that in places a knife cannot even be slipped between them. Perhaps in celebration of their own skill, the Inca stonemasons countersunk their joints so that the faces of the stones bulge outward slightly, accenting by their lightness the darker values of the joints.

MIXED MEDIA

A final category in additive construction is the use of *mixed media*—the assembling of different materials to form a coherent whole. For this approach to work, the varying materials must hold together both physically and visually.

In Carol Hepper's *Lunar Chamber* (Fig. 12.26), our associations of the materials with those used by the Plains Indians to build their tipis makes their juxtaposition seem logical. For her structures, Hepper tans hides of deer, cattle, and sometimes rabbit and buffalo, then stretches them across frameworks of willow or chokecherry branches, held together with waxed linen thread or rawhide thongs. All are things of the earth, prized as useful materials for survival on the South Dakota

12.26 Carol Hepper. *Lunar Chamber.* 1983. Mixed media, 5′5″ × 6′3″ × 5′. Collection of the artist. © 1983.

12.27 Georg Jensen. *Dragonfly Brooch.* 1904. Silver and semiprecious stones, $3^1/_2 \times 1^{13}/_{16}$" (7.8 × 4.6 cm). Museum of Decorative Art, Copenhagen.

prairies where Hepper's great-grandparents once homesteaded and where the artist herself grew up on an Indian reservation. However, her structure transcends its tipi-like associations to suggest in its apparent fragility, translucency, and airiness a more delicate reality.

Artists who make jewelry have long recognized the beauty of certain stones, their supposed magical properties, and their accepted use to proclaim wealth and status. They have combined their stones with precious metals, such as gold and silver, exploiting both their reflective qualities and malleability. The challenge is varied: to fasten stone to metal in a way that is sturdy but does not spoil the design or the beauty of the stone, and to make stone and metal work together visually, complementing rather than competing with each other. Georg Jensen's *Dragonfly Brooch* (Fig. 12.27) captures semiprecious stones in *bezels* (metal collars) and weaves their oval shapes into the design by repeating oval shapes in space. These shapes are defined by silver lines that move, widen, and narrow continually, with the rhythm of natural forms. Against such a setting, the stones act as rich, colored accents, neither overwhelming the design nor being lost in it.

Even the synthetic products of industrialization can be used together so harmoniously that they suggest a single variegated being. Naum Gabo's *Linear Construction* (Fig. 3.19) marries clear plastic sheeting and nylon thread so perfectly that we have difficulty in perceiving them as two different materials. The thread is added to provide visual textures that allow us to "see" the plastic and to elaborate the forms begun in the plastic. But so subtly are the two joined physically and aesthetically that together they create a single *gestalt,* or whole, that is much greater than the sum of the parts. One of its most beautiful features is the central void defined by the apparent absence of either material.

There is no limit to what materials can be combined with one another. Our everyday lives are full of examples. John Matt, whose *Wind*

Chant (Fig. 2.18) is assembled from metals and woods, discusses the feasibility of additive construction, particularly with mixed media:

> It's so obvious it will hit you between the eyes. Your automobile is built in pieces. Jet planes, your house, your watch—everything is assembled. Why can't it be so with sculpture? Why does it have to be one solid form that you subtract from: In the past, I was doing big asymmetrical blocks. I remember sitting in the studio in Rome, looking out a huge window, and all of a sudden I noticed the telephone poles and wires. The telephone poles were wood, the wires were copper, the insulators were glass, there was rubber around certain things. There was aluminum this, galvanized that, plexiglas. . . . I was looking through a window, which was made of glass and wood, and the walls were concrete and paint, and so it went, all the way down to me! If you think about it, your shoes are glue, leather, cloth, string—all sorts of stuff. Your teeth probably have silver and plastic and maybe gold in them now. It can be the same with art. No holds are barred if you are confident in yourself about visual things. You can use anything in any combination, and if you're convinced you can do it, it's going to work. If your sense of the aesthetics is strong, what's to hold you back except your ignorance of the technical details? Even then, you just find out how to do it, and then you do.

Reference Books on Addition and Manipulation

Gerald F. Brommer. *Wire Sculpture and Other Three-Dimensional Construction.* Worcester, Massachusetts: Davis Publications, Inc., 1968. Simply written how-to suggestions for wire sculpture, wood construction, and cardboard and paper construction, illustrated with student works.

Geoffrey Clarke and Stroud Cornock. *A Sculptor's Manual.* New York: Reinhold Book Corporation, 1968. Includes technical descriptions of direct plaster and cement forming, flame and electric welding, plastics, and additive construction methods for plastics, wood, and metal.

Frank Eliscu. *Direct Wax Sculpture.* Philadelphia: Chilton Book Company, 1969. Instructions on where and how to buy wax, wax-working tools, sheet wax techniques, and step-by-step illustrations of specific projects.

Frank Eliscu. *Sculpture: Techniques in Clay, Wax, Slate.* Philadelphia: Chilton Book Company, 1959. Step-by-step illustrations of specific projects, including demonstration of use of armatures as well as self-supporting wet-clay modeling.

Chuck Evans. *Jewelry: Contemporary Design and Technique.* Worcester, Massachusetts: Davis Publications, Inc., 1983. Attractively illustrated, informative guide to jewelry and metalsmithing tools, materials, and techniques, including methods of forming, enriching surface textures, forging, fastening devices, inlays, laminations, and stone settings.

Nathan Cabot Hale. *Welded Sculpture.* New York: Watson-Guptill Publications, 1968. Good discussions of basic tools and techniques of torch and electric arc welding, followed by specific directions for constructing abstract forms, organic forms, and large-scale works, and for modeling solid figures.

James E. Hammesfahr and Clair L. Stong. *Creative Glass Blowing.* San Francisco:

W. H. Freeman and Company, 1968. Simple, heavily illustrated, step-by-step instructions for working glass in traditional ways.

R. Bruce Hoadley. *Understanding Wood: A Craftsman's Guide to Wood Technology.* Newtown, Connecticut: The Taunton Press, 1980. Everything you ever wanted to know about wood, from characteristics of different woods such as density and cellular structure, to knots and insect damage, shrinkage and swelling, wood movement, strength properties, types of lumber and plywood, and methods of joining and finishing wood.

Dona Z. Meilach. *Decorative and Sculptural Ironwork: Tools, Techniques, Inspiration.* New York: Crown Publishers, 1977. Illustrated procedures and creative uses of metal forging.

Dona Z. Meilach and Don Seiden. *Direct Metal Sculpture: Creative Techniques and Appreciation.* New York: Crown Publishers, Inc., 1966. How-to instructions and illustrations combined with photographs of masterworks, including discussions of metal-working equipment and metals, soldering and brazing techniques, welded iron and steel sculptures, working with nonferrous metals, combining ferrous and nonferrous metals, and combining metals with nonmetals.

Fred Meyer. *Sculpture in Ceramic.* New York: Watson-Guptill Publications [no date]. Information on kinds of clays, preparing clays, kilns, tools for the ceramic studio from the practical to the whimsical, glazes, considerations of clay's suitability for intended projects, building methods, armatures, firing, and presentation. Includes chapters on specific techniques used by certain artists.

Glenn C. Nelson. *Ceramics: A Potter's Handbook,* 5th edition. New York: Holt, Rinehart and Winston, 1984. Excellent, well-illustrated discussions of clay bodies, hand-building techniques, wheel techniques, decorating and glazing, kilns and firing.

Thelma R. Newman. *Plastics as Sculpture.* Radnor, Pennsylvania: Chilton Book Company, 1974. Includes descriptions of various plastics; additive construction processes with sheets, blocks, and rods; manipulation of plastics by foaming, buttering, modeling; and working with fibers, films, and liquid plastics.

Susan Peterson. *The Craft and Art of Clay.* Englewood Cliffs, NJ: Prentice Hall, 1992. A complete reference source for clay work, by the *grande dame* of American ceramics, with all technical information, process photos, and an exciting gallery of contemporary pieces.

Jack C. Rich. *The Materials and Methods of Sculpture.* New York: Oxford University Press, 1947. Technical information on modeling of wax, plaster, papier-mâché, and clays.

John Rood. *Sculpture with a Torch.* Minneapolis: University of Minnesota Press, 1963. Information on oxyacetylene welding, brazing, and arc-welding techniques, illustrated with sculptures by the author.

Claude Smale. *Creative Plastics Techniques.* New York: Van Nostrand Company, 1973. Explanations of types of plastics and how they can be worked in studios with varying levels of equipment.

Sunset Editorial Staff with Robert and Joan Dawson. *Sculpture with Simple Materials.* Menlo Park, California: Lane Books, 1968. Very simple illustrated explanations of wire sculpture, papier-mâché, and clay modeling.

Wilbert Verhelst. *Sculpture: Tools, Materials, and Techniques.* Englewood Cliffs, New Jersey: Prentice-Hall, 1973. Includes chapters on fabrication processes with

wood, plastic, and metal, as well as direct modeling of plaster, concrete, plastics, clay, and spray metal.

Arthur Zaidenberg. *Sculpting in Steel and Other Metals.* Radnor, Pennsylvania: Chilton Book Company, 1974. Instructions and safety considerations in welding, soldering, bending rods, creating solid areas, using a cutting torch, forging, and brazing.

William Zorach. *Zorach Explains Sculpture.* New York: American Artists Group, 1947. Includes detailed directions for clay modeling on an armature.

CHAPTER 13

SUBTRACTION

The opposite of the additive approach to creating three-dimensional forms is *subtraction*. In this process, the artist begins with material larger than the desired finished piece and then carves away any excess. A very explicit example of this method is Sabu Oguro's *Katzenfamilie* (Fig. 13.1), where areas have been cut out of the overall shape. These shapes interplay with one another, and can be taken apart from the larger form. Each form that leaves the main shape becomes a cat, thus accenting the rhythm of the whole with an interplay of contrasting sizes. Because the total piece is a standing puzzle, each of the cats fit precisely into one another.

We usually think of subtraction in terms of carving away extraneous material from the outside of a form. Atsuo Okamoto has revealed this process by reassembling the major blocks of stone removed from a white granite boulder. The inner material is presented as if it were a work in progress next to its matrix, which now looks like an empty womb (Fig. 13.2).

Subtraction can also refer to the shaping of the interior of a form. A monumental example is the *chaitya,* or Buddhist assembly hall,

13.1 (top left) Sabu Oguro, designer. *Katzenfamilie* from *Tierpuzzles.* Manufactured by Naef AG, CH-4314 Zeiningen, Switzerland. Copyright Naef AG.

13.2 (top right) Atsuo Okamoto. *Stones Dimension/Resolution for Materials.* 1987. White granite, 8 × 23 × 7.5 m. Gallery Yamaguchi, Tokyo.

13.3 (right) Interior of carved Chaitya Cave, Karli, India. c. A.D. 100. Photo courtesy Department of Archaeology, Government of India.

carved as a cave from the living rock in Karli, India (Fig. 13.3). Modeled on wood architecture, it is lined with huge fluted columns bearing figures riding elephants. Above them a vaulted ceiling soars 45 feet (13.72 m) upward within the hollowed-out cliff.

By extension, subtraction may also involve the forces of nature in wearing away materials. Fire, wind, and water all have their ways of altering and eroding matter and are sometimes engaged aesthetically by artists.

QUALITIES OF THE MATERIALS

Materials most often used subtractively are wood and stone. Wood has perennial appeal because of its warm organic feel, texture, and grain patterns. As it ages and is repeatedly handled, it develops a pleasing soft patina. The softest woods include white pine, redwood, spruce, and cedar. Medium-hard woods include birch, butternut, and fruitwoods such as apple, cherry, and pear. The fruitwoods sometimes grow rounded knobs called *burls* with beautiful grain patterns that may be emphasized by the artist. Hardwoods such as maple, walnut, oak, hickory, and teak have attractive fine grain and are very durable. Softness is not directly equated to ease of working, for the soft woods may mash or splinter when chiseled unless the tools are kept extremely sharp. The artist may have more control when working with harder, more cohesive woods.

Like woods, stones used for subtractive sculpture range from relatively soft to extremely hard. At the soft end of the spectrum are rocks such as sandstone, soapstone, and alabaster, which can even be carved with a knife when wet. Marble is harder and has long been prized for its beauty. Granite is extremely hard but also extremely durable.

Working these resistant materials is often a slow and painstaking process. Wood may split along the grain as it is being carved, or check (developed cracks) as it dries if it has not been fully dried before being worked; knots and other faults in the wood must be dealt with somehow. Sculptors may encounter unexpected fissures running through the interior of pieces of stone and must either work with or around them or else abandon the work. Some stones are also quite expensive; one doesn't tackle them lightly. In ancient China, an artist might spend his entire life carving a single jade bowl such as the work shown in Figure 13.4.

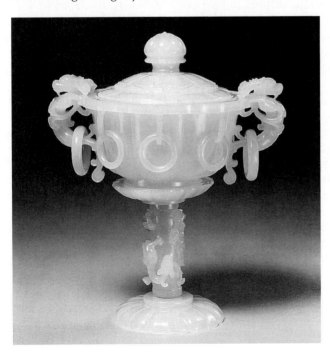

13.4 *Carved Bowl on Pedestal (Yu-Yung Cup).* China, 18th century (Ch'ien-lung mark and period). White jade, height 5³/₈". The Asian Art Museum of San Francisco, The Avery Brundage Collection (B60 J144).

The initial stages of roughing out a design can in some cases be facilitated by power tools, such as chainsaws for wood or electric drills or pneumatic hammers for stone. But for the most part, subtraction is a lengthy process of careful removal of excess material by the use of points, chisels, or gouges struck with a mallet or hammer. For a highly polished surface, various abrasives are used for final finishing after the initial roughing-out and intermediate carving.

Although the artist who works subtractively in resistant media is not directly hand-shaping the material, as in modeling clay, the artist's hands are nevertheless closely linked with the material through the tools used. Sculptor Barbara Hepworth notes the very different functions of her two hands, as the right wields the hammer against a point held to the stone by the left hand:

> My left hand is my thinking hand. The right is only a motor hand. This holds the hammer. The left hand, the thinking hand, must be relaxed, sensitive. The rhythms of thought pass through the fingers and grip of this hand into the stone. It is also a listening hand. It listens for basic weaknesses of flaws in the stone; for the possibility or imminence of fractures.

For quicker, less expensive subtractive work, plaster or cement can be cast into blocks and then carved. Even plastic in the form of acrylic, epoxy, or polyester blocks can be carved by sawing, drilling, and filing rather than the chipping and gouging techniques used with wood and stone.

REVEALING THE FORM

It is often said that a sculptor is one who sees a form in a block of material and simply carves away everything that covers the form. In some cases, sculptors do get their ideas from the existing form. But more characteristically, they choose a piece of material that will allow them to develop a form they have imagined. To release the image in the stone or wood then means working the piece to its best advantage.

Carved wood sculptures may often retain a strongly vertical linear thrust, having been subtracted from a cylindrical tree trunk. In the ancient sculpture of *Sheikh el Beled* (Fig. 13.5), there is a strong sense of the trunk, which has been carved into only slightly to release the torso, legs, and head. Note that the arms and spear were carved out of separate pieces of wood and then attached at the shoulders. If they, too, had been carved with the body, the sculptor would have required a very thick piece of wood; a great deal of excess would have been carved away in order to reveal the form. To carve projecting forms in the full round out of a solid block can be done, but it does take time. Projecting limbs are also highly susceptible to being broken during or after creation of a piece. The great effort and skill needed to release the linear forms of the lyre player (Fig. 13.6) from a small block of marble also rendered the piece vulnerable to breaking afterward, as evidenced by the many places it has been glued back together or where pieces are missing altogether.

13.5 *Sheikh el Beled,* from his tomb at Saqqara. 2400 B.C. Wood, approximately 43″ high (109 cm). Partially restored. Egyptian Museum, Cairo. Hirmer Fotoarchiv, Munich.

13.6 Classical Cycladic statuette: Seated man with harp. Marble, height 11½" (29 cm). Metropolitan Museum of Art (Rogers Fund, 1974). Hirmer Fotoarchiv, Munich.

Most earlier sculptures from Western civilizations are *monolithic*. That is, they retain the closed form of the original single stone or wood, with arms and legs of figurative works perhaps carved away from the body to a certain extent. In the twentieth century, sculptors like Henry Moore introduced *open forms* in which carving into the original material penetrated so deeply as to open voids in its center. In Moore's *Internal and External Forms* (Fig. 13.7), the center of a trunk has been penetrated only to reveal another trunk-like form. In both internal and external forms, the vertical thrust of the original trunk is still apparent, if hollowed out.

Some contemporary sculpture abandons the original form of the material or materials entirely. Fumio Yoshimura's *Bicycle with Parking Meter* (Fig. 13.8) is carved entirely of wood. This tour de force is so masterfully carved into likenesses of things not made of wood—metal chains, rubber tires, flexible gear cables—that the wood totally loses its identity as tree trunk and instead becomes whatever Yoshimura declares it to be.

When approaching a piece of wood or stone, the artist must have a very clear sense of how the form fits into it. The process of chipping away just enough but not too much to reveal that form has been likened to playing three-dimensional chess: The artist plans many

13.7 Henry Moore. *Internal and External Forms.* 1953–54. Elmwood, 8'7" × 3' × 8'13" (circumference). Albright-Knox Art Gallery, Buffalo, New York. General Purchase Fund, 1955.

13.8 Fumio Yoshimura. *Bicycle with Parking Meter.* 1978. Linden wood, 5′8″ × 4′ 5½″ × 1′ 4½″. Albuquerque Museum of Art. Photo Chie Nishio Trager, New York.

13.9 Michelangelo. *St. Matthew.* 1506. Marble, height 8′11″ (2.72 m). Museo Nazionale, Florence. Alinari/Art Resource, New York.

moves in advance, even though the form may change as it is developed. Usually a rough guide to where everything will lie is sketched in chalk on the surface of the material. Some artists then work into all sides of a piece at once, continually shaping areas in relationship to one another.

An alternative approach is to work one side at a time. This is more difficult than continually working around the piece. Unless the form is flexible or one knows precisely where it lies, the sculptor can carve himself or herself into an impasse, with not enough material left to develop certain contours. Michelangelo apparently had some such trouble with his *St. Matthew* (Fig. 13.9), for he abandoned it after carving partway toward the back from the front. The figure appears imprisoned within the marble, unable to open fully. Is there enough marble left to carve the foot on the right side of the photograph, for example? The sculptor can make certain compromises or changes as a piece develops, but beyond a certain point areas simply may not work well in relationship to one another and the piece may seem spatially starved.

A third possibility is for the artist to make a small model of the form in some malleable material like clay. The model can then be translated into a more permanent material such as stone by master stonecutters taking points from the model to determine how deeply to carve each section.

No matter which approach is used, artists are advised to think of the inside rather than the outside of the form they are modeling. Rodin explains this principle, which he learned from his teacher:

> Never consider a surface except as the extremity of a volume, as the point, more or less large, which it directs toward you. . . . Instead of imagining the different parts of a body as surfaces more or less flat, I represented them as projectures of interior volumes. I forced myself to express in each swelling of the torso or of the limbs the efflorescence of a muscle or of a bone which lay deep beneath the skin. And so the truth of my figures, instead of being merely superficial, seems to blossom from within to the outside, like life itself.

TEXTURES AND VALUES

Although the surface is not the chief consideration in developing the form, its final appearance does affect how a piece works. Constantin Brancusi purposely left and accentuated the chisel marks used in sculpting the lower portion of *Blond Negress, II* (Fig. 13.10). He has used the coarse and rippling texture of these marks to emphasize by contrast the polished smoothness of the bronze upper portion.

In highly representational works, chisel marks are not designed to be seen as such. Rather, they are blended into the appearance of the visual texture of the object being represented. It is impossible to tell that Fumio Yoshimura's *Bicycle with Parking Meter* has been created by a carving process, for the artist's tools have left no tracks. Instead, we are presented with many nonwood textures, from the patterns of rubber tires to the slickness of the parking meter, each convincingly disguising both the characteristics of wood and the artist's hand at work.

Sometimes wood or stone is highly polished to bring a pleasing smoothness and glossiness to its surface. In pieces that are handled often over time, such as the slate *Birdstone* in Figure 13.11, the smooth quality is heightened by the patina of wear. Many touchstones from

13.10 Constantin Brancusi. *Blond Negress, II.* 1933 (after a marble of 1928). Bronze, 15³/₄″ high; on four-part pedestal of marble 3⁵/₈″ high × 3³/₄″ diameter; limestone 9⁷/₈ × 14⁵/₈ × 14¹/₈″; and two wood sections (carved by the artist) 7³/₈ × 14³/₈ × 14¹/₂″. The Museum of Modern Art, New York. The Philip L. Goodwin Collection.

13.11 *Birdstone.* Hopewell. Slate, length 6¹/₂″ (17 cm). National Museum of the American Indian, Smithsonian Institution (#22/278).

13.12 *Hitching Post of the Sun,* altar for observation and worship of the sun, Machu Picchu, Peru. Carved from the live rock. Photo Richard E. Swibold AIA, North Canton, Connecticut.

primitive cultures were clearly designed to be fondled—to be appreciated by hand as well as eye. In our culture, people collect old wooden tools out of appreciation for the hands that used them as well as the hands that carved them.

Surfaces are also used to develop values. Any areas that are deeply undercut will tend to create dark shadows where light cannot penetrate. The Incas referred to Machu Picchu's most sacred altar as the *Hitching Post of the Sun* (Fig. 13.12). This stone structure, dedicated to worship and observation of the sun, owes much of its drama to the severe contrasts between light and dark created by the chiseling of sharply angled forms from the living rock of the mountain. Value shifts in the unworked rock below are much more gradual, demonstrating in one picture the artistic potential of the subtractive process in enhancing the impact of one's chosen material.

Reference Books on Subtractive Sculpture

Cecil C. Carstenson. *The Craft and Creation of Wood Sculpture.* New York: Charles Scribner's Sons, 1971. Simple explanations of tools, choice of woods, sculpting and finishing techniques, with helpful observations on subtractive creation of

form: avoiding frontality, working all the way around, adding to by taking away, avoiding commitment, working major forms first, and correcting mistakes.

R. Bruce Hoadley. *Understanding Wood: A Craftsman's Guide to Wood Technology.* Newtown, Connecticut: The Taunton Press, 1980. Good discussion of properties of various woods, carving actions, planing, sawing, and finishing.

Malvina Hoffman. *Sculpture Inside and Out.* New York: W. W. Norton and Company, 1939. Old but still valuable discussions of stone and wood carving.

Dona Z. Meilach. *Contemporary Stone Sculpture.* New York: Crown Publishers, 1970. Well-illustrated guide to choosing stones, hand tools, hand carving methods, and power tools and methods.

John Mills. *The Encyclopedia of Sculpture Techniques.* New York: Watson Guptill Publications, 1990. A useful compendium of information about traditional, contemporary, and experimental three-dimensional techniques and materials.

Jack C. Rich. *The Materials and Methods of Sculpture.* New York: Oxford University Press, 1947. Detailed discussions of carving materials and methods for stone and wood, plus suggestions for subtractive work with inexpensive materials such as brick, concrete, horn and bone, and soap.

John Rood. *Sculpture in Wood.* Minneapolis: The University of Minnesota Press, 1950. Readable accounts of wood-carving tools and techniques, with the step-by-step progress of various works illustrated and discussed.

Wilbert Verhelst. *Sculpture: Tools, Materials, and Techniques.* Englewood Cliffs, New Jersey: Prentice-Hall, 1973. Includes a chapter on carving of wood, stone, plaster, cement, foam, and plastics.

William Zorach. *Zorach Explains Sculpture.* New York: American Artists Group, 1947. Includes several chapters on subtractive sculpture in wood and stone.

CHAPTER 14

CASTING

The final three-dimensional construction method we will consider is casting. It is an ancient process, sufficiently perfected thousands of years ago to allow production of pieces as aesthetically and technologically advanced as the ceremonial vessel we see in Figure 14.1, created during the Shang Dynasty in China. In general, casting involves creation of a *mold*—an outer shell into which another material is poured in a fluid state. When this material hardens, the mold is removed leaving its imprint in the more permanent material of the inner form—the *cast*.

Casting is an indirect process, with most shaping work done on the mold or the *pattern* from which the mold is made, rather than on the finished piece. It therefore allows artistic use of a number of desirable materials that cannot easily be worked directly into complex forms. The traditional material used for casts is bronze, poured into molds in a hot liquid state. Bronze is prized for its durability and rich color, seeming translucency and softness of its surface patina, a glow that gets richer with time. Other metals, such as steel, aluminum, and iron, can also be cast, as can wax, clay, plaster, and concrete. Many plastics are also readily cast for both artistic and industrial purposes. Even handmade

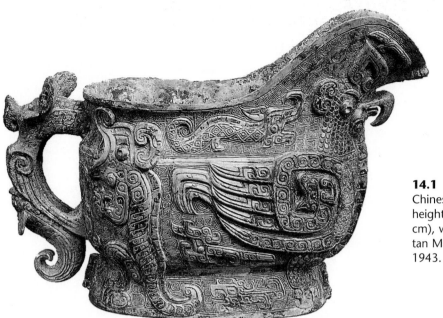

14.1 Ceremonial Vessel, *Kuang.* Chinese, Shang Dynasty. Bronze, height 8⅞″ (23 cm), length 13″ (33 cm), width 5″ (13 cm). The Metropolitan Museum of Art, Rogers Fund, 1943.

14.2 Frank Gallo. *The Faint.* Cast in handmade paper, 32″ (81 cm) high × 48″ (1.22 m) wide. Edition of 150. Reproduced by permission of the artist and special permission of *Playboy* magazine. © 1978 by Playboy.

paper, which is a liquid slurry before it dries, can be used to make casts, as in Frank Gallo's *The Faint* (Fig. 14.2).

SOLID CASTS

Casting can be approached in many different ways. Perhaps the simplest is the *direct relief mold* method—preparation of a negative mold into which the desired material is simply poured and then removed when hard. This produces a relief with one finished side. The negative mold can be made of a great variety of materials, including sand, clay, dirt,

14.3 Albert S. Vrana. Negative mold being prepared from carved sheets of polystyrene foam. Courtesy of the artist.

plaster, wood, cardboard, and styrofoam, with some kind of border added to contain the poured casting material. In Figure 14.3, a negative mold is being created with sheets of polystyrene foam. The design was then cut into blocks and surrounded with wood sides; cast stone—a refined concrete—was poured into these shallow molds. In the result, used as a facade for a building (Fig. 14.4), anything that was concave in the mold became convex in the finished cast, and vice versa. The cast picks up the surface qualities of the mold—in this case, a smooth surface—as well as the textures of the materials used in the cast. Cast stone, for instance, can be compounded from cement, sand, and rock aggregates of varying size.

For a form to be cast in the full round, there are several general options. One is to cast the form as a solid, suitable for lightweight, inexpensive materials or small objects. A full-size pattern is first created out of some malleable material. This might be wax or clay; for the sculpture entitled *Mutant,* Elbert Weinberg first created a pattern out of

14.4 Albert S. Vrana. Front view of building with sculpture relief. 200 panels pre-cast in carved polystyrene foam for exterior of Professional Arts Building, Miami. 1967. Panels of Chattahoochee stone and sand aggregate in Lehigh Early Strength Cement over 23,000 square feet. Individual panels are 6″ (15.2 cm) thick and vary from 9 × 12′ (2.7 × 3.6 m) to 17 × 12′ (5.18 × 3.6 m). Courtesy of the artist.

14.5 Elbert Weinberg. Plaster model for epoxy cast of *Mutant,* 1973. Height 33″ (84 cm), length 31″ (79 cm), width 27″ (69 cm). Collection of the Elbert Weinberg Trust.

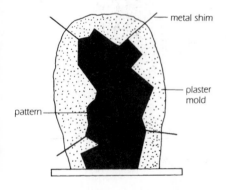

14.6 Plaster piece mold.

plaster, shown in Figure 14.5. Negative molds are then made from this positive pattern.

For a *rigid plaster piece mold,* the surface of the pattern is divided into separate areas by thin metal *shims* or *fences,* as shown in Figure 14.6. Each fenced area is coated with plaster to make a partial mold that can be pulled away from that part of the form without breaking. The inner pattern is then removed and the partial molds are reassembled to create a full hollow mold into which the casting material is poured. This process is not suitable for bronze or for casts with intricate details or numerous undercuts.

The cast shown of Auguste Rodin's *Severed Head of St. John the Baptist* (Fig. 14.7) has not been worked to remove lines where the pieces of the mold came together. We can see exactly how the piece was thought out so that the pieces of the mold could be pulled away from the cast.

Plaster piece molds with ball-and-socket joints for precise assembly are often used for *slipcasting* of ceramic objects or sculptural modules. In this process, clay in liquid suspension (*slip*) is poured into the plaster molds. Because the plaster is porous, it absorbs water from the slip, allowing it to harden. Excess slip that does not harden is poured off. When the cast slip is hard as leather, the molds are removed for drying and firing of the piece.

For a *flexible mold,* more suitable for multiple reproductions or more complex forms, the positive pattern is coated with liquid rubber or silicone, which picks up all the surface characteristics. A shell of plaster is then applied on top of the rubber for stiffness. The resulting mold (shown diagrammatically in Figure 14.8 and in a foundry setting in Figure 14.9) is then cut in half and removed from the original pattern. The empty halves (plaster outside, rubber inside) may then be reassembled and the material desired for the finished piece poured in to fill the assembled mold. When the molten material hardens, the two halves of the mold are pulled away, revealing a positive form that exactly duplicates the form of the original pattern. The cast of *Mutant,* made of lightweight plastic resin, looks exactly like the pattern in Figure 14.5, except that the material is different.

14.7 Auguste Rodin. *Severed Head of St. John the Baptist.* 1916. Untinted plaster with traces of piece mold, 10³/₈ × 8¹/₈ × 6³/₁₆". The Fine Arts Museum of San Francisco. Gift of Adolph B. Spreckels, Jr. (1933.12.6).

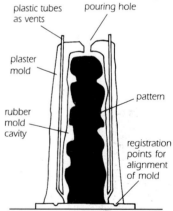

plastic tubes as vents

pouring hole

plaster mold

pattern

rubber mold cavity

registration points for alignment of mold

14.8 Flexible mold.

14.9 Shidoni Foundry, Dow Corning® HSII RTV Clay Catalyst being applied for rubber molding systems, with the two halves of one mold in the foreground. Photo courtesy of Shidoni Foundry.

Sculptors sometimes go directly to the real thing for their patterns. Duane Hanson uses real people as his patterns, coating them with cutaway molds of silicon rubber, and then filling these molds with a melted plastic—polyvinyl acetate. This material, colored with oil paint to match human skin tones, becomes astonishingly lifelike when painted and clothed in human likeness and surrounded by familiar objects such as ashtrays and catsup bottles, as in *Dockman* (Fig. 14.10).

HOLLOW CASTS

If a piece is large or the material to be used for the cast is very heavy, as is the case with metals such as bronze, the *lost-wax process* is often used to create a hollow cast. In the *direct lost-wax method,* the original pattern is built of some nonmelting material such as clay or plaster with its final surface modeled in a layer of wax of the same thickness as the ultimate metal cast. A negative mold is constructed over this wax surface, with vents here and there to allow air to escape during the later casting process. Provisions are made for breaking the mold in half and reassembling it after the cast has set. The piece is then heated to the point that the wax melts, leaving a cavity that duplicates the contours of the pattern. What was wax becomes metal as the material for the final piece is poured into this cavity and allowed to harden. Once it is hard, the negative molds are pulled away from each side, the hollow walls of the cast are separated, the inner core of the original pattern is removed, and the pieces of the cast are reassembled, leaving a hollow core.

The more complex *indirect lost-wax* procedure, illustrated in Figure 14.11, involves first creating a negative plaster or gelatine mold of

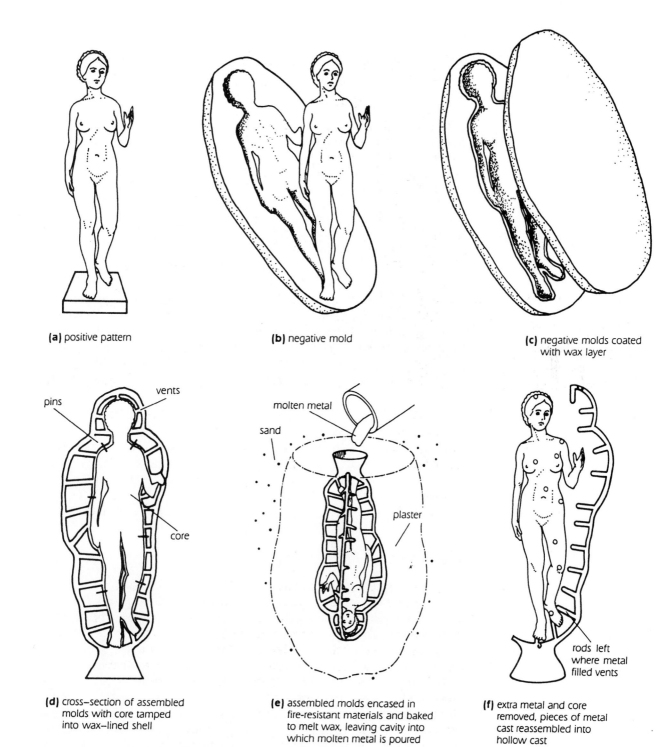

(a) positive pattern

(b) negative mold

(c) negative molds coated with wax layer

pins

vents

core

(d) cross–section of assembled molds with core tamped into wax–lined shell

molten metal

sand

plaster

(e) assembled molds encased in fire-resistant materials and baked to melt wax, leaving cavity into which molten metal is poured

rods left where metal filled vents

(f) extra metal and core removed, pieces of metal cast reassembled into hollow cast

the positive pattern. The pattern is then removed and wax is applied to the inner surface of the negative mold. Wax rods to form vents are added and a core of some material such as ground brick and plaster mixed with water is poured or tamped into the wax shell. Metal pins are added to hold the layers together. Layers of fire-resistant material

14.11 Stages of lost-wax casting.

are also built up around the outside of the wax shell. The finished mold is then baked to melt the wax and molten metal is poured into all the cavities once occupied by the wax.

Yet another process uses *sand molds,* frames of sand mixed with a binder to create negative molds. Sand is often porous enough that complex venting is not needed to allow gases to escape when molten material is poured into the mold. The sand mixture is packed in halves or sections around a positive pattern to receive its imprint. The molds are then taken apart, the pattern is removed, a core is added if the piece is to be hollow, the sand molds are reassembled, and the molten casting material is poured in. Like all mold materials, the sand must be sufficiently fine-textured to recreate fine details and strong enough to hold its shape when the heavy metal or other casting material is poured in. Although sand molds can be used to make many duplicates of a piece, they tend to lose fine details; lost-wax processes yield a single cast since the original wax modeling is lost in the process, but they register finer detail than sand molds.

No matter what process is used, large and/or complex pieces must often be cast in sections with ends designed to be rejoined after casting. *The Great Image of Buddha* at Kamakura, Japan (Fig. 14.12) is 53 feet (16.16 m) tall, so huge that it could be cast only by breaking the

14.12 *The Great Image of Buddha,* Kamakura, Japan. 1252. Bronze, height 53' (16.17 m). Scala/Art Resource, New York.

14.13 Apprentices Betsy Brown and Jill Rednor chasing piece by Andrea Grassi at the Johnson Atelier, Mercerville, New Jersey. Photo © Don Hamerman, New York. Courtesy of Johnson Atelier Foundry.

form down into pieces. Some of the lines along which they were reassembled can be seen in the photograph as horizontal marks across the chest, arms, and folded legs.

FOUNDRIES AND EDITIONS

Because of the exacting technology, skill, and time required for casting and the great cost of some casting equipment, many artists now send their work to foundries to be cast. At every stage of the process, certain qualities of the original model may be lost, so provision is often made for retouching molds as well as the finished piece. In Figure 14.13, workers at the Johnson Atelier are chasing a cast sculpture by Andrea

14.14 Pablo Picasso. *She-Goat.* Vallauris (1950). Bronze (cast 1952), after an assemblage of palm leaf, ceramic flowerpots, wicker basket, metal elements and plaster, 46³/₈ × 56³/₈ × 28¹/₈". The Museum of Modern Art, New York. Mrs. Simon Guggenheim Fund.

Grassi to bring out the grooves in its surface. Some artists choose to turn over all such details to the foundry; others rework both molds and finished pieces.

With some casting processes, it is possible to create small editions of a piece by saving the molds and repeating the procedures several times to create several more or less identical copies of a work. Each is an original work of art, and by casting an edition, the artist is able to lower the per-unit cost of casting by spreading certain fixed costs across many units. Industrial casting processes are designed to allow a great number of copies to be cast from the same mold. Certain casting procedures do not allow deep undercuts, which would prevent detaching the mold from the cast without breaking the mold; industrial designers must sometimes work within the limitations of this consideration, beveling all angles with ease of separation from the mold in mind.

THE OUTSIDES AND INSIDES OF CASTS

Casts can be used to create a great range of surface textures, for they duplicate the surface of whatever is used for the mold or the pattern, depending on the process used. A sand casting will have the granular texture of the sand mold. Pieces cast from a pattern made of a malleable

material such as wax will retain the freshness and immediacy of the modeling without the impermanence of the original material. Picasso's *She-Goat* (Fig. 14.14) is a permanent copy of an assemblage of ceramic flower pots, metal elements, a palm leaf, and a wicker basket, with plaster added to create all the textures of goathood, from the scraggly fur of an unkempt animal to the coarse undulations of the horns to the smoothness of the udder. The casting process allows considerable surface detail to be elaborated, as in the Shang ceremonial vessel (Fig. 14.1). Textures can also be developed on the surface after casting, as in Andrea Grassi's piece shown in Figure 14.13, which is polished to an extremely smooth, reflective sheen.

Traditional hollow bronze casts also reflect the unique quality of hollowness, of being merely the outer covering bulging out around an inner void. As metal is poured, it thrusts outward into every cavity of the mold. This outward thrust may give casts a curious vitality, as if instead of being merely empty, the casts are bursting with inner life.

Reference Books on Casting

C. W. Ammen. *The Complete Handbook of Sand Casting* and *Lost Wax Investment Casting*. Blue Ridge Summit, Pennsylvania: Tab Books, Inc., 1979 and 1977 respectively. Informative, useful, and humorously written references on metal casting and molding processes.

Oliver Andrews. *Living Materials.* Berkeley, California: University of California Press, 1988. An excellent overall text on sculpture, with good chapters on lost wax, sand mold, and ceramic shell casting techniques.

Arnold Auerbach. *Modelled Sculpture and Plaster Casting.* Cranbury, New Jersey: A. S. Barnes and Co., 1977. Directions for clay modeling with and without an armature, plaster casting, and waste molds, for figures and reliefs.

Geoffrey Clarke and Stroud Cornock. *A Sculptor's Manual.* New York: Reinhold Book Corporation, 1968. Sections on plaster casting, sand casting, lost-wax processes, and techniques for making editions, with some technical drawings.

Chuck Evans. *Jewelry: Contemporary Design and Technique.* Worcester, Massachusetts: Davis Publications, 1983. Detailed, well-illustrated chapter on casting techniques used in jewelry making.

Christian Hauser. *Art Foundry.* Geneva, Switzerland: Les Editions de Bonvent, 1972. Illustrated discussions of metals, foundries, lost-wax processes, and sand casting.

Malvina Hoffman. *Sculpture Inside and Out.* New York: W. W. Norton and Company, 1939. Contains a chapter on plaster and terra-cotta with numerous simple processes suitable for inexpensive student projects in casting.

Dennis Kowal and Dona Z. Meilach. *Sculpture Casting.* New York: Crown Publishers, 1972. Beautifully illustrated explanations of casting techniques, including latex and rubber flexible molds, lost-wax casting, gelatin molds, ceramic shell molds, sand casting, and casting of concrete, plaster, and plastics.

Thelma R. Newman. *Plastics as Sculpture.* Radnor, Pennsylvania: Chilton Book Company, 1974. Descriptions of various plastics and methods of casting them.

Jack C. Rich. *The Materials and Methods of Sculpture.* New York: Oxford University Press, 1947. Includes detailed discussions of numerous casting techniques.

Sunset Editorial Staff with Robert and Joan Dawson. *Sculpture with Simple Materials.* Menlo Park, California: Lane Books, 1968. Includes directions for very simple casting projects: casting from clay with rubber molds, casting papier-mâché from clay, and negative casting.

Wilbert Verhelst. *Sculpture: Tools, Materials, and Techniques.* Englewood Cliffs, New Jersey: Prentice-Hall, 1973. Includes three detailed chapters on the stages of casting: modeling and pattern-making, mold-making techniques, and casting and reproduction.

William Zorach. *Zorach Explains Sculpture.* New York: American Artists Group, 1947. Includes chapters on plaster casting with waste molds, cast stone, lost-wax casting, sand casting, piece molds, and gelatin molds.

PART FOUR

STUDIO PROJECTS

S T U D I O P R O J E C T S

C H A P T E R 1

1.1 From Three-Dimensionality to Two-Dimensionality

Using the medium of photography—perhaps with a Polaroid-type camera for instant prints—transpose a three-dimensional experience of an actual object or sculpture into a two-dimensional visual experience. How can you photograph the piece to best indicate its three-dimensionality? Its size? What features of the original object are enhanced or lost in the photograph? In a class situation, each student could take one photograph of the same object on campus and then the class could compare the results.

1.2 From Two-Dimensionality to Three-Dimensionality

First draw a simple nonrepresentational design on an 8½ × 11″ piece of paper. Then translate the drawing into a three-dimensional piece of sculpture of any material(s) you choose, such as wood, cardboard, fabric, or wire. How can this be done? What aesthetic differences can be seen in the two versions of the design? What factors do you have to deal with in the three-dimensional piece that were not at issue in the two-dimensional drawing?

1.3 Modular Low Relief

Use two pieces of foam core (plastic-coated foam sold in ¼-inch thick sheets at art supply stores) to create a low-relief work. Use one for backing; cut the other into a series of identical or similar flat shapes and attach them to the backing to build up a low-relief design. These *modules* (the series of similar pieces) can be joined to each other and to the backing in any way you choose—glue, cut grooves, pins, even some form of tying. What visual effects develop as the flat shapes begin to move outward into three-dimensional space?

1.4 The Wrapped Object

Choose an everyday functional object and wrap it with some other material, such as string or lace, so that no portion of the object remains uncovered. Then do the same thing with an object from nature, perhaps wrapping it with a different material. How can you accomplish this in a way that will draw viewers into looking at the solution? Could the object and the wrapping be antitheses of each other, such as a hammer wrapped with lace? Is there a sense of mystery about what the wrapping conceals? What about evoking a sense of humor or intellectual curiosity? Can the underlying shape be easily recognized within a wrapping that creates a visual pun? You might work with contrasts, such as hard and soft, or with a close relationship between the object and the wrapping.

1.5 Walk-Through Work

Given or choosing a specific location, create an installation piece that controls how people move through the space. You can use any material(s) you choose, such as cardboard or fabric or sand. Part of the problem is figuring out how to set up the piece and how to take it down. Your control of people's movement through the space can be physical or psychological. This project could be done by individuals or by groups of three to five students working together.

CHAPTER 2

2.1 Good and Bad Design

Bring in a functional piece that you consider well designed and a functional piece that in your opinion is poorly designed. If you can't bring in the pieces themselves, photographs will do. Consider both aesthetic appeal and functionality, or lack thereof, and describe for the class the characteristics that enhance or detract from the aesthetics and functionality of the pieces you have selected.

2.2 Form and Function

Using any materials, make a chair. It must support weight without falling over or falling apart and must also be aesthetically interesting.

2.3 Working with the Setting

Using whatever materials and as many forms as you choose, create a site-specific piece that controls all space within an existing indoor or outdoor environment. That is, all the space within certain obvious boundaries should appear to "belong to" the work.

This problem can be solved in any size, from a large-scale designed environment to a small-scale model within a scaled-down indication of an environment, and by individuals or small groups. An alternative would be for several students to use pieces created as earlier projects and explore ways to combine and present them so they work well together and in relationship to a specific setting.

2.4 Defying Gravity

Using any materials you choose, create a piece that appears to defy gravity and by so doing, draws the force of gravity to the viewer's attention. For instance, the piece might fly or appear to be about to fall. If it flies, it should not look so much like a standard kite that the viewer takes its ability to fly for granted. If it is earthbound and seemingly about to fall, whatever keeps it from falling should not be apparent to the viewer to preserve the illusion of defying gravity.

2.5 Working on a Large Scale

The point of this project is to create the largest three-dimensional piece you can using no more than $5 for materials. At the instructor's discretion, a time factor might even be specified; that is, the piece might have to be sturdy enough to stand up on its own for a certain number of hours—perhaps 6 to 8 hours. The student who turns in the largest work that holds up for the duration "wins"—perhaps a prize might be offered. This project may get you thinking about the economics of materials and size as well as the artistic challenge of creating a large piece.

CHAPTER 3

Projects for this chapter are based on varying arrangements of identical or similar forms, from cubes or slabs of wood or clay to scissors, cups, or paper bags. To aid exploration of the effects of each principle of design, the same forms could be used and simply disassembled and rearranged, if bonding techniques used allow their reuse; if not, one could start with many identical forms and use some of them for each project. The decision whether to require that all projects be done with the same forms rests with the instructor. If you are required to use the same forms, you might want to review all projects assigned for this chapter before deciding what forms to use.

3.1 Repetition

Assemble four or more identical or similar forms, either found objects or forms made from some easily worked material such as wood or clay. Use them together to create a piece that is more than the sum of its parts. The viewer should be aware that the same unit is being repeated, but the real excitement should be the overall form.

3.2 Variety

Again using four or more identical or similar forms, assemble them in such a way that they give an impression of variety. For instance, they might be piled together in varying amounts or placed in varying directions, but yet maintain a clear overall cohesiveness.

3.3 Visual Rhythm

Using four or more identical or similar forms, set up a visual rhythm that gives the viewer a distinctive way to "read" the work. A certain rhythm may well appear in the solutions to the first two problems, but here the emphasis is placed on a rhythmic effect. Note that apparent movement varying through space and time—in and out, up and down, flowing and pausing—can be used to create the impression of rhythm.

3.4 Visual Balance

Using four or more identical or similar forms, assemble them in two ways: (1) a symmetrically balanced structure; (2) an asymmetrically balanced structure.

3.5 Emphasis

Using four or more identical or similar forms, assemble them in a way that emphasizes some aspect of their nature or some area of the sculpture. The object is to give the viewer a visual tool for organizing the whole. If necessary, the forms can be altered to emphasize some characteristic, or an auxiliary part—such as a base—may be added.

CHAPTER 4

4.1 From Flat Material to Volume

Experiment with paper folding to develop an understanding of *planar construction*—creation of flat-sided forms. First use an 8½ × 11" sheet of paper, creasing or scoring it along one or more lines and then folding it along the creased lines to raise the flat surface into a series of planes angling away from or back toward each other in three-dimensional space. Do as many as you like, choosing the one that is most effective as a low relief or free-standing sculpture. A minimum of tape can be used to fasten edges together if necessary. Then do the same thing with the additional option of cutting the original sheet to see what forms can evolve. The forms need not be symmetrical, and the fold lines can be either straight or curving.

4.2 Curvilinear Form

Using any media, accent the strong horizontality or verticality of a piece by using curvilinear form. That is, use curving contours to draw the viewer's eye along the longest dimension of a very horizontal or very vertical piece.

4.3 Exterior and Interior Forms

Using any method and material you choose, create a piece that reveals both external and internal forms and uses their interplay as the major focus of the work.

4.4 Metamorphosis

Using plasticene clay, transform one representational form into another in five stages. First create the two representational forms in a realistic manner; then create an abstraction of each in which its form approaches the other. Finally, construct the middle stage using the two abstracted forms as reference, so that it becomes an abstraction of abstractions.

4.5 Fill-a-Bag

Fill a bag of any sort with some loose material—such as sand, sugar, water, or stones—in such a way that the bag controls the form of the loose material. The bag need not be tightly bound—floppiness is a possibility, provided that it is under control.

CHAPTER 5

5.1 Negative Forms in Space

Assemble six to eight blocks of wood in such a way that they delineate and draw attention to one or more forms in unfilled space. The pieces of wood should be similar but need not be identical; you can paint them if you choose.

5.2 Activated Surrounding Space

Using materials of your own choosing, create a piece that seems to extend beyond its own physical limits, activating a larger area of the space around it. Refer to the text for ideas about how this subtle effect might be achieved.

5.3 Confined Space

Using any materials, including found objects, create a confined space and then develop forms within it. By thus isolating these forms, you will draw special attention to them.

5.4 Scale Change

Using any materials, create a situation in which the viewer must realize that something has been presented in an unaccustomed scale, much larger or smaller than its usual reality.

5.5 Illusionary Space

Using any materials, create a piece that gives the illusion of behaving differently in space than it actually does. For example, by the way you cut or paint a form, you could make a shallow piece appear to occupy very deep space or make square contours appear rounded.

CHAPTER 6

6.1 Wire Sculpture

Use wire to create a line or lines in space that describe a human or animal form. The wire can vary in size and can be painted black to be seen more readily. Bend the wire into curves that encompass fully three-dimensional forms in unfilled space, as if you are creating a three-dimensional drawing.

6.2 Directional Line

Using any material, create a work that uses line to lead the eye in a specific direction. The larger the piece, the more the eye will follow it.

6.3 Line and Form

Use wire to create a linear three-dimensional sculpture, fully rounded in space rather than frontal; present it in relationship to a wooden base, perhaps with U-nails used unobtrusively to join the two. The mass of the base should work with the airy linear structure to create a unified, well-balanced whole. Using standard bases available in most art departments, experiment with various sizes and shapes of bases to determine what works best. If the linear sculpture extends horizontally beyond the edges of the base, how well do they relate to each other?

7.1 Texture Switch

Taking two already existing objects, create a new surface texture on each that will contradict the previous sense of pleasantness or unpleasantness. For example, the smoothness of a bar of soap might be covered with crushed glass, and the roughness of a cinder block might be covered with terrycloth.

7.2 Three Textures Together

Using worked and/or found textures, create a piece using three different textures that work well together. They might be unified by contrast rather than by similarity.

7.3 Visual Textures

Using an existing object or a solution to a previous problem, manipulate its surface to alter its visual texture and affect the way viewers would respond to it. The new optical effects could be created by painting or drawing on the surface, or you could devise some other way of optically changing the visual texture of the piece.

7.4 Soft Sculpture

Manipulate soft material(s) by processes such as sewing, wrapping, stuffing, and tying to create a soft sculpture large enough to work well by itself as a floor piece. What are the possibilities and limitations of each process?

7.5 Contradicting a Form

Using applied or real texture, try to contradict an existing form. For instance, take a solid block of wood and paint holes in it. In 7.1 you will switch textures. In this project, try to obliterate the form.

CHAPTER 8

8.1 Natural vs. Artificial Lighting

Show how the appearance of any of your previous projects could be altered by artificial lighting and natural lighting. Note the changes that occur as the placement of the light source changes, as in the movement of the sun through the day or intentional shifts in studio lighting to heighten the impact of the piece. If your piece has both straight edges and curved contours, note the different ways that they are affected by light.

8.2 Shadows

Create an outdoor sculpture in which shadows are part of the excitement of the piece. Utilize shadows on the form and shadows cast by it.

8.3 Light as a Medium

Using materials of your own choosing, create a piece in which light is used as a "three-dimensional" medium. Some examples might be a series of mirrors reflecting a flashlight beam, a fishtank full of smoke with a light shining in one end, or a light shining through colored water.

CHAPTER 9

9.1 Natural Colors

Find three to five objects with different local colors, such as wood, stone, brick, or fabric. Put them together in such a way that they are harmonious not only in form but also in color.

9.2 Applied Color

Create or find three identical simple geometric forms or use projects you have already completed. Apply color to each piece in a different way, comparing the effects: (1) Paint the piece in a solid color; (2) Paint each surface a different color; (3) Break up the surfaces by painting them in geometric patterns or splattering paint on them.

9.3 Psychological Effects of Color

Find an everyday object and paint it in such a way that viewers will respond to it in a different way. You could simply change its solid color to another solid color, as in painting a yellow banana purple. Or you could paint its surface with nonobjective designs such as stripes or representational images. How can you use color to alter the psychological effect of the object?

9.4 Removal of Color

Increase sensitivity to the effects of color by removing color from a familiar environment. Create an installation using objects from our everyday world, painting the objects in values of gray to replace local colors. The values need not be the same as the original color values.

9.5 Color Combinations

Using nine simple wooden forms, create three 3-piece sculptures that are identical except for color. Paint each sculpture in a different kind of color combination, choosing from monochromatic, analogous, complementary, split-complementary, triad, or tetrad color schemes. What effects does each create? Which seems to work best for the piece? For comparative purposes, it is helpful to paint each 3-piece sculpture identically, except for the colors chosen. If you further limit the variables to combinations that involve one particular hue, you will be better able to judge the effects of different combinations.

CHAPTER 10

10.1 Growth or Decay

Using any media, including found objects, create a piece that is not permanent and that draws attention to processes of growth or decay. Influences such as wind, rain, fire, color, or heat can be used to alter the physical appearance of the piece through time.

10.2 Kinetic Sculpture

Make a three-dimensional object that moves in a controlled space, in controlled time. Solutions could include wind-up toys or fan-moved works.

10.3 Controlling the Viewer's Movements

Using inexpensive materials, create an installation piece or even an earthwork that controls the movements of viewers, forcing them to become participants in the work. What happens psychologically when one is led through physically awkward or through welcoming spaces?

10.4 Changes by the Viewer

Design a piece that changes with each viewer's participation in it. Some possibilities include games, processes, forms to be manipulated. Consider the possibility of motion or movable parts as a primary focus of the piece.

CHAPTER 11

11.1 Ready-Made

Find an object that already suggests a human or animal form, or that will if slightly altered. Present it as a sculpture.

11.2 Assemblage

Put together three or more found objects in such a way that they present a coherent whole. In a successful solution, the new whole will be perceived before its components.

CHAPTER 12

12.1 Clay or Wax Sculpture

Using clay, plasticene, or wax, model a simple sculptural form whose surface reflects the tools used to shape it.

12.2 Addition with Malleable Materials

Use at least three different malleable materials together—paper, plaster, cement, papier-mâché, fibers, soft metals, clay, wax, or any similar easily shaped material—to create a three-dimensional piece. How do you use these materials? How can you attach them to each other? What do they do together?

12.3 Fabrication with Rigid Materials

Use three or more materials that are rigid in their final form to create a three-dimensional piece. What effects are typical? Do you choose to contradict these effects? How can you attach the materials to one another?

12.4 Skin and Structure

Use balsa wood and light coverings such as rice paper, sheet fabric, or plastic to create a piece in which the "skin" and the structure that supports it are equally important. References to kites, flight vehicles, or oriental design may develop.

12.5 Wood, Burlap, and Plaster Construction

Build a sculpture using wood, burlap, and plaster of Paris. Using the wood as an armature and then building up plaster forms on it is a common solution. In such a solution, the burlap can be used both to bind the wood joints and as a base for the plaster.

12.6 Joinery

Using any materials, create an additive sculpture in which the way the parts are held together is a significant aspect of the design. No screws, nails, or glue can be used.

13.1 Wood Carving

Carve a simple form in soft wood in such a way that one area flows into another in a continuous series of changes. Concentrate on exploring the subtractive process of creating form by removing excess material. Excess could be carved away with a pocket knife, hammer and wood chisels, file, drill, saw, or sandpaper.

13.2 Plaster Carving

Fill a half-gallon milk carton with plaster of Paris mixed according to the directions on the package. After the plaster dries, pull away the carton and carve the mass into a three-dimensional form using tools such as a knife, file, drill, and/or sandpaper. The piece may be monolithic or open, pierced by a void. Either way, its form must draw the viewer into moving all the way around it to see all sides.

13.3 "Stone" Carving

For an introduction to the experience of stone carving, cast a block of cement or cast stone in a box or carton. Sketch a simple form onto its surface and then work into the material with hammer and stone chisels, always being aware of where the form is within the block.

CHAPTER 14

14.1 Paper Casting

Manipulate a piece of paper and then use it as a mold into which plaster of Paris is poured. After the plaster has hardened, cut away any undesired edges of the cast with a saw. The result can be put together with other students' work to make a modular wall piece.

14.2 Plaster Casting in Clay

Build a simple wooden frame with a plywood floor, not too large (anywhere from 12″ × 12″ [30.48 × 30.48 cm] to 18″ × 22″ [45.72 × 55.88 cm]), to hold clay and liquid plaster. Place a layer of nonhardening clay or plasticene on the floor of the frame. Shape the clay by pushing, pounding, squeezing and drawing it into a desired "terrain" whose concave areas will be convex in the finished piece, and vice versa. Concentrate on the process of working in reverse. Any tools or materials may be used to create desired textural effects. Then prepare plaster of Paris according to the directions on the package and pour or scoop it quickly into the clay mold, smoothing the upper surface of the plaster, which will become the back of the piece. When the plaster dries, lift the plaster and clay out of the frame and peel away the clay, exposing the surface of the plaster as a low relief that is the reverse of the contours of the clay bed.

An alternative is to use wet sand rather than clay to create the mold. Sand will not hold fine details as well as the clay but is good for rough work.

14.3 Cast Hands

Mix a quantity of plaster of Paris, remove any jewelry, and grease your hands well with petroleum jelly. Make a "bowl" of your cupped and joined hands. Have a classmate fill the "bowl" with plaster. Hold it in your hands until it sets. Experiment with different ways of holding your hands to create interesting effects. Once the plaster is dry, cut off the rough edges with a saw. Can the hands of the whole class be combined as an effective modular construction?

G L O S S A R Y

Words used that are defined elsewhere in this glossary are *italicized*.

abstract referring to art that simplifies, emphasizes, or distorts qualities of a real-life image rather than art that tries to represent its surface details accurately. In some cases, the intent is to present the essence of an object rather than its outer form.

activated space the area controlled by a three-dimensional piece, including not only its form but also a subtly energized but physically unfilled area in or around the work.

additive color mixing mixtures of light to create colors, called "additive" since each colored light adds its energy to the mixture, raising its *value* slightly.

additive sculpture three-dimensional work made by putting pieces of material(s) together to build up a form.

analogous colors *hues* lying next to each other on a *color wheel,* sometimes used together in color schemes.

annealing the process of heating and cooling of metal while shaping it by techniques such as hammering, to return it to a *malleable* state.

applied color color added to a material, concealing or changing its original color.

applied design use of the principles and elements of design to create functional pieces.

armature a simple inner skeleton that provides support for *modeling* with more pliable materials, such as clay or wax.

artificial lighting use of light from human-made sources such as incandescent or fluorescent bulbs to illuminate an area or a work of art.

assemblage a work made from objects or pieces of objects originally intended for other purposes.

asymmetrical balance placement of non-identical forms to either side of a balancing point in such a way that the two sides seem to be of the same visual weight.

atmospheric perspective the optical illusion that areas closer to the viewer are sharper in detail, color *intensity,* and *value contrast* than areas farther away, sometimes used intentionally by artists to create illusions of spatial depth.

bas-relief See *low relief.*

bezel a metal collar designed to hold a stone in a piece of jewelry.

box set in set design, the illusion of a room with one wall cut away so that the audience can see in.

cast a form made by any of various techniques of creating a mold into which a material is poured in liquid form, allowed to harden, and removed from the mold.

ceramics decorative or functional pieces made from clay and *fired* for permanence; also, the art of making ceramic pieces.

chasing engraving of the surface of a piece, often to help define contours or details.

chroma See *saturation.*

clay body a mixture of clays compounded for specific characteristics.

closed form a relatively solid volume with little *negative space.*

color wheel a two-dimensional circular model of relationships among *hues.*

complementary colors *hues* that are opposite each other on a *color wheel.* When mixed, they gray or neutralize each other; when juxtaposed, they intensify each other.

conceptual art works or events in which idea is more important than outer form.

confined space a spatial field with clearly defined enclosing boundaries.

content the subject matter of a work of art, plus its emotional, intellectual, symbolic, spiritual, and/or narrative implications, as opposed to its physical form.

controlled time referring to the movement of works of art through a predetermined sequence of events.

cool colors *hues* in the green and blue range.

crafts disciplines in which functional pieces are made by hand or as if by hand, with the individuality associated with handmade objects. In a broader sense, crafts are occupations requiring manual skill and aesthetic sensitivity to create objects that may or may not be functional.

delineated space an unfilled area described by filled areas of a three-dimensional work.

directional line a line that seems to guide the viewer's eye along a particular visual path.

dominance emphasis placed on a particular area or characteristic of a work, with other areas or aspects given subordinate or supporting roles.

ductility the ability to be stretched or extended without breaking.

dynamic form a three-dimensional work that conveys an illusion of movement and change.

earthenware ceramics made from the coarsest clays, usually fired at the lowest temperatures.

economy deletion of nonessential details to reveal the essence of a form.

elements of design those qualities of a design that can be seen and worked with independently of the figurative content. They include *line, form, value, space, texture,* color, and time.

emphasis stress placed on a single area of a work or a unifying visual theme.

encaustic a method of painting with pigment-bearing hot wax.

ergonomics the study of how people relate physically to their environment, of particular interest to designers seeking to increase job efficiency and decrease workers' fatigue.

exterior form the surface shape of a work of art.

eye line the illusionary line between a figure's eyes and something at which it appears to be looking.

fabrication assembling of rigid materials into units by techniques such as welding, bolting, or *lamination.*

fiber art work created by manipulation of strands of varying materials by any of a variety of methods.

figurative representing human or animal forms.

firing the baking of ceramic pieces to make the clay's form permanent.

focal point the area in a work to which the eye is most compellingly drawn.

folk art works that are created by people without aesthetic training but that may be appreciated for their vigor, humor, and highly personal style.

forced perspective exaggeration of the illusionary convergence of parallel lines toward the horizon, used in set design to make a shallow space appear deeper.

forging shaping of metal by hammering it over a hard surface, often after first heating the metal to a *malleable* state.

form the volume and shape of a three-dimensional work, perhaps including unfilled areas that are integral to the work as a whole.

found object an object not originally created as art but used in or appreciated as a work of art.

free time referring to art that moves and changes somewhat unpredictably through time.

frontal seen or made to be seen only from the front, as opposed to pieces that encourage viewing in the *full round.*

full round works designed to be appreciated from all sides, in fully three-dimensional space.

gestalt in a successful work of art, a whole that has properties that transcend the sum of its parts.

glaze in *ceramics,* a colored or transparent liquid applied to pieces made of clay; when *fired,* it bonds to the clay and forms a hard, glassy coating.

gray scale the representation of gradations of *value* as a series of equal steps from black to white.

half-round three-dimensional works in which only 180 degrees of a full circle is presented as being of aesthetic interest.

high contrast in *values,* dramatic juxtaposition of very light and very dark areas.

high relief three-dimensional *form* raised considerably off a flat background.

highlight a brightly lit area that appears as a luminous spot on a work.

hologram a record of laser-light patterns that allows three-dimensional perception of a three-dimensional object on a two-dimensional surface.

hue the characteristic of color identified by color names, such as red and blue. It corresponds to a particular wavelength within the spectrum of visible light.

idealized in representational art, the portrayal of objects as approaching some imagined rather than actual appearance of perfection.

implied form See *negative form.*

implied line a line in a work that is subtly perceived by the viewer but that has no physical form; the overall flow of one line into another in a work, with continuation from one to the next suggested by their common direction and/or juxtaposition.

industrial design design of the mass-produced products of our everyday environment, from sinks and furniture to computers.

inner form See *interior form.*

installation pieces designed environments installed in museums or galleries, sometimes temporarily.

intensity See *saturation.*

interior form the shape of the inside of a hollow work of art; an inner form that appears to be emerging from or contained within the outer form.

intermediate hues Albert Munsell's term for *secondary colors.*

junk sculpture three-dimensional works of art created from the castoff products of our society.

kiln an oven, furnace, or other enclosure used for the *firing* of *ceramics.*

kinetic art works designed to move and perhaps change through time.

laminate to create a larger unit by gluing together thin sheets of a material or materials.

line an area whose length is considerably greater than its width, or in which two planes are abutted.

linear of or relating to a line or lines.

linear perspective the optical illusion that parallel lines converge toward a distant vanishing point.

local color the natural color of an object

lost-wax any of several *casting* processes by which a layer of wax is melted away from surrounding positive and negative *molds* to create a space into which the material for the cast can be poured.

low relief three-dimensional form that is barely raised from a flat background.

malleable capable of being shaped, pliable.

maquette a small-scale model of a work, usually developed to aid the planning process.

mass See *form.*

minimal art *nonrepresentational art* using very few forms and colors.

mixed media combinations of different materials to create a visually and physically coherent whole.

mobiles hanging sculptures that turn when moved by air currents.

modeling shaping pieces from a pliable material such as clay by using the hands and hand tools.

moiré an illusory wavelike pattern.

mold a hollow form created for casting materials that flow into the form when in a liquid state and then duplicate it in reverse when hardened.

monochromatic a color scheme using closely related colors derived from a single *hue* but perhaps varying in *value* and *saturation.*

monolithic a piece having a relatively closed form that reflects the single stone or block of wood from which it was carved.

monumental works very large, imposing works of art that may or may not serve memorial purposes.

narrative art pieces that tell a visual story.

natural lighting the use of existing outdoor lighting rather than artificial lights to illuminate a piece.

negative form a shaped space that has no physical existence but is enclosed or defined by *positive forms;* a void.

negative mold a receptacle for *casting* that is the reverse of the finished form. See *mold.*

negative space a physically unfilled area in a three-dimensional work; in subtractive sculpture, a previously filled area that was cut away to reveal the *form.*

neutrals colors of very low *saturation,* approaching grays.

nonobjective art works that have no apparent relationship to objects from our three-dimensional world; nonrepresentational art.

nonrepresentational art See *nonobjective art.*

open form a *mass* penetrated by *negative spaces.*

optical color mixture colors mixed visually, as when *hues* are closely juxtaposed in space or when transparent layers of different colors are overlaid.

outline the line described by the outer boundary of a *form.*

participatory sculpture three-dimensional art designed to engage the viewer physically.

patina the sheen produced on a surface by aging or handling; the thin layer of coloration, usually green or brown, that appears on a bronze surface as it oxidizes or weathers.

performance piece a live experience conducted or set up by the artist.

pigment a powder that is the coloring ingredient for paint or other color media.

point of view the distance and angle from which something is seen.

plastic capable of being shaped; polymerized organic compounds that can be shaped in many different ways.

polychromed (polychromatic) multicolored.

porcelain usually white ceramic pieces made of very fine clay and fired at the highest temperatures.

positive form a solid area that physically occupies space in a three-dimensional work of art.

primary colors in color theory, those basic *hues* from which all other hues can be mixed. Different color theories suggest different primaries. In traditional color theory about pigment mixtures, the primary colors are red, yellow, and blue.

primary contour(s) the shape of the outermost extremity of a three-dimensional work.

principal hues Albert Munsell's term for *primary colors.*

principles of design basic aesthetic considerations that guide organization of a work of art.

proportion a sense of appropriateness in the size relationships of different parts of a work.

raising in metalworking, the hammering of a flat sheet of metal over a stake, thus compressing and curving it into a hollow form. In ceramics, one of the stages of the throwing process.

read to scan or perceive a work of art in a particular way or with a particular understanding.

ready-made a functional manufactured object that is displayed as a work of art for its unintentional aesthetic qualities.

realism visual accuracy in artistic representation of known objects.

reflected light the light waves that bounce back to our eye from a surface rather than being absorbed into it. These reflected waves determine what we call the "color" of the object.

refracted light the bands of color seen when white light is passed through a prism.

relief three-dimensional form raised from a flat surface.

rhythm unification of parts of a work through measured repetition of visual accents.

saturation a measure of the relative purity and brightness or grayness of a color, also called "chroma" or "intensity."

scale the size of an object in relationship to other objects and to its surroundings.

secondary colors in color theory, the *hues* created by mixing two *primary colors* together.

secondary contours the forms developed within the outer boundaries of a work.

shadow study an analysis of where natural lighting will create shadows at different times of day and different seasons at a particular location.

simultaneous contrast the principle that the juxtaposition of two colors exaggerates their differences and reduces their similarities.

site-specific referring to works expressly designed for and installed in a particular location.

space the three-dimensional field with which the artist works, including both filled and unfilled areas.

spatial presence the size and impact of the field in which a three-dimensional work is experienced. This field may not stop at the physical boundaries of the work.

static form a three-dimensional work that appears stationary.

stoneware *ceramic* pieces made of medium-fine clays and fired at medium temperature ranges.

stylized altering the visual characteristics of an object to fit a desired way of design or cultural aesthetic.

subtraction creation of a work of art by carving away the excess from a larger piece of material.

subtractive color mixing mixing of *pigments*, producing a slightly darker *value* since each pigment subtracts its energy from the light reflected by the mixture.

super-realism extremely accurate representation of actual three-dimensional objects.

symmetrical balance the placing of identical forms to either side of the central axis of a work to stabilize it visually.

temporal relating to existence in and perhaps change through time.

tensile strength the resistance of a material to a force tending to tear it apart.

tertiary colors in color theory, the *hues* created when a *primary* and a *secondary color* are mixed.

texture the tactile surface characteristics of a work of art that are either felt or perceived visually.

thermoformed in plastics, a shape created by bending when hot.

thermoplastic capable of being remelted and re-formed, a characteristic of some plastics, metals, and glass.

thermosetting not capable of being remelted after initial shaping and setting, a characteristic of certain plastics, rubbers, and clay.

three-dimensional having height, width, and depth.

trompe l'oeil "fool the eye" optical illusion.

two-dimensional having height and width, but not depth.

undercutting creation of an overhanging surface by carving material beneath away.

unity organization of parts so that all contribute to a coherent whole. The term is sometimes listed as one of the organizing principles of design, but in this book it is used to connote the combined result of all principles of design (repetition, variety, rhythm, balance, emphasis, economy, and proportion).

value degree of lightness or darkness.

value contrast juxtaposition of light and dark areas.

vertical balance distribution of *visual weights* in a piece in such a way that top and bottom seem to be in equilibrium.

video art use of television techniques for purely aesthetic purposes.

visible spectrum the humanly perceptible bands of colored light created when white light passes through a prism.

visual economy See *economy*.

visual texture the apparent rather than actual tactile quality of a surface.

visual weight the apparent lightness or heaviness of a work or a portion of a work.

void See *negative form*.

volume See *form*.

warm colors red, orange, and yellow *hues*.

I N D E X

Many technical terms are included in the index, with references to their text definitions. Consult the glossary for further definition of technical terms.

PHOTOGRAPHIC CREDITS

Copyright in each work of art belongs to the artist unless otherwise specified. Copyright in each photograph belongs to the photographer unless otherwise specified.

Chapter 1 *1.5:* Charles Simonds © 1994 Charles Simonds/Artists Rights Society (ARS), New York. *1.8, 1.9:* Constantin Brancusi © 1994 Artists Rights Society (ARS), New York/ADAGP, Paris. *1.21:* © Nancy Graves/VAGA, New York 1995. *1.25:* Artistide Maillol © 1994 Artists Rights Society (ARS), New York/SPADEM, Paris. *1.29:* Henri Matisse © 1994 Succession H. Matisse, Paris/Artists Rights Society (ARS), New York. *1:31:* Charles Simonds © 1994 Charles Simonds/Artists Rights Society (ARS), New York. *1.44:* Meret Oppenheim © 1994 Artists Rights Society (ARS)/Pro Litteris, Zurich.

Chapter 3 *3.7:* © Robert Rauschenberg/VAGA, New York 1995. *3.8:* Antoni Tàpies © 1994 Artists Rights Society (ARS), New York/ADAGP, Paris. *3.11:* Max Bill © 1994 Artists Rights Society (ARS), New York/ Pro Litteris, Zurich. *3.15:* © Estate of Jacques Lipchitz/VAGA, New York 1995. *3.22:* Richard Serra © 1994 Richard Serra/Artists Rights Society (ARS), New York.

Chapter 4 *4.13:* Le Corbusier © 1994 Artists Rights Society (ARS), New York/SPADEM, Paris. *4.24:* Constantin Brancusi © 1994 Artists Rights Society (ARS), New York/ADAGP, Paris. *4.25:* Antoine Pevsner © 1994 Artists Rights Society (ARS), New York/ADAGP, Paris.

Chapter 5 *5.1:* © Estate of David Smith/VAGA, New York 1995. *5.2:* © Louise Bourgeois/VAGA, New York 1995. *5.4:* © George Rickey/VAGA, New York 1995. *5.6:* © Clement Meadmore/VAGA, New York 1995.

Chapter 6 *6.3:* Jesus Rafael Soto © 1994 Artists Rights Society (ARS), New York/ADAGP, Paris. *6.4:*

Alexander Calder © 1994 Artists Rights Society (ARS), New York/ADAGP, Paris. *6.6:* Alberto Giacometti © 1994 Artists Rights Society (ARS), New York/ADAGP, Paris. *6.10:* Etienne Hajdu © 1994 Artists Rights Society (ARS), New York/ADAGP, Paris. *6.11:* © Lynda Benglis/VAGA, New York 1995.

Chapter 7 *7.6:* © Marisol (Escobar)/VAGA, New York 1995. *7.14:* Frank Stella © 1994 Frank Stella/Artists Rights Society (ARS), New York. *7.17:* © Estate of David Smith/VAGA, New York 1995.

Chapter 8 *8.7:* Alberto Giacometti © 1994 Artists Rights Society (ARS), New York/ADAGP, Paris. *8.19:* Dan Flavin © 1994 Dan Flavin/Artists Rights Society (ARS), New York.

Chapter 10 *10:10:* Alexander Calder © 1994 Artists Rights Society (ARS), New York/ADAGP, Paris.

Chapter 11 *11.3:* Marcel Duchamp © 1994 Artists Rights Society (ARS), New York/ADAGP, Paris. *11.8:* Pablo Picasso © 1994 Artists Rights Society (ARS), New York/SPADEM, Paris. *11.11:* © John Chamberlain/VAGA, New York 1995.

Chapter 12 *12.2:* Crown copyright. © The Board of Trustees of the Victoria & Albert Museum *12.8:* Auguste Rodin © 1993 Artists Rights Society (ARS), New York/ADAGP, Paris. *12.22:* © Estate of H. C. Westermann/VAGA, New York 1995.

Chapter 13 *13.10:* Constantin Brancusi © 1994 Artists Rights Society (ARS), New York/ADAGP, Paris.

Chapter 14 *14.14:* Pablo Picasso © 1994 Artists Rights Society (ARS), New York/SPADEM, Paris.

Color Insert: *Color Plates 6, 17, and 21:* © George Segal/VAGA. New York 1995.